THE Art OF CIRCULAR YOKES

 Interweave

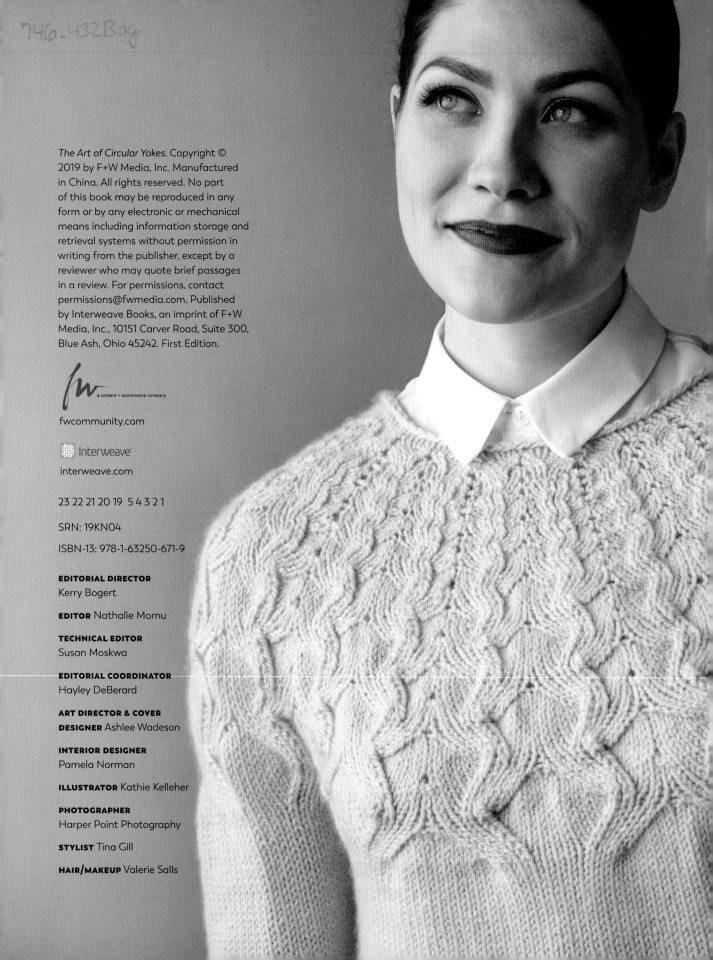

fw
a content + ecommerce company

fwcommunity.com

Interweave
interweave.com

23 22 21 20 19 5 4 3 2 1

SRN: 19KN04

ISBN-13: 978-1-63250-671-9

EDITORIAL DIRECTOR
Kerry Bogert

EDITOR Nathalie Mornu

TECHNICAL EDITOR
Susan Moskwa

EDITORIAL COORDINATOR
Hayley DeBerard

ART DIRECTOR & COVER DESIGNER Ashlee Wadeson

INTERIOR DESIGNER
Pamela Norman

ILLUSTRATOR Kathie Kelleher

PHOTOGRAPHER
Harper Point Photography

STYLIST Tina Gill

HAIR/MAKEUP Valerie Salls

Contents

INTRODUCTION

MERRIAM-WEBSTER'S DICTIONARY defines art form as "an undertaking or activity enhanced by a high level of skill or refinement." Thus, even though some consider it humble, knitting is an art form. Whether sitting at an elder's knee or in a designer's classroom, we can spend a lifetime refining our techniques and conquering a variety of skills.

As we practice our craft with yarn and needles, we work on canvases of stitches to create knitted masterpieces. One of the most iconic canvases is the circular yoke. Designers, with their boundless ingenuity, give us garments with painterly colorwork, illustrative lace, beautifully chiseled cables, and so much more.

Have you ever stopped to wonder just how they do it? How do knitting masters design the nearly seamless sweaters that frame our faces and drape across our shoulders so beautifully? We explore the answers to these questions in *The Art of Circular Yokes*. Our instructor in the math behind circular yokes and the nuances of shaping is designer Holli Yeoh. Whether you seek to design this style of sweater or to simply feed your knitterly curiosity, deepening your understanding will be fascinating.

From there, walk through the halls of our sweater "gallery," a curated collection of 15 unique and stunning patterns to expand your handknitted wardrobe while honing your skills in a variety of techniques. Top down or bottom up, with colorwork, lace, cables, or slipped stitches, this collection acts as your master class to knitting the finest circular yoke pullovers and cardigans our designers have to offer. They act as our tutors, giving us new lessons with each pattern they create.

Grab your yarn and needles, choose your next cast-on, and knit your way to a new design that shows your love of this art form.

Kerry Bogert

Kerry Bogert, *Knitter and Editorial Director, Books*

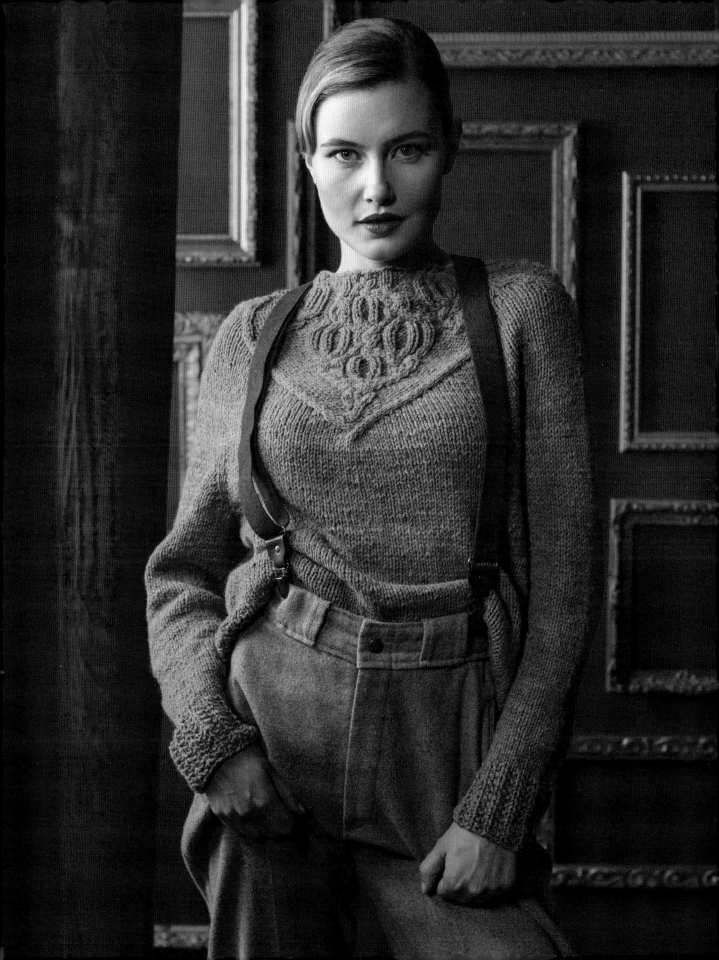

The Math

OF CIRCULAR YOKES

There are many approaches to calculating a circular yoke, and the rules can easily be bent. The patterns in this book give examples of several different approaches, yet they all share the same basic principles. | **BY HOLLI YEOH**

WHETHER WORKING BOTTOM UP or top down, the same calculations are required. You need to decide on your neckline stitches and determine the lower yoke stitches where the sleeves meet the body and the distance over which you'll work your shaping rounds. Circular yoke sweaters can be worked in the round or flat (sometimes, in the case of cardigans). All references to rounds/rows throughout this section will be stated more simply as rounds, but rows may be substituted.

Basic Yoke Construction

The circular yoke sweater is composed of three cylinders (one for the body and two for the sleeves), plus a funnel for the yoke **(FIGURE 1)**. Where the body and sleeves join—or separate, depending on which direction you're working—there's an underarm span of stitches that are set aside or added to each of those cylinders where they meet.

The yoke is shaped throughout its depth to create a funnel shape. It can be further shaped by raising the back neck so the front sits more comfortably on the wearer. This is achieved by working short-row shaping at the back, adding height to the back of

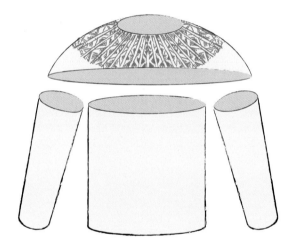

FIGURE 1: The cylinders and funnel shapes that make up a sweater with a circular yoke.

the sweater but not the front. The short-rows can be added anywhere on the back of the yoke, often just below the neckline or below the yoke motif (or both).

Before you begin your calculations, you'll need accurate body measurements and the stitch and round gauges for your chosen yarn and stitch pattern(s).

Body Measurements

Taking accurate body measurements is a two-person job. Take the following measurements **(FIGURE 2)** over basic undergarments and, at most, a close-fitting T-shirt, while standing straight and looking forward.

Neck Circumference: Measure around the base of the neck, crossing over the prominent bone at the back of the neck and the hollow at the front of the neck. It's easier to place a length of yarn or string around the neck and then measure the yarn.

Cross-Back Width: About halfway between the top of the shoulder and the underarm, beginning and ending directly above the underarm crease, measure across the back. This is the distance between armhole seams on a well-fitting T-shirt.

Yoke Depth: Tie a piece of elastic or string around the body just below the armpits (this is shown in the figure with a horizontal broken line). Make sure the arms can be raised above the head and that the string is tied snugly. It should be about 1" (2.5 cm) below where the arm meets the body. Measure from the prominent bone at the back of the neck straight down the back to the string.

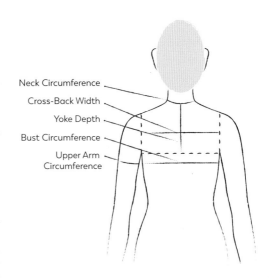

Neck Circumference
Cross-Back Width
Yoke Depth
Bust Circumference
Upper Arm Circumference

FIGURE 2: Body measurements, viewed from back.

Bust Circumference: Measure around the fullest part of the bust, making sure the measuring tape is parallel to the floor and not sagging in the back.

Upper Arm Circumference: Measure around the fullest part of the upper arm.

"I calculated the yoke-pattern gauge along with the Stockinette stitch gauge. I had to take care that the neck circumference didn't get too small, because there was a significant difference between the two gauges."
—JENNIFER WOOD

Left: One of the swatches Jennifer made for the Morris sweater.

Gauge

Swatching is a necessity when designing a sweater. Knit a large-enough swatch to get a good sense of the drape and feel of the fabric you're creating with your chosen yarn. Measure the gauge both before and after washing and blocking. Large swatches also give a better representation of the gauge. At a minimum, work a 6" (15 cm) square plus additional edging stitches and rows. If your sweater will be worked in the round, then you need to knit the swatch in the round for accuracy, as working flat versus in the round can affect your gauge (see note on How to Swatch in the Round below). Measure in the center of the swatch, away from the edges, where the stitches tend to be distorted **(FIGURE 3)**. If the sweater contains more than one stitch pattern, they all need to be swatched.

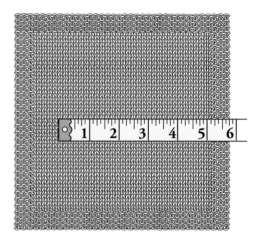

FIGURE 3: Make a swatch at least 6" (15 cm) square and measure the 4-inch (10 cm) section—or the increment given in the pattern—at the center of the swatch.

HOW TO SWATCH IN THE ROUND

A shortcut to swatching in the round is to cast on the same number of stitches on a circular needle as you would for a flat swatch. Work garter stitch or moss stitch for a few rows, then work the first right-side round in your stitch pattern with a moss-stitch border at the edges. When you come to the end of the row, don't turn; with the right side facing, slide the stitches back to the other end of the needle. Leaving a large loop of the working yarn running across the back, work another right-side round. Continue in this manner, working only right-side rounds, until the swatch is the desired length. Finish off with more garter stitch or moss stitch and bind off. The edges will be messy, but don't worry about it. You can tidy them as you go or cut the strands and tie them off at the end to make blocking and measuring the swatch easier. If the strands are left long enough for the swatch to lie flat, they don't need to be cut.

If the pre- and post-blocking gauges are different, you'll need to take that change into consideration. Use the blocked gauge for most of your calculations, but in situations where you want to knit to a particular length as opposed to a number of rounds, convert the measurement so you know the unblocked length. For example, imagine your unblocked gauge is 7.5 rnds/inch (3 rnds/cm) and the blocked gauge is 7 rnds/inch (2.8 rnds/cm). You want to have a 15" (38 cm) body length (from hem to armhole). Multiply that length by the blocked round gauge and then divide it by the unblocked round gauge to get the actual measurement to knit.

IMPERIAL

15" × 7 rnds/inch = 105 rnds

105 rnds ÷ 7.5 rnds/inch = 14"

METRIC

38 cm × 2.8 rnds/cm = 106.4 rnds = 106 rnds

106 rnds ÷ 3 rnds/cm = 35.3 cm

In this example, you would knit until your body length measures 14" (35.5 cm), since the yarn is unblocked when you're measuring it; after you finish and block the sweater, it will grow to the desired 15" (38 cm).

You'll note that doing the math with metric versus imperial measurements resulted in a slightly different number of rounds (106 versus 105). This is because knitters specify gauge in blocks of 4" (10 cm), but 4" isn't *precisely* equal to 10 cm. If we were designing high-precision equipment, this might present a problem, but knitting is inherently flexible and forgiving, and if you calculate 1 more or 1 fewer round than someone from a different country might, no one's going to notice, and the sweater is still going to fit.

Design Decisions

EASE

Ease is the difference between the measurements of the wearer's body and the finished measurements of a garment. The finished sweater can be larger than, the same size as, or smaller than the body measurements. These are referred to as positive ease, zero ease, and negative ease, respectively.

There are two kinds of ease that need to be taken into account when designing a sweater. *Wearing ease* is the minimum ease needed for comfort. For example, a tight sleeve with negative ease wouldn't be very comfortable, especially through the elbow, so even though a sweater with negative ease through the bust can be attractive, some positive ease is probably desired in the sleeve. *Design ease* is the ease required to create a particular silhouette, such as puffed sleeves or an A-line shape.

NECK TREATMENT

The neckline of a sweater is the line around the neck opening before any neck finishing is worked. The neck finishing is the trim or edging applied to the neckline, such as ribbing, a turtleneck, or a rolled edge. It's not completely necessary to have a neck finishing; this would be a design decision. The neck finishing will most likely impact both the yoke depth and the neckline circumference, so decisions should be made before calculating the yoke shaping.

The Math

With basic measurements, gauge in hand, and the design decisions made, the next step is to determine the stitch and round counts. This is done by combining body measurements and ease, then multiplying by gauge. The next few pages explain the calculations to make, followed by examples showing you the math. The accompanying figures give you the same formulas without any sample math.

The math doesn't always work out to be perfect whole numbers. There will be many instances where you'll need to round to the nearest whole number, or possibly the nearest even or odd number. To make it work with a stitch pattern, you'll need to round to the pattern repeat number. For example, imagine you have 38" × 5 sts/inch = 190 sts (for those of you working in metric, that would be 95 cm x 2 sts/cm = 190 sts), but the stitch pattern has a 6-stitch pattern repeat. So the actual number will need to be 186 sts or 192 sts, depending on which works best with your design and other calculations. This is where you, the designer, step in to make decisions.

One of the swatches Holli Yeoh made for her Twill cardigan.

Regardless of the direction of knitting, the calculations are the same, and the shaping will either add or eliminate stitches to create the desired shape. The example numbers provided in the calculations in this section are for a round-neck sweater to fit a 36" (91.5 cm) bust with 2" (5 cm) positive ease at a gauge of 20 sts and 28 rnds = 4" (10 cm), i.e., 5 sts and 7 rnds per inch (2 sts and 2.8 rnds per cm).

Note that the body and sleeve cylinders are not discussed here, other than determining their circumference where they join the yoke.

MEASUREMENTS

These are the basic measurements that are key to calculating the circular yoke. *Remember, the numbers and calculations given below are just for the purpose of giving an example—they're not universal.*

> **Bust Circumference** = 36" (91.5 cm)
>
> **Cross-Back Width** = 14¾" (37.5 cm)
>
> **Neck Circumference** = 14½" (37 cm)
>
> **Upper Arm Circumference** = 11" (28 cm)
>
> **Yoke Depth** = 7" (19.5 cm)

DESIGN DECISIONS

There are more design decisions that can be made than the ones listed below, but the following are essential.

> **Body Ease** = 2" (5 cm)
>
> **Sleeve Ease** = 1" (2.5 cm)
>
> **Neck Ease** = 0" (0 cm)
>
> **Neck Edging** = 1" (2.5 cm)
>
> **Front Neck Drop** = 1½" (3.8 cm)
>
> **Yoke Depth Ease** = 0" (0 cm)

STITCH COUNTS

Circumference and width stitch counts are determined by adding together the body measurement and ease and then multiplying by the stitch gauge. Refer to **FIGURE 4** (page 12) as you read the next sections.

Body and Sleeve Stitches

IMPERIAL

(A) **Bust sts** = (Bust Circumference + Body Ease) × st gauge = (36" + 2") × 5 sts = 190 sts

(B) **Sleeve sts** = (Upper Arm Circumference + Sleeve Ease) × st gauge = (11" + 1") × 5 sts = 60 sts

METRIC

(A) **Bust sts** = (Bust Circumference + Body Ease) × st gauge = (91.5 cm + 5 cm) × 2 sts = 193 sts

(B) **Sleeve sts** = (Upper Arm Circumference + Sleeve Ease) × st gauge = (28 cm + 2.5 cm) × 2 sts = 61 sts

Underarm Stitches

The underarm span is about 35–50% of the difference between the sweater width and the cross-back width, with the greater percentage used for the smaller sizes. The remaining stitches that are the difference between the sweater width and the cross-back width can be used in a short section of raglan shaping on each side of the underarm span, if desired. The raglan shaping helps distribute the yoke shaping and provides a better fit through the underarm area, but is entirely optional. If raglan shaping is included, it can also be worked over fewer sts (it's not necessary to use the full amount of Raglan Shaping stitches as calculated below).

(C) **Bust Width** = Bust sts ÷ 2 = 190 sts ÷ 2 = 95 sts*

IMPERIAL

Cross-Back sts = Cross-Back Width × st gauge = 14¾" × 5 sts = 73.75 sts (if bust width is odd/even, round to nearest odd/even number) = 73 sts

METRIC

Cross-Back sts = Cross-Back Width × st gauge = 37.5 cm × 2 sts = 75 sts

(D) **Underarm Span sts** = (Bust Width – Cross-Back sts) ÷ 2 = (95 sts – 73 sts) ÷ 2 = 11 sts

(E) **Lower Yoke Circumference (around sleeves and body)** = Bust sts + (2 × Sleeve sts) – (4 × Underarm Span) = 190 sts + (2 × 60 sts) – (4 × 11 sts) = 266 sts

(F) **Raglan Shaping sts (optional)** = 2 × Underarm Span = 2 × 11 sts = 22 sts (round up or down to a number divisible by 8) = 16 or 24 sts

This calculation, and some that follow, are the same regardless of which measurement system you use; in these cases, we've drawn values from previous Imperial calculations (e.g., 190 bust sts instead of 193) rather than showing the same calculation twice.

FIGURE 4 Stitch counts.

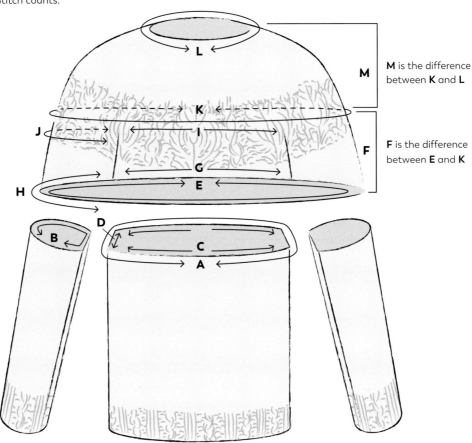

M is the difference between **K** and **L**

F is the difference between **E** and **K**

A: Bust sts = (Bust Circumference + Body Ease) x st gauge

B: Sleeve sts = (Upper Arm Circumference + Sleeve Ease) x st gauge

C: Bust Width = Bust sts ÷ 2

D: Underarm Span sts = (Bust Width − Cross-Back sts) ÷ 2

E: Lower Yoke Circumference (around sleeves and body) = Bust sts + (2 x Sleeve sts) − (4 x Underarm Span)

F: Raglan Shaping sts (optional) = 2 x Underarm Span (round up or down to a number divisible by 8)

G: Lower Front/Back Width sts = (Bust sts − [Underarm Span x 2]) ÷ 2

H: Lower Sleeve sts = Sleeve sts − Underarm Span

I: Upper Front/Back Width sts = Lower Front/Back Width sts − (Raglan Shaping sts ÷ 4)

J: Upper Sleeve sts = Lower Sleeve sts − (Raglan Shaping sts ÷ 4)

K: Upper Total Stitch Count = (2 x Upper Front/Back Width sts) + (2 x Upper Sleeve sts)

L: Neckline sts = Neckline Circumference x st gauge

M: Total Yoke Shaping sts = Lower Yoke Circumference − Neckline sts − Raglan Shaping sts

Stitch Distribution for Raglan Markers

If the optional raglan shaping is included, the following calculations determine how many stitches fall between the sleeve and body markers, both at the wide end and the narrow end of the raglan shaping. Each section of raglan shaping is like a triangular wedge between sleeve and body sts, increasing (if you're working top down) or decreasing (if you're working bottom up) additional stitches.

(G) Lower Front/Back Width sts = Bust sts – [Underarm Span × 2]) ÷ 2 = (190 sts – [11 sts × 2]) ÷ 2 = 84 sts

(H) Lower Sleeve sts = Sleeve sts – Underarm Span = 60 sts – 11 sts = 49 sts

To Confirm Lower Total Stitch Count = (2 × Lower Front/Back Width sts) + (2 × Lower Sleeve sts) = (2 × 84) + (2 × 49 sts) = 266 sts (same st count as Lower Yoke Circumference)

(I) Upper Front/Back Width sts = Lower Front/Back Width sts – (Raglan Shaping sts ÷ 4) = 84 sts – (24 sts ÷ 4) = 78 sts

(J) Upper Sleeve sts = Lower Sleeve sts – (Raglan Shaping sts ÷ 4) = 49 sts – (24 sts ÷ 4) = 43 sts

(K) Upper Total Stitch Count = (2 × Upper Front/Back Width sts) + (2 × Upper Sleeve sts) = (2 × 78) + (2 × 43 sts) = 242 sts

Neckline Stitches

The neckline circumference is the upper edge of the sweater, *excluding* any neck edging. The neck circumference is the circumference of the finished edging at its top edge. For round neck designs, the neck circumference is usually a smaller circle inside the slightly larger circle of the neckline circumference. Neckline circumference is therefore calculated by determining the radius of the desired neck circumference, adding the depth of the neck edging, then using the old high-school formula $C = 2\pi r$ to determine the circumference without edging, and finally multiplying it by the stitch gauge.

IMPERIAL

Neck Circumference = (Neck Circumference + Neck Ease) × st gauge = (14½" + 0") × 5 sts = 71.25 sts (round to a whole number) = 71 sts

Neckline Circumference = (Neck Circumference ÷ π ÷ 2 + Neck Edging) × π × 2 = (14½" ÷ 3.14 ÷ 2 + 1") × 3.14 × 2 = 20.78"

(L) Neckline sts = Neckline Circumference × st gauge = 20.78" × 5 sts = 103.9 sts (round to a whole number) = 104 sts

METRIC

Neck Circumference = (Neck Circumference + Neck Ease) × st gauge = (37 cm + 0 cm) × 2 sts = 73 sts

Neckline Circumference = (Neck Circumference ÷ π ÷ 2 + Neck Edging) × π × 2 = (37 cm ÷ 3.14 ÷ 2 + 2.5 cm) × 3.14 × 2 = 52.7 cm

(L) Neckline sts = Neckline Circumference × st gauge = 52.7 cm × 2 sts = 105.4 sts (round to a whole number) = 105 sts

In situations where the neck finishing will stand up from the neckline, such as a vertical collar or turtleneck, the neckline is often the same circumference as the neck circumference (including any desired ease).

Shaping Stitches

The total number of stitches to be either increased or decreased when shaping the yoke is the difference between the *lower yoke circumference* and the *neckline circumference*. If *raglan shaping* is used, then these stitches should also be subtracted.

> **(M) Total Yoke Shaping sts** = Lower Yoke Circumference – Neckline sts – Raglan Shaping sts = 266 sts – 104 sts – 24 sts = 138 sts

Short-Row Shaping Stitches

If short-rows are used to raise the back neckline, they need to run the whole width of the back yoke and taper around the front. The short-row closest to the neck should use half of the yoke sts in that round. The lowest short-row should leave about ¼ to ⅙ of the front stitches untouched. If the resulting intervals between short-row turns are fewer than 2 stitches, consider splitting the short-rows into two groups. The Shaping Interval is the number of stitches between the end of each short-row and the previous short-row.

IMPERIAL

Number of Short-Rows = Front Neck Drop × row gauge = 1½" × 7 rows/inch = 10.5 rows (round to an even number) = 10 rows

METRIC

Number of Short-Rows = Front Neck Drop × row gauge = 3.8 cm × 2.8 rows/cm = 10.5 rows (round to an even number) = 10 rows

Back Yoke sts = circumference sts* ÷ 2 = 104 sts ÷ 2 = 52 sts*

Side Yoke sts (how far short-rows extend past either side of Back Yoke sts) = circumference sts ÷ 6 = 104 sts ÷ 6 = 17.33 (round to a whole number) = 17 sts each side

Number of Shaping Intervals = Number of Short-Rows ÷ 2 = 10 rows ÷ 2 = 5 times

Shaping Interval = Side Yoke sts ÷ Number of Shaping Intervals = 17 sts ÷ 5 times = 3.4 sts (needs to be a whole number, so will change Side Yoke sts to 15) = 3 sts

ROUND COUNTS

The full yoke depth includes the neck edging treatment (unless you plan for it to rise higher than the prominent bone at the back neck, as with a turtleneck) and short-rows, if they're used. Therefore, the only place on the completed yoke that measures the full yoke depth is at the back neck. With that in mind, both the depth of the neck edging and the depth of the short-rows need to be subtracted from the yoke depth measurement to determine the number of rounds remaining to distribute the yoke shaping and create any decorative patterning. If raglan shaping is used at the underarms, these rounds also need to be subtracted. Refer to **FIGURE 5** as you read the following sections.

IMPERIAL

(A) Back Yoke rnds = (Yoke Depth + Yoke Depth Ease – Neck Edging) × rnd gauge = (7⅝" + 0" – 1") × 7 rnds = 46.375 rnds (round to a whole number) = 46 rnds

(B) Number of Short-Rows = Front Neck Drop × row gauge = 1½" × 7 rows = 10.5 rows (round to an even number) = 10 rows

*circumference sts = the number of sts in the round where the short-row shaping will begin. This may be the Neckline sts, the Lower Yoke Circumference, or the circumference at any point along the depth of the yoke where you plan the shaping. For this example, the Neckline sts are used.

FIGURE 5: Round counts.

A: Back Yoke rnds = (Yoke Depth + Yoke Depth Ease – Neck Edging) × rnd gauge (round the result to a whole number)

B: Number of Short-Rows = Front Neck Drop × row gauge (round the result to an even number)

C: Front Yoke rnds = Back Yoke rnds – Number of Short-Rows

D: Raglan rnds (optional) = (Raglan Shaping sts ÷ 8) × 2 (note that raglan shaping is worked every other round)

E: Remaining Rnds for Shaping = Front Yoke rnds – Raglan rnds

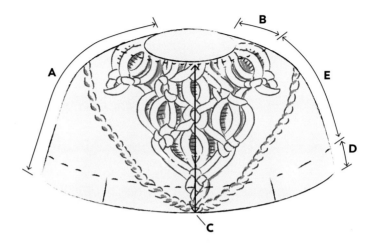

(C) Front Yoke rnds = Back Yoke rnds – Number of Short-Rows = 46 rnds – 10 rows = 36 rnds

(D) Raglan rnds (optional) = (Raglan Shaping sts ÷ 8) × 2 = (24 sts ÷ 8) × 2 = 6 rnds (raglan shaping is worked every other round)

(E) Remaining Rnds for Shaping = Front Yoke rnds – Raglan rnds = 36 rnds – 6 rnds = 30 rnds

METRIC

(A) Back Yoke rnds = (Yoke Depth + Yoke Depth Ease – Neck Edging) × rnd gauge = (19.5 cm + 0 cm – 2.5 cm) × 2.8 rnds = 47.6 rnds (round to a whole number) = 48 rnds

(B) Number of Short-Rows = Front Neck Drop × row gauge = 3.8 cm × 2.8 rows = 10.64 rows (round to an even number) = 10 rows

(C) Front Yoke rnds = Back Yoke rnds – Number of Short-Rows = 48 rnds – 10 rows = 38 rnds

(D) Raglan rnds (optional) = (Raglan Shaping sts ÷ 8) × 2 = (24 sts ÷ 8) × 2 = 6 rnds (raglan shaping is worked every other round)

(E) Remaining Rnds for Shaping = Front Yoke rnds – Raglan rnds = 38 rnds – 6 rnds = 32 rnds

A wider neckline that sits lower on the shoulders will have an impact on the yoke depth. Since the neckline is lower, the yoke depth should be shorter. A wide neckline with a deep yoke can have a sloppy look.

The Art of Circular Yoke Shaping

There are countless ways to arrange the shaping stitches and rounds on circular yokes. This flexibility provides endless design possibilities, but it's also difficult to narrow it down to a simple formula. That said, here are a few methods to get you started.

Take a look at your body and note where the greatest difference in circumference is through the yoke region. Note that the neck is a small circumference, but just a couple of inches below the neck, the yoke needs to expand to cover the shoulders and upper torso. That short distance, between the neckline and shoulders, is where the majority of the yoke shaping occurs at a rapid rate. Between the shoulders and lower yoke, less shaping is required.

Once you have all your numbers, you need to fit the yoke motif into the space remaining. This is where things will change and shift, and the final numbers are somewhat at the mercy of the motif. Some adjustments will need to be made to accommodate both the yoke motif and the yoke shaping. Don't obsess if the numbers for the yoke motif aren't exactly the same as your initial numbers. It's knitting. It stretches. The beauty of designing circular yokes is that they're forgiving.

A few approaches for yoke shaping and motif placement are outlined below. Often a combination of shaping strategies along with the dictates of a given yoke motif is used to achieve the desired results.

FUNNEL SHAPING WITH CONCENTRIC ROUNDS

Consider raglan constructions that suggest decreasing 8 sts every other round from underarm to neck; that translates to 4 sts every round. For a circular yoke, you're decreasing the same number of stitches, but they're redistributed so there are sections where there is no shaping, then the accumulated stitches are eliminated in a single round a few times throughout the depth of the yoke. The yoke depth on a circular yoke sweater is more customizable because of the non-shaping rounds than its raglan counterpart with its rigid formula.

The number of shaping rounds can be anywhere from three **(FIGURE 6)** to five or more. The stitches from one of the shaping rounds can be converted into raglan shaping, as touched upon earlier in "The Math". Shaping rounds are positioned closer together toward the neckline and farther apart toward the lower yoke. As much as half of the lower yoke can be worked without any shaping. The number of shaping stitches on each shaping round can be divided fairly evenly, with fewer shaping stitches in the round nearest the neckline, especially if working only three shaping rounds. The rounds between the shaping rounds are worked without shaping and are an excellent opportunity to work design motifs.

Shetland knitters, with their wealth of small colorwork motifs, use this method by inserting plain rounds of knitting between bands of stitch motifs. The shaping occurs in those plain rounds. Elizabeth Zimmermann—the late renowned knitting teacher, PBS host, author and publisher, and designer—also embraced this method and placed three shaping rounds in the top half of the yoke, equally distributing the shaping stitches across each shaping round.

PATTERN SHAPING

Wedges

Designs with skinny, pie-shaped repeats include the shaping stitches as part of the pattern repeat. These are essentially wedges that are strung together to make a circle **(FIGURE 7)**. There is a bit of trial and error in this approach. Working with graph paper and swatching are essential to developing a wedge motif, as is playing with the numbers. For example, determine your lower yoke stitch count and figure out how many pattern repeats will fit. Then look at what the neckline stitch count will be based on that number of repeats. You may need to adjust the

FIGURE 6: Three concentric rounds of shaping, their placement indicated with black dots.

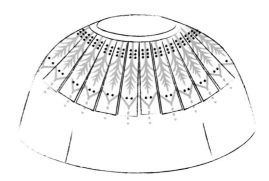

FIGURE 7: Pattern shaping with wedges, the shaping stitches indicated with black dots.

"I was working with a lace pattern and constrained by the design on where I could logically decrease."
—ANDREA CULL

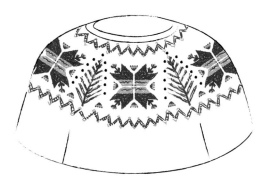

FIGURE 8: Shetland pine tree and star motif, with the shaping stitches indicated by black dots.

shaping in your wedge, work an extra shaping round between the motif and the neckline, or adapt your original design plan. The traditional Icelandic Lopi sweater takes advantage of the wedge approach.

Shetland Tree and Star

The iconic Shetland pine tree and star motif is distinctive in its shaping as well. The yoke motif is composed of wedge-shaped trees alternating with square-shaped stars **(FIGURE 8)**. All of the shaping in the motif occurs at the ends of the tree branches. Additional concentric shaping rounds before and after the colorwork are often used to achieve the desired stitch counts.

Fit and Other Considerations

For some body shapes, you may want to redistribute the shaping stitches around the body. For example, someone with rounded shoulders and a hunched back will need more fabric across the back of the yoke for a good fit. Therefore, more shaping stitches should be placed across the back yoke and fewer across the front yoke. When taking body measurements, compare the front and back halves of the circumference measurements and look for discrepancies. It will be easier to accommodate these differences if the concentric-rounds method of shaping is used.

Raglan shaping as part of the underarm shaping may be used for a more refined fit. This shaping creates a flattering transition from the underarm span to the yoke, around the curved area of the arms, helping to eliminate some of the extra fabric that can bunch around the underarm on circular yoke sweaters.

The placement of the yoke motif has evolved with the fashions and trends of the time. Early circular yoke sweaters had a shallow yoke motif close to the neckline. This seems to be a development from sweaters with deep and decorative neck edgings on a set-in sleeve construction. As the circular style evolved and the yoke motif became deeper, it was recommended that there should be at least 1" (2.5 cm) of plain knitting at the lower yoke so the motif wouldn't become distorted by the underarm. At the time of writing, very deep yoke motifs are popular, with the yoke motif extending the full depth of the yoke or even beyond.

Generally, circular yoke sweaters are seamless. Since the framework of the seams is omitted, structure can be introduced in other ways. There are various strategies to consider that help limit the amount a sweater might stretch out of shape, including gauge, yarn choice, sweater construction, and stitch patterns. Use a cast-on or bound-off edge to stabilize the neckline before working the neck finishing. A yoke motif that employs stranded stitch patterns, either as colorwork or slipped stitches, helps limit the amount that the shoulders can stretch out. Cable crosses and twisted stitches also curb over-stretching.

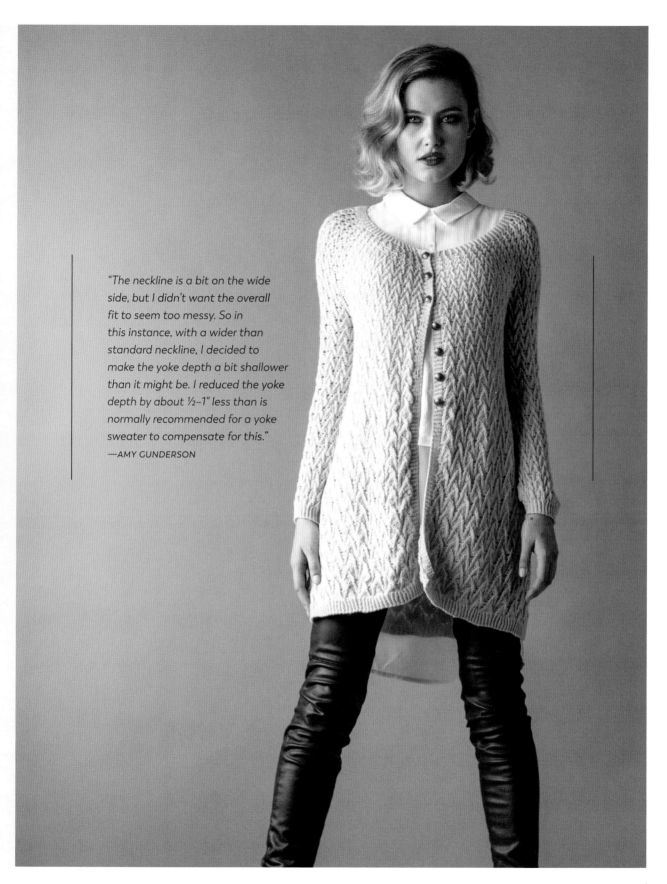

"The neckline is a bit on the wide side, but I didn't want the overall fit to seem too messy. So in this instance, with a wider than standard neckline, I decided to make the yoke depth a bit shallower than it might be. I reduced the yoke depth by about ½–1" less than is normally recommended for a yoke sweater to compensate for this."
—AMY GUNDERSON

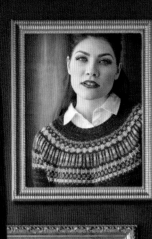

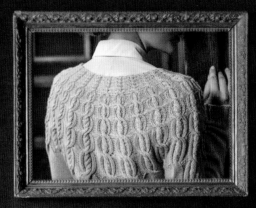

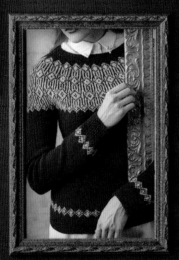

"I've designed many yoke sweaters, and each has been just a little different in the approach." —AMY GUNDERSON

the Patterns

Diamond

Delicately geometric, this colorwork yoke sweater features diamonds set into vertical stripes and a string of smaller diamonds around the waist and wrists. Tubular cast-ons and bind-offs add a clean finish, and subtle waist shaping completes this comfortable sweater, perfect for wearing with your favorite pair of jeans. | **BY SARAH REDMOND**

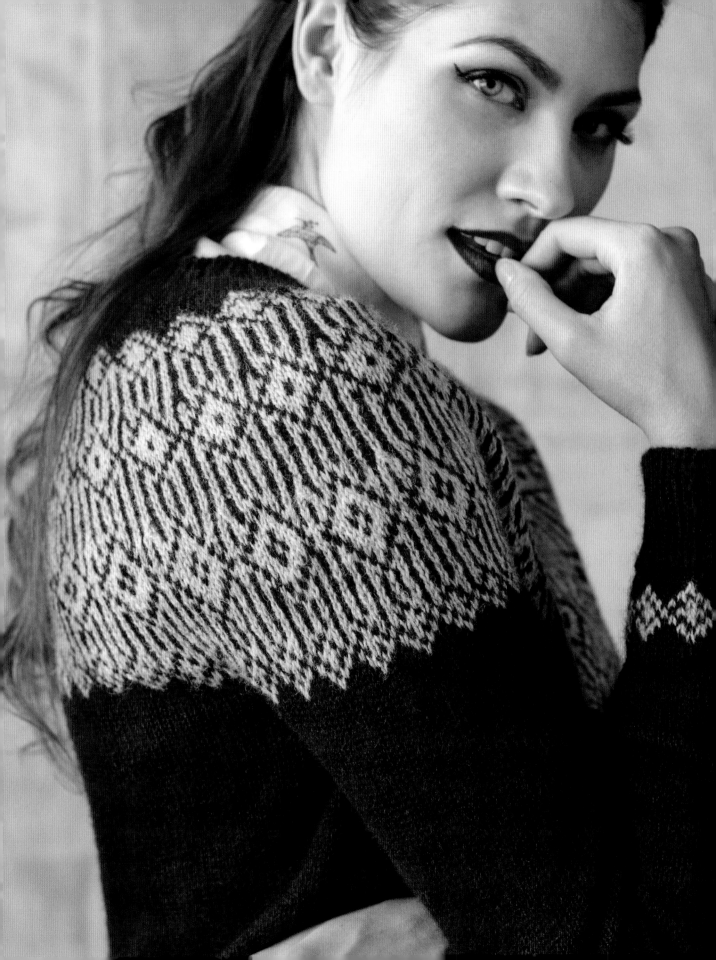

FINISHED SIZE

Sizes: XS (S, M, L, XL).

Bust circumference: about 32 (36, 40, 44, 48)" (81.5 [91.5, 101.5, 112, 122] cm).

Sweater shown measures 40" (101.5 cm), modeled with 5½" (14 cm) of positive ease.

YARN

Fingering weight (#1 Super Fine).

MC: about 1140 (1330, 1450, 1750, 1900) yd (1042 [1216, 1326, 1600, 1737] m).

CC: about 213 yd (195 m).

Shown here: Tukuwool Fingering (100% Finnish wool; 213 yd [195 m]/1¾ oz [50 g]): #H30 haave (MC), 6 (7, 7, 9, 9) skeins; #08 runo (CC), 1 (1, 1, 1, 1) skein.

NEEDLES

Size U.S. 1½ (2.5 mm), or two sizes (0.5 mm) smaller than above: 32" (80 cm) cir; 16" (40 cm) cir; 9" (23 cm) cir or dpn.

Size U.S. 2½ (3 mm): 32" (80 cm) circular (cir); 16" (40 cm) cir; 9" (23 cm) cir or set of double-pointed (dpn).

Size U.S. 3 (3.25 mm): 32" (80 cm) cir; 9" (23 cm) cir or dpn.

Adjust needle size if necessary to obtain the correct gauge.

NOTIONS

Stitch markers (m); stitch holders or waste yarn; tapestry needle.

GAUGE

24 sts and 36 rnds = 4" (10 cm) in St st with middle-sized needle.

24 sts and 30 rnds = 4" (10 cm) in colorwork with largest needle.

NOTES

— When knitting colorwork, hold MC as background color and CC as pattern color.

— 9" (23 cm) circular needles are used for knitting small circumferences in the round, but you may use whatever method (dpn, Magic Loop, etc.) you prefer.

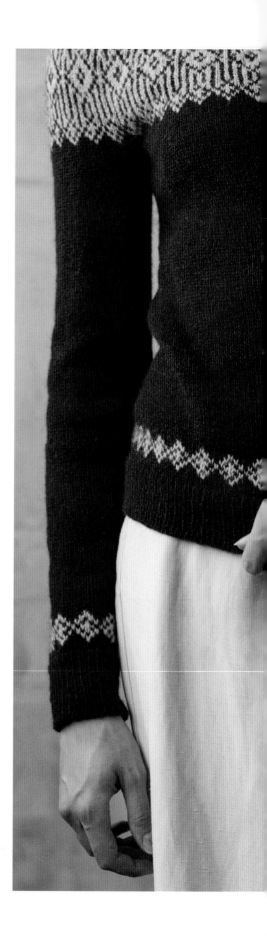

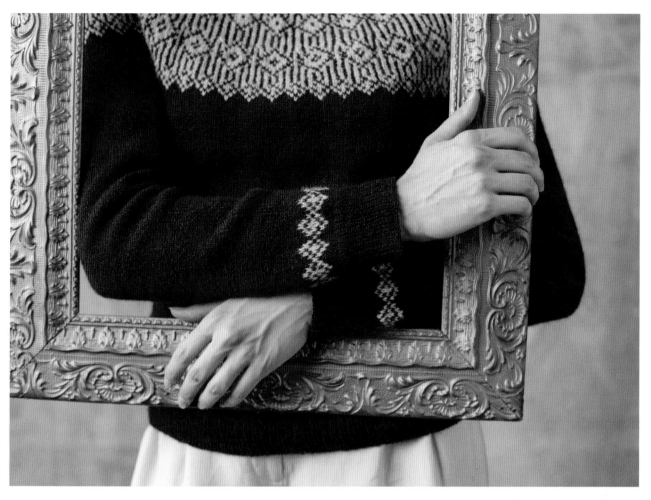

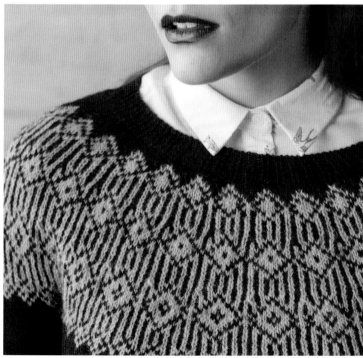

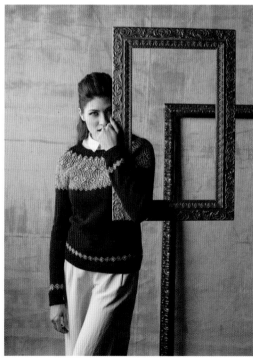

Sleeves (make 2)

With smallest 9" (23 cm) cir needle and MC, CO 54 (60, 60, 60, 66) sts using the long-tail tubular cast-on (see Glossary). Pm and join for working in the round, being careful not to twist.

Rib rnd: *K1, p1; rep from * to end.

Rep this rnd until piece measures 2" (5 cm) from cast-on edge.

Switch to middle-sized 9" (23 cm) cir needle and work in St st for 3 rnds.

Switch to largest 9" (23 cm) cir needle and work Chart A 9 (10, 10, 10, 11) times around, joining CC as needed.

After completing all rows of Chart A, switch to middle-sized 9" (23 cm) cir needle and knit 1 rnd.

Sleeve inc rnd: K1, M1R, knit to 1 st before m, M1L, k1.

Rep Sleeve inc rnd every 10th rnd 5 (5, 8, 11, 11) more times—66 (72, 78, 84, 90) sts.

Work even in St st until sleeve measures 18 (18¼, 18½, 18¾, 19)" (45.5 [46.5, 47, 47.5, 48.5] cm) from cast-on edge, ending 6 sts before BOR marker on the final rnd.

Transfer next 12 sts to stitch holder or waste yarn, removing m, and place on hold for underarm.

Set remaining sts aside.

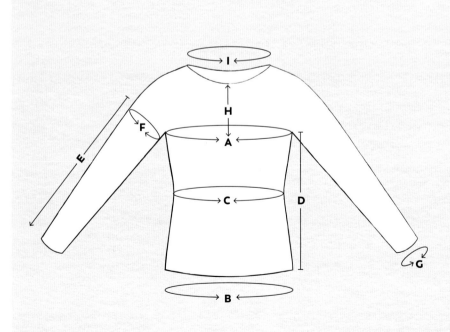

A: 32 (36, 40, 44, 48)" (81.5 [91.5, 101.5, 112, 122] cm)

B: Same as A

C: 30 (33¼, 37¼, 40¾, 44¾)" (76 [84.5, 94.5, 103.5, 113.5] cm)

D: 13¼ (14½, 14½, 16½, 16½)" (33.5 [37, 37, 42, 42] cm)

E: 18 (18¼, 18½, 18¾, 19)" (45.5 [46.5, 47, 47.5, 48.5] cm)

F: 11 (12, 13, 14, 15)" (28 [30.5, 33, 35.5, 38] cm)

G: 9 (10, 10, 10, 11)" (23 [25.5, 25.5, 25.5, 28] cm)

H: 7¾ (7¾, 8, 8¾, 9)" (19.5 [19.5, 20.5, 22, 23] cm)

I: 17¼ (17¼, 19¼, 19¼, 19¼)" (44 [44, 49, 49, 49] cm)

Body

With smallest 32" (80 cm) cir needle and MC, CO 192 (216, 240, 264, 288) sts using the long-tail tubular cast-on. Pm and join for working in the round, being careful not to twist.

Rib rnd: *K1, p1; rep from * to end.

Rep this rnd until piece measures 2" (5 cm) from cast-on edge.

Switch to middle-sized 32" (80 cm) cir and work in St st for 3 rnds.

Switch to largest 32" (80 cm) cir and work Chart A 32 (36, 40, 44, 48) times around, joining CC as needed.

Switch to middle-sized 32" (80 cm) cir. K96 (108, 120, 132, 144), pm (side seam), knit to end. Knit 4 more rnds.

SHAPE WAIST

Dec rnd: *K1, k2tog, knit to 3 sts before marker, ssk, k1, sl m; repeat from * to end—4 sts dec'd.

Repeat Dec rnd every 10th rnd 2 (3, 3, 4, 4) more times—180 (200, 224, 244, 268) sts.

Work even in St st until piece measures 10 (10, 10, 11, 11)" (25.5 [25.5, 25.5, 28, 28] cm) from cast-on edge.

Inc rnd: *K1, M1R, knit to 1 st before m, M1L, k1, sl m; rep from * to end—4 sts inc'd.

Repeat Inc rnd every 10th rnd 2 (3, 3, 4, 4) more times—192 (216, 240, 264, 288) sts.

Knit 9 rnds in St st, ending 6 sts before BOR m on the final round.

Transfer next 12 sts to stitch holder or waste yarn, removing BOR m, and place on hold for underarm.

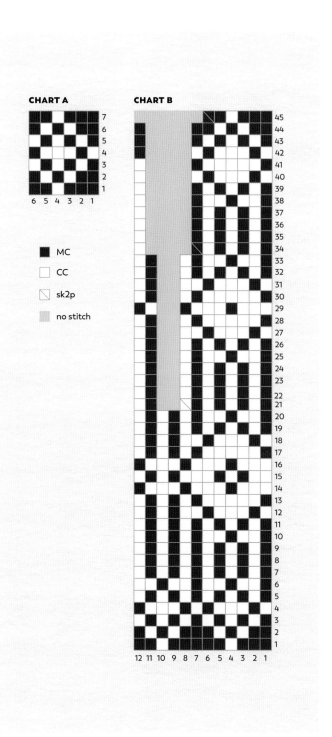

CHART A

CHART B

- ■ MC
- □ CC
- ◨ sk2p
- ▨ no stitch

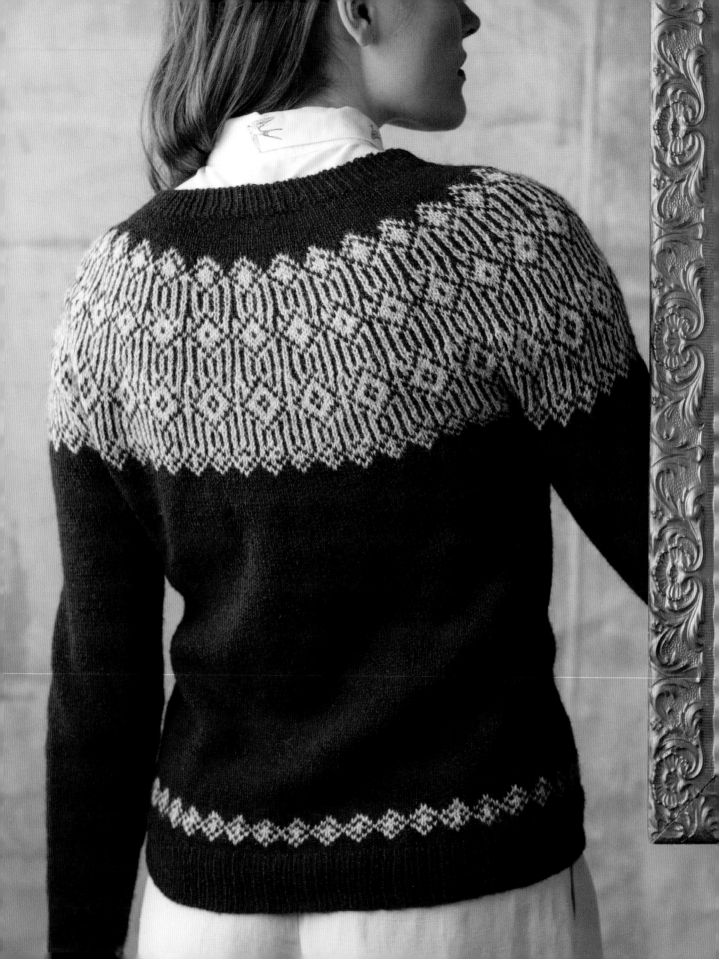

Join Sleeves and Body

Knit across 27 (30, 33, 36, 39) sleeve sts, pm for new BOR, knit across rem 27 (30, 33, 36, 39) sleeve sts, knit across 84 (96, 108, 120, 132) front sts, transfer next 12 body sts to stitch holder or waste yarn, removing m, and place on hold for underarm; knit across 54 (60, 66, 72, 78) sleeve sts, knit across 84 (96, 108, 120, 132) back sts, knit to BOR—276 (312, 348, 384, 420) sts total.

Knit 2 (2, 4, 11, 13) rnds even.

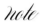 *If you have a different colorwork row gauge than is called for, adjust the number of St st rnds worked here: work fewer rnds if your row gauge is looser than called for and more rnds if your row gauge is tighter.*

Switch to largest 32" (80 cm) cir and work Chart B 23 (26, 29, 32, 35) times around, switching to smaller needle cord lengths as needed—138 (156, 174, 192, 210) sts after completing Chart B.

Switch to middle-sized 16" (40 cm) cir.

Size XS Only
Next rnd: *K10, k2tog, k11, k2tog; rep from * 4 more times, k10, k2tog, k1—127 sts.

Sizes – (S, M, –, –) Only
Next rnd: Knit to end—– (156, 174, –, –) sts.

Size L Only
Next rnd: *K14, k2tog; rep from * to end—180 sts.

Size XL Only
Next rnd: *K6, k2tog, k7, k2tog; rep from * 11 more times, knit to end—186 sts.

All Sizes
Beg short-row shaping as folls:

 See Glossary for details on w&t (wrap & turn) short-rows.

Short-row 1: (RS) K5, w&t.

Short-row 2: (WS) P73 (88, 97, 100, 103), w&t.

Short-row 3: Knit to 7 sts before gap, w&t.

Short-row 4: Purl to 7 sts before gap, w&t.

Repeat Short-rows 3 and 4 three more times.

Knit to BOR, working wraps together with wrapped sts.

Knit 1 rnd, working wraps together with wrapped sts.

Size XS Only
Next rnd: *K3, k2tog, k4, k2tog; rep from * 10 more times, k4, k2tog—104 sts.

Sizes – (S, M, –, –) Only
Next rnd: *K1, k2tog; rep from * to end—– (104, 116, –, –).

Sizes – (–, –, L, XL) Only
Next rnd: *K2tog, k1, k2tog; rep from * – (–, –, 31, 34) more times, knit to end—– (–, –, 116, 116) sts.

All Sizes
Knit 1 rnd.

Switch to smallest 16" (40 cm) cir.

Rib rnd: *K1, p1; rep from * to end.

Rep this rnd until ribbing measures 1¼" (3.2 cm).

BO all sts using the tubular bind-off (see Glossary).

Finishing

Graft underarms closed using Kitchener stitch (see Glossary).

Weave in all ends, wash, and block to measurements.

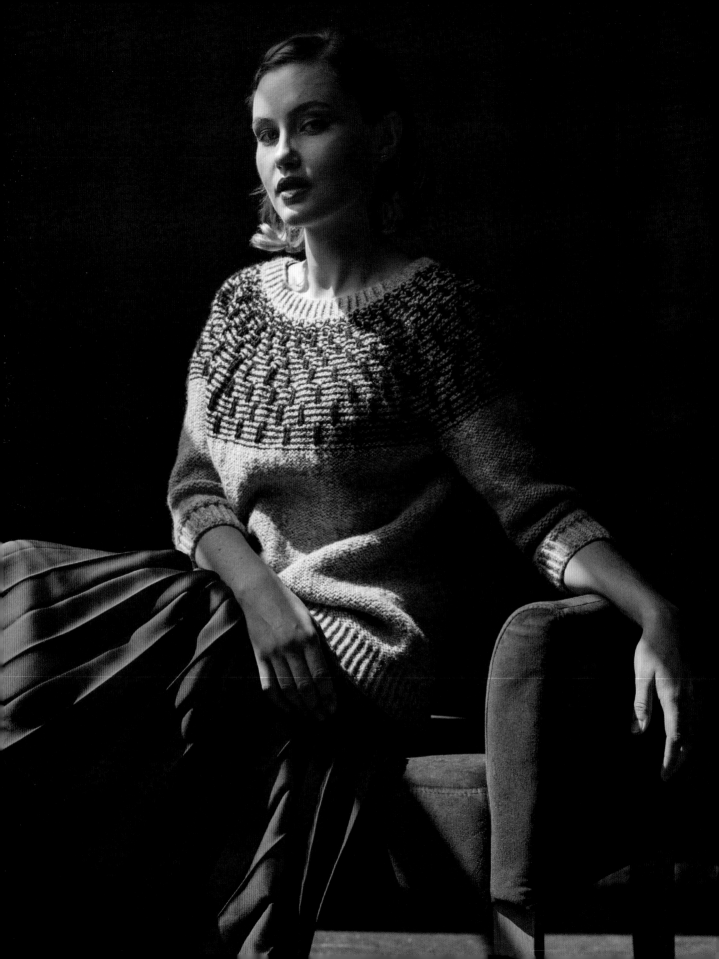

Strike

This top-down sweater uses slipped stitches to create a lovely textured cascading effect in a sequence of concentric circles. Three-quarter-length sleeves are worked after the yoke and body are knitted; positive ease and gentle waist shaping create a garment with a flattering silhouette. The finished piece is seamless, and the simplicity of the techniques used makes it appropriate for adventurous beginners. | **BY K.M. BEDIGAN**

FINISHED SIZE

Sizes: XS (S, M, L, XL).

Bust circumference: about 35 (38, 42¼, 45½, 50¼)" (89 [96.5, 107.5, 115.5, 127.5] cm).

Designed to be worn with 3–4" (7.5–10 cm) of positive ease.

Sweater shown measures 38" (96.5 cm), modeled with 6" (15 cm) of positive ease.

YARN

Aran weight (#4 Medium).

MC: about 707 (808, 909, 1010, 1212) yd (647 [739, 832, 924, 1109] m).

CC: about 127 (152, 202, 253, 303) yd (116 [139, 185, 231, 277] m).

Shown here: Jamieson's of Shetland Shetland Heather (100% Shetland wool; 101 yd [92 m]/1¾ oz [50 g]): #106 moorit (MC), 7 (8, 9, 10, 12) balls; #1401 nightshade (CC), 2 (2, 2, 3, 3) balls.

NEEDLES

Size U.S. 6 (4 mm): 16–32" (40–80 cm) circular (cir); set of double-pointed (dpn).

Size U.S. 8 (5 mm): 16–32" (40–80 cm) cir; dpn.

Adjust needle size if necessary to obtain the correct gauge.

NOTIONS

Stitch markers (m); stitch holders or waste yarn; tapestry needle.

GAUGE

19 sts and 24 rnds = 4" (10 cm) in St st with larger needle.

NOTES

— This sweater is designed to be worn with about 3–4" (7.5–10 cm) of positive ease; for a more fitted look, knit the size closest to your actual bust measurement.

— All slipped stitches are slipped purlwise with the yarn held in back.

— The reverse St st sections (below the patterned yoke) are worked inside out. This allows you to work them as all knit sts (which will appear as purl sts on the finished RS), since many people prefer knitting to purling.

STITCH GUIDE

Backward-loop Cast-on

*Loop working yarn as shown in **FIG. 1** and place it on needle backward, with right leg of loop in back of needle. Repeat from *.

FIG. 1

pkp [purl, knit, purl] into 1 stitch (increases 2 stitches)

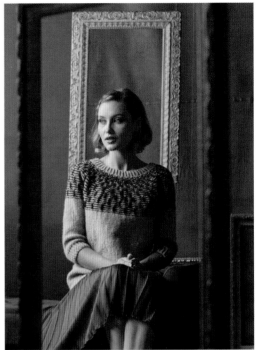

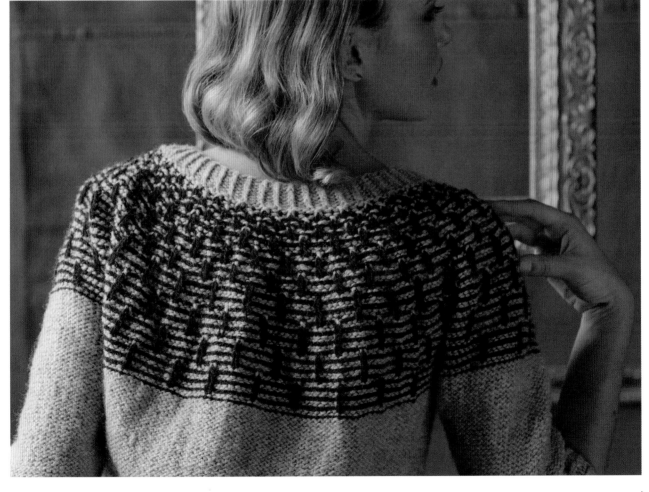

Yoke

Using smaller needle and MC, CO 90 (102, 108, 120, 120) sts. Pm and join for working in the round, being careful not to twist.

Rib rnd: *K1 tbl, p1; rep from * to end.

Rep this rnd until ribbing measures 1½" (3.8 cm).

Switch to larger needle and work yoke patterning from either written instructions (below) or Yoke Chart, repeating chart 15 (17, 18, 20, 20) times around.

YOKE PATTERN

Rnd 1: Purl to end.

Rnd 2: Join CC, *p2, k1; rep from * to end.

Rnd 3: With MC, *p2, sl 1; rep from * to end.

Rnd 4: With CC, *p1, M1, p1, k1; rep from * to end—120 (136, 144, 160, 160) sts.

Rnd 5: With MC, *p1, sl 1, p2; rep from * to end.

Rnd 6: With CC, *p1, k1; rep from * to end.

Rnd 7: With MC, *p3, sl 1; rep from * to end.

Rnd 8: With CC, *p1, pkp (see Stitch Guide), [p1, k1] 3 times; rep from * to end—150 (170, 180, 200, 200) sts.

Rnd 9: With MC, *p2, sl 1, p2; rep from * to end.

Rnd 10: With CC, *p2, k1, p2; rep from * to end.

Rnd 11: Rep Rnd 9.

Rnd 12: With CC, *p2, k1, p2, M1; rep from * to end—180 (204, 216, 240, 240) sts.

Rnd 13: With MC, *p5, sl 1; rep from * to end.

Rnd 14: With CC, *p5, k1; rep from * to end.

Rnd 15: Rep Rnd 13.

Rnd 16: With CC, *p2, k1; rep from * to end.

Rnd 17: With MC, *p2, sl 1, p3; rep from * to end.

Rnd 18: With CC, *p2, k1, p3; rep from * to end.

Rnd 19: Rep Rnd 17.

Rnd 20: With CC, *[p2, k1] 3 times, p2, pkp; rep from * to end—210 (238, 252, 280, 280) sts.

Rnd 21: With MC, *p5, sl 1, p1; rep from * to end.

Rnd 22: With CC, *p5, k1, p1; rep from * to end.

Rnd 23: Rep Rnd 21.

Rnds 24 and 25: Rep Rnds 22 and 23.

Rnd 26: With CC, *p2, M1, p3, k1, p1; rep from * to end—240 (272, 288, 320, 320) sts.

Rnd 27: With MC, *p2, sl 1, p5; rep from * to end.

Rnd 28: With CC, *p2, k1, p5; rep from * to end.

Rnds 29 and 30: Rep Rnds 27 and 28.

Rnd 31: Rep Rnd 27.

Rnd 32: With CC, *p2, k1, p1; rep from * to end.

Rnd 33: With MC, *p6, sl 1, p1; rep from * to end.

Rnd 34: With CC, *p6, k1, p1; rep from * to end.

Rnd 35: Rep Rnd 33.

Rnds 36 and 37: Rep Rnds 34 and 35.

Sizes – (S, M, L, XL) Only

Rnd 38: Rep Rnd 32.

Rnds 39–42: Rep Rnds 27 and 28.

Rnd 43: Rep Rnd 27.

Sizes – (-, -, L, XL) Only

Rnd 44: Rep Rnd 32.

Rnds 45–48: Rep Rnds 33 and 34.

Rnd 49: Rep Rnd 33.

Size L Only

Rnd 50: Rep Rnd 34.

YOKE CHART

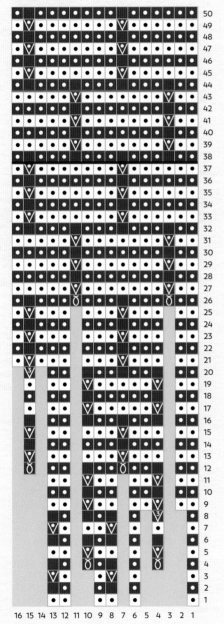

- ☐ MC
- ■ CC
- ☐ knit
- ● purl
- ▨ no stitch
- Ⅴ̄ M1
- Ⅴ slip purlwise with yarn in back
- Ⅴ̄³ pkp
- ▬ Size XS: end of chart
- ▬ Sizes S and M: end of chart
- ▬ Size XL: end of chart

FINISH YOKE

Size XS Only

Rnd 38 (inc): With CC, *[p6, k1, p1] twice, p6, kf&b, p1; rep from * to end—250 sts.

Size S Only

Rnd 44: With CC, *p2, k1, p5; rep from * to end.

Size M Only

Rnd 44 (inc): With CC, *[p2, k1, p5] 3 times, p2, kf&b, p5; rep from * to end—297 sts.

Size XL Only

Rnd 50 (inc): With CC, *[p6, kf&b, p1] 3 times, p6, k1, p1; rep from * to end—350 sts.

All Sizes

Break CC. Turn yoke inside out and begin working garment from the WS (knitting in the opposite direction). This allows you to work the rest of the sweater as knit sts (which will appear as purl sts on the finished RS), since most people prefer knitting to purling.

With WS facing, using MC only, knit all sts until piece measures 8½ (9, 9½, 10½, 10½)" (21.5 [23, 24, 26.5, 26.5] cm) from cast-on edge.

Divide for Sleeves and Body

Next rnd: Transfer 48 (52, 56, 60, 64) sleeve sts to stitch holder or waste yarn; using backward-loop method, CO 6 (6, 8, 8, 9) sts, k77 (84, 93, 100, 111) body sts, transfer 48 (52, 56, 60, 64) sleeve sts to stitch holder or waste yarn; using backward-loop method, CO 6 (6, 8, 8, 8) sts, k77 (84, 92, 100, 111) body sts— 166 (180, 201, 216, 239) body sts rem.

Next rnd: Rm, k3 (3, 4, 4, 4), pm for new BOR, k83 (90, 101, 108, 120), pm, knit to end.

Work even in St st (knit all sts) for 2 (2, 2½, 2½, 3)" (5 [5, 6.5, 6.5, 7.5] cm).

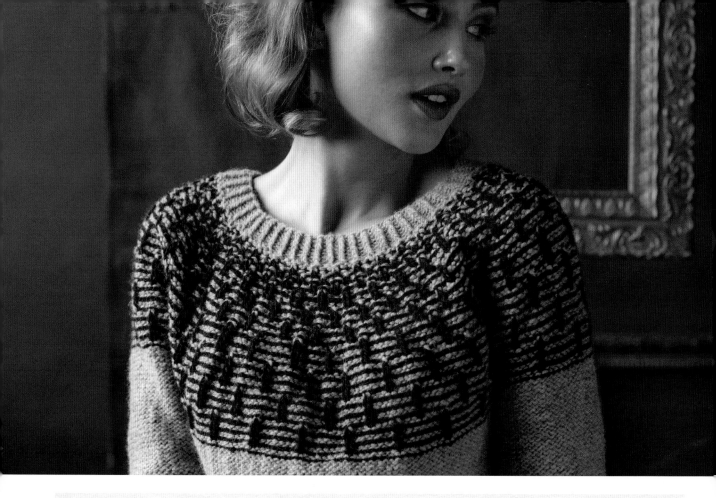

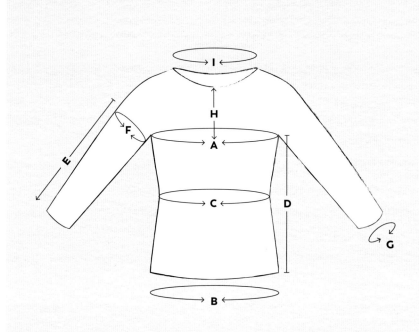

A: 35 (38, 42¼, 45½, 50¼)"
(89 [96.5, 107.5, 115.5, 127.5] cm)

B: Same as A

C: 31½ (33¾, 38, 40½, 45¼)"
(80 [85.5, 96.5, 103, 115] cm)

D: 15½ (16½, 16½, 17½, 18)"
(39.5 [42, 42, 44.5, 45.5] cm)

E: 11 (11, 12, 12, 13)"
(28 [28, 30.5,30.5, 33] cm)

F: 11¼ (12¼, 13½, 14¼, 15¼)"
(28.5 [31, 34.5, 36, 38.5] cm)

G: 8¾ (9¾, 10½, 11¼, 11¾)"
(22 [25, 26.5, 28.5, 30] cm)

H: 8½ (9, 9½, 10½, 10½)"
(21.5 [23, 24, 26.5, 26.5] cm)

I: 19 (21½, 22¾, 25¼, 25¼)"
(48.5 [54.5, 58, 64, 64] cm)

OPTIONAL WAIST SHAPING

Dec rnd: *K1, ssk, knit to 3 sts before m, k2tog, k1, sl m; rep from * once more—162 (176, 197, 212, 235) sts.

Work 5 rnds in St st.

Rep prev 6 rnds 3 (4, 4, 5, 5) more times—150 (160, 181, 192, 215) sts.

Work 3 rnds in St st.

Inc rnd: *K1, M1, knit to 1 st before m, M1, k1, sl m; rep from * once more—154 (164, 185, 196, 219) sts.

Work 5 rnds in St st.

Rep prev 6 rnds 3 (4, 4, 5, 5) more times—166 (180, 201, 216, 239) sts.

Work even in St st until body measures 13½ (14½, 14½, 15½, 16)" (34.5 [37, 37, 39.5, 40.5] cm) from underarm, or to desired length.

Turn the body inside out again (changing your direction of knitting) and work the rest of the body with RS facing you.

Switch to smaller needle.

Rib rnd: *K1 tbl, p1; rep from * to end.

Rep this rnd until ribbing measures 2" (5 cm). BO loosely in patt.

Sleeves (make 2)

Transfer 48 (52, 56, 60, 64) sleeve sts to larger needle. Turn work inside out. With WS facing and MC, knit across sleeve sts, then pick up and knit 3 (3, 4, 4, 4) sts from body at the underarm, pm for BOR, pick up and knit 3 (3, 4, 4, 4) sts, join for working in the rnd, knit to m—54 (58, 64, 68, 72) sts.

Work even in St st for 1½ (2, 2, 2½, 2½)" (3.8 [5, 5, 6.5, 6.5] cm).

SHAPE SLEEVE

Dec rnd: *K1, ssk, knit to last 3 sts, k2tog, k1—52 (56, 62, 66, 70) sts.

Work 5 rnds in St st.

Rep these 6 rnds 5 (5, 6, 6, 7) more times—42 (46, 50, 54, 56) sts.

Work even in St st until sleeve measures 9 (9, 10, 10, 11)" (23 [23, 25.5, 25.5, 28] cm) from underarm.

Turn the sleeve inside out again (changing your direction of knitting) and work the rest of the sleeve with RS facing you.

Change to smaller needle.

Rib rnd: *K1 tbl, p1; rep from * to end.

Rep this rnd until ribbing measures 2" (5 cm). BO loosely in patt.

Finishing

Block to finished measurements.

Weave in ends.

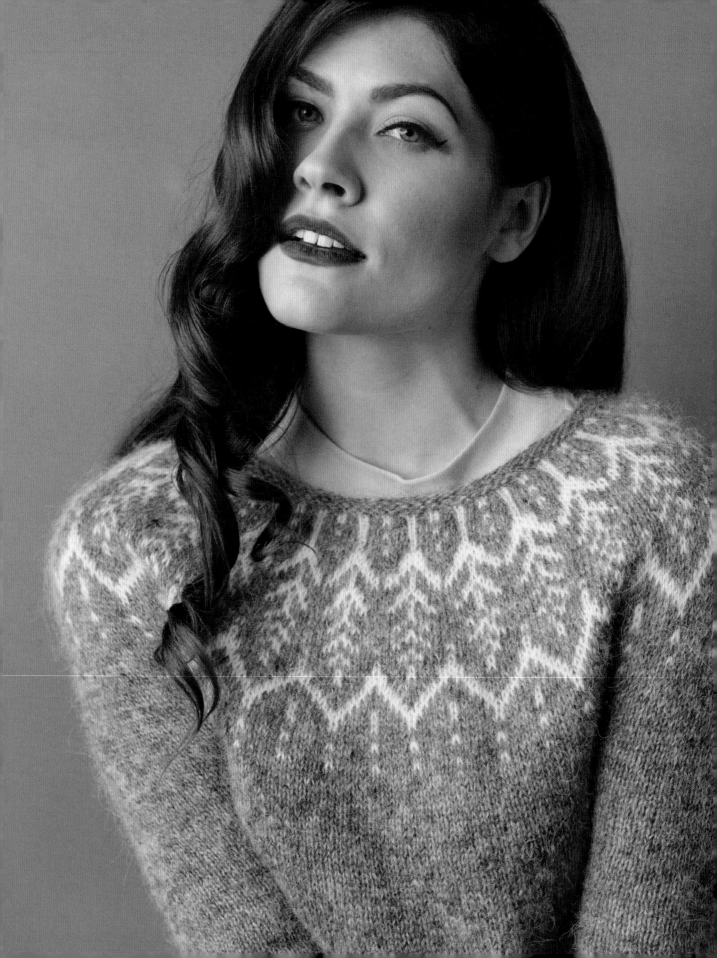

Altheda

Made of unspun Icelandic wool, this sweater is both lightweight and warm. It's worked seamlessly and in the round from the top down. Short-rows are worked under the stranded yoke to shape the neckline. Garter-stitch neckline, cuffs, and hem are simple yet elegant. Choose a size that's 2–4" (5–10 cm) larger than your bust size for positive ease. | **BY JENN STEINGASS**

FINISHED SIZE

Sizes: 3XS (2XS, XS, S, M)
(L, XL, 2XL, 3XL, 4XL).

Bust circumference: about
33¼ (36, 38½, 42, 45)(47, 49,
51½, 53¼, 56)" (84.5 [91.5, 98,
106.5, 114.5][119.5, 124.5, 131,
135, 142] cm).

Designed to be worn with
1–4" (2.5–10 cm) of positive ease.

*Sweater shown measures
36" (91.5 cm), modeled with
1½" (3.8 cm) of positive ease.*

YARN

Worsted weight (#4 Medium).

MC: about 900 (1000, 1100,
1200, 1300)(1400, 1500, 1600,
1700, 1800) yd (823 [915, 1006,
1098, 1189][1281, 1372, 1464,
1555, 1646] m).

CC: about 180 (190, 200,
210, 220)(230, 240, 250, 260,
270) yd (165 [174, 183, 192, 202]
[211, 220, 229, 238, 247] m).

Shown here: Ístex Plötulopi
(100% Icelandic wool; 328 yd
[300 m]/3½ oz [100 g]): #9102
steel grey (MC), 3 (4, 4, 4, 4)(5,
5, 5, 6, 6) plates; #0001 undyed
white (CC), 1 plate for all sizes.

NEEDLES

Size U.S. 4 (3.5 mm):
16" (40 cm) circular (cir);
24" (60 cm) or 32" (80 cm) cir;
set of double-pointed (dpn).

Size U.S. 5 (3.75 mm): 24"
(60 cm) or 32" (80 cm) cir; dpn.

*Adjust needle size if necessary
to obtain the correct gauge.*

NOTIONS

4 unique stitch markers (m);
stitch holders or waste yarn;
tapestry needle.

GAUGE

20 sts and 28 rnds = 4" (10 cm)
in St st in the round with larger
needle.

NOTE

— This sweater is worked
seamlessly from the top down,
starting with a garter-stitch
neckline. The stranded yoke is
worked, then short-row shaping
is added on the back. The
sleeves and body are separated
and worked top down.

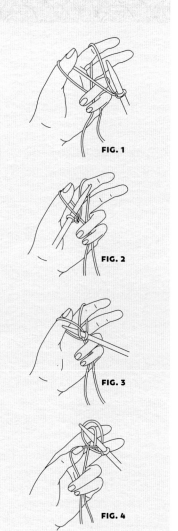

STITCH GUIDE

Long-tail Cast-on

Leaving a long tail (about 1–2"
[2.5–5 cm] for each stitch to be
cast on), make a slipknot and
place on right needle. Place
thumb and index finger of left
hand between yarn ends so that
working yarn is around index
finger and tail end is around
thumb. Secure ends with your
other fingers and hold palm up-
ward, making a V of yarn **(FIG. 1)**.
Bring needle up through loop on
thumb **(FIG. 2)**, grab first strand
around index finger with needle,
and go back down through loop
on thumb **(FIG. 3)**. Drop loop off
thumb and, placing thumb back
in V configuration, tighten result-
ing stitch on needle **(FIG. 4)**.

Invisible Increase Left (Inv-L)

Slip 1 stitch purlwise, then pick
up the left leg of the stitch in the
row below the slipped stitch from
behind with left needle. Knit the
lifted stitch through the back loop.

FIG. 1

FIG. 2

FIG. 3

FIG. 4

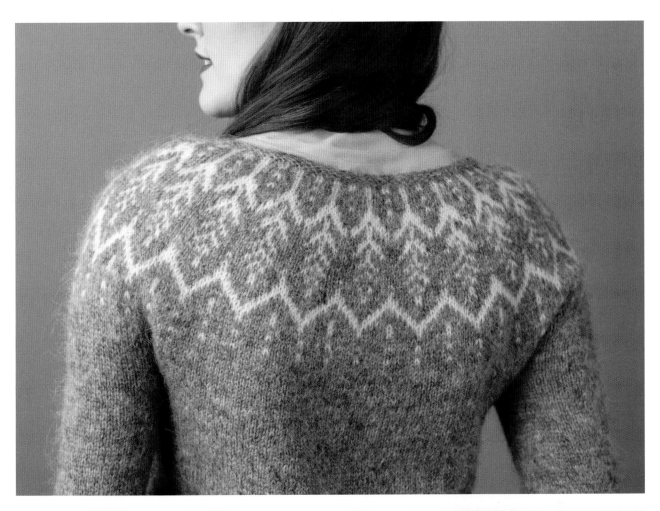

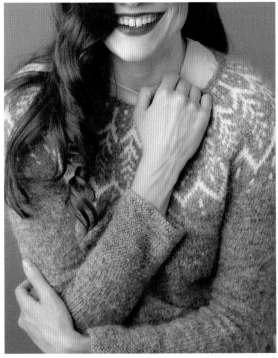

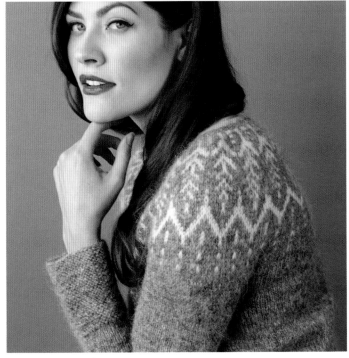

Neckline

With MC and smaller 16" (40 cm) cir needle, loosely CO 80 (84, 88, 90, 96)(98, 100, 104, 110, 112) sts using the long-tail CO. Pm and join for working in the round, being careful not to twist.

Work garter-stitch collar as folls:

Rnds 1 and 3: Knit.

Rnds 2 and 4: Purl.

Switch to larger needle and knit 1 rnd.

Next rnd: K0 (2, 0, 0, 0)(4, 2, 4, 0, 2), [k19 (9, 10, 8, 11)(8, 7, 7, 10, 8), Inv-L] 4 (8, 8, 10, 8)(10, 12, 12, 10, 12) times, k0 (2, 0, 0, 0)(4, 2, 4, 0, 2)—84 (92, 96, 100, 104)(108, 112, 116, 120, 124) sts.

Yoke

 For best results, use Inv-L increases (see Stitch Guide)—this style of increase is nearly invisible and lies very flat.

Join CC and work Rnds 1–44 of Yoke Chart, changing to longer cir when necessary. Chart is repeated 21 (23, 24, 25, 26)(27, 28, 29, 30, 31) times around. For optimal color dominance, make sure CC strand is held to the left and MC strand to the right.

Upon completion of chart, 252 (276, 288, 300, 312)(324, 336, 348, 360, 372) sts.

Pm for short-row shaping and body and sleeve separation as folls, making sure each m looks unique:

Next rnd: K76 (83, 87, 93, 98)(102, 106, 111, 114, 120) back sts, pm A, k50 (55, 57, 57, 58)(60, 62, 63, 66, 66) sleeve sts, pm B, k76 (83, 87, 93, 98)(102, 106, 111, 114, 120) front sts, pm C, k50 (55, 57, 57, 58)(60, 62, 63, 66, 66) sleeve sts to BOR.

Work even in St st until yoke measures 7 (7¼, 7½, 7¾, 8)(8¼, 8½, 8¾, 9, 9¼)" (18 [18.5, 19, 19.5, 20.5] [21, 21.5, 22, 23, 23.5] cm), not including garter-stitch collar.

SHAPE BACK WITH SHORT-ROWS

 Short-row shaping is used to make the back of the sweater taller than the front. Use your preferred short-row method.

Short-row 1: (RS) Knit across back and sleeve to m B, sl m, k6, turn.

Short-row 2: (WS) Purl to m C, sl m, p6, turn.

Short-row 3: Knit to 2 sts before m B, turn.

Short-row 4: Purl to 2 sts before m C, turn.

Short-row 5: Knit to 8 sts before m B, turn.

Short-row 6: Purl to 8 sts before m C, turn.

Short-row 7: Knit to BOR.

Next rnd: Knit to BOR, closing the short-row gaps as you come to them.

SEPARATE BODY AND SLEEVES

Knit to m A, rm, transfer next 50 (55, 57, 57, 58)(60, 62, 63, 66, 66) sts to stitch holder or waste yarn, rm B, CO 3 (3, 4, 6, 7)(7, 8, 9, 9, 10) underarm sts with backward-loop method, place side m, CO 4 (4, 5, 6, 7)(8, 8, 9, 10, 10) more underarm sts, knit to m C, rm, transfer next 50 (55, 57, 57, 58)(60, 62, 63, 66, 66) sts to stitch holder or waste yarn, remove BOR m, CO 3 (3, 4, 6, 7)(7, 8, 9, 9, 10) underarm sts with backward-loop method, replace BOR m, CO 4 (4, 5, 6, 7)(8, 8, 9, 10, 10) more underarm sts—83 (90, 96, 105, 112)(117, 122, 129, 133, 140) sts each front and back; 166 (180, 192, 210, 224)(234, 244, 258, 266, 280) sts total.

YOKE CHART

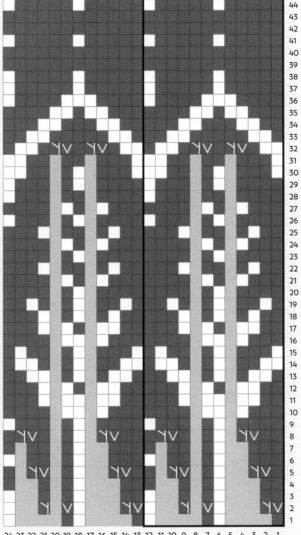

Row 32: 252 (276, 288, 300, 312
(324, 336, 348, 360, 372) sts

Row 8: 210 (230, 240, 250, 260)
(270, 280, 290, 300, 310) sts

Row 5: 168 (184, 192, 200, 208)
(216, 224, 232, 240, 248) sts

Row 2: 126 (138, 144, 150, 156)
(162, 168, 174, 180, 186) sts

Row 1: 84 (92, 96, 100, 104)
(108, 112, 116, 120, 124) sts

■ knit in MC

□ knit in CC

Ⅴ step 1 of Inv-L: slip
stitch purlwise

Ɣ step 2 of Inv-L: lift leg of
the st in the row below
slipped st on the left needle,
K lifted stitch TBL

▨ no stitch

□ repeat

Body

Work even in St st until front of body measures 12" (30.5 cm) from underarm CO—about 84 rnds— or 3" (7.5 cm) less than desired final body length.

Switch to smaller needle. Work in garter stitch as folls:

Rnd 1: Knit.

Rnd 2: Purl.

Rep Rnds 1 and 2 until garter hem measures 3" (7.5 cm).

BO all sts knitwise.

Sleeves (make 2)

Transfer 50 (55, 57, 57, 58)(60, 62, 63, 66, 66) sleeve sts from stitch holder to spare needle.

With RS facing, join MC at right end of underarm CO sts on body. With larger dpn or 16" (40 cm) cir, pick up and knit 3 (3, 4, 6, 7)(7, 8, 9, 9, 10) sts from CO edge, pm for BOR, pick up and knit 4 (4, 5, 6, 7)(8, 8, 9, 10, 10) more sts from CO edge, then pick up and knit 2 sts in the corner between the CO and the sleeve. Knit across sleeve sts, then pick up and knit 2 sts in the corner between sleeve and armhole sts. Knit to BOR— 61 (66, 70, 73, 76)(79, 82, 85, 89, 90) sts.

Knit even in St st until sleeve measures 1¼" (3.2 cm) from underarm.

SLEEVE SHAPING

Dec rnd: K4, k2tog, knit to last 6 sts, ssk, k4— 2 sts dec'd.

Rep Dec rnd every 12 (10, 8, 9, 8)(8, 7, 6, 6, 6)th rnd 7 (8, 10, 9, 11)(10, 12, 13, 14, 14) more times, changing to dpn when necessary—45 (48, 48, 53, 52) (57, 56, 57, 59, 60) sts.

Knit 2 rnds even.

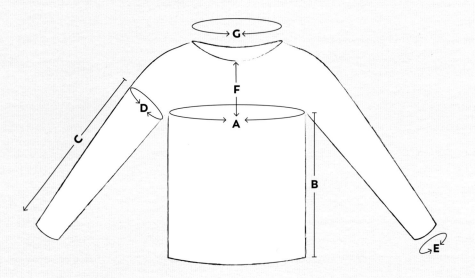

A: 33¼ (36, 38½, 42, 45)
(47, 49, 51½, 53¼, 56)"
(84.5 [91.5, 98, 106.5, 114.5]
[119.5, 124.5, 131, 135, 142] cm)

B: 15" (38 cm)

C: 18½" (47 cm)

D: 12¼ (13¼, 14, 14½, 15¼)
(15¾, 16½, 17, 17¾, 18)"
(31 [33.5, 35.5, 37, 38.5]
[40, 42, 43, 45, 45.5] cm)

E: 8¾ (9¾, 9¾, 10½, 10½)
(11¼, 11¼, 11¼, 11¾, 12)"
(22 [25, 25, 26.5, 26.5]
[28.5, 28.5, 28.5, 30, 30.5] cm)

F: 7 (7¼, 7½, 7¾, 8)
(8¼, 8½, 8¾, 9, 9¼)"
(18 [18.5, 19, 19.5, 20.5]
[21, 21.5, 22, 23, 23.5] cm)

G: 16 (16¾, 17½, 18, 19¼)
(19½, 20, 20¾, 22, 22½)"
(40.5 [42.5, 44.5, 45.5, 49]
[49.5, 51, 52.5, 56, 57] cm)

Sizes 3XS (–, –, S, –)(L, –, 2XL, 3XL, –) Only
Next rnd: K4, k2tog, knit to end—44 (–, –, 52, –)
(56, –, 56, 58, –) sts.

All Sizes
Work even until sleeve measures 14½" (37 cm)
from underarm, or 4" (10 cm) less than desired
total length (about 101 rnds).

Switch to smaller needle. Work even in garter
st as folls:

Rnd 1: Knit.

Rnd 2: Purl.

Rep Rnds 1 and 2 until garter cuff measures
4" (10 cm).

BO all sts knitwise.

Finishing

Weave in ends. Block to desired measurements.

Emerge

This slim-fitting pullover is designed to flatter the female figure with gentle waist shaping and sleeves that are knit with more negative ease than the body. The lace ribbing and simple lace yoke add to the feminine allure. YOTH Yarns Father is a classic worsted-weight yarn that's soft and squishy to knit, with excellent stitch definition and lovely bloom upon blocking. | **BY ANDREA CULL**

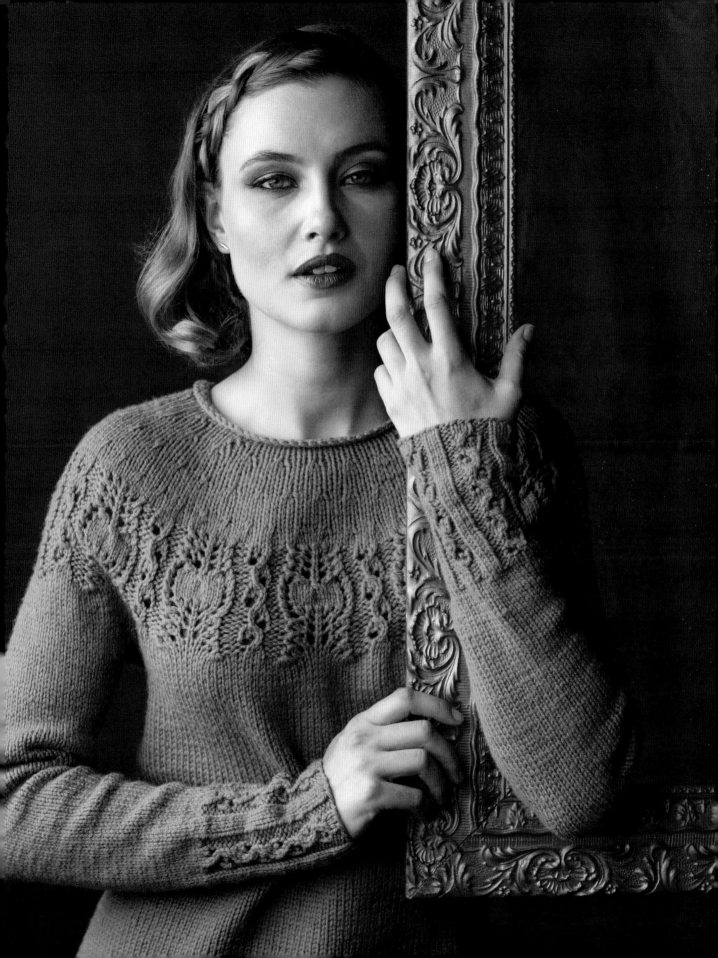

FINISHED SIZE

Sizes: XS (S, M, L, XL, 2XL).

Bust circumference: about 33¼ (37¾, 42¼, 46¾, 51, 55½)" (84.5 [96, 107.5, 118.5, 129.5, 141] cm].

Sweater shown measures 37¾" (96 cm), modeled with 5¾" (14.5 cm) of positive ease.

YARN

Worsted weight (#4 Medium).

About 960 (1040, 1180, 1320, 1480, 1640) yd (878 [951, 1079, 1207, 1353, 1500] m).

Shown here: YOTH Yarns Father (100% Rambouillet wool; 220 yd [201 m]/3½ oz [100 g]): raw honey, 5 (5, 6, 6, 7, 8) skeins.

NEEDLES

Size U.S. 5 (3.75 mm): 16" (40 cm) circular (cir); 32" (80 cm) cir; set of double-pointed (dpn).

Size U.S. 6 (4 mm): 16" (40 cm) cir; 32" (80 cm) cir; dpn.

Adjust needle size if necessary to obtain the correct gauge.

NOTIONS

Stitch markers (m); stitch holders or waste yarn; tapestry needle.

GAUGE

18 sts and 27 rnds = 4" (10 cm) in St st with larger needle.

NOTES

— The body of this pullover is worked in the round from the lower edge to the underarm. The sleeves are worked separately in the round, then the sleeves and body are joined to work the yoke. Short-rows are used to raise the back neck. While working the yoke, change to 16" (40 cm) cir needle when necessary.

— When shaping the yoke, if a marker falls in the center of a decrease, remove the marker and replace it after the decrease.

STITCH GUIDE

Backward Yarnover (byo)

Bring yarn between the needles from front to back, then over the right needle from back to front.

Lace Rib (multiple of 10 sts)

Rnd 1: *K3, p2, k3tog, yo, p2; rep from * to end.

Rnd 2: *K3, p2, k1, yo, k1, p2; rep from * to end.

Rnd 3: *K3, p2; rep from * to end.

Rnd 4: Rep Rnd 3.

Rnd 5: *K3, p2, yo, sssk, p2; rep from * to end.

Rnd 6: Rep Rnd 2.

Rnds 7 and 8: Rep Rnd 3.

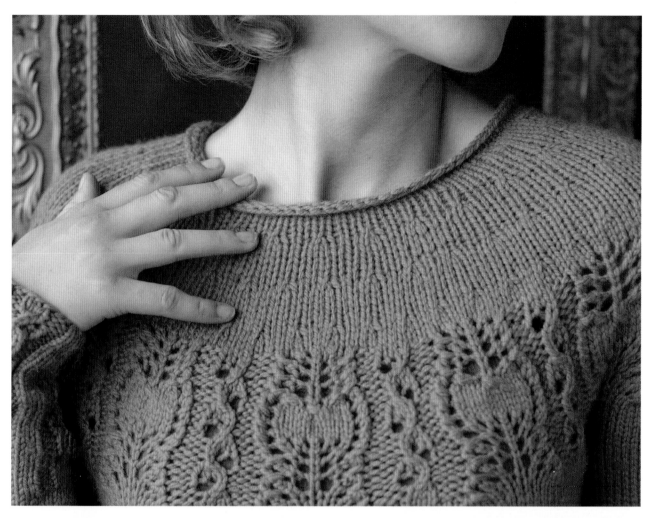

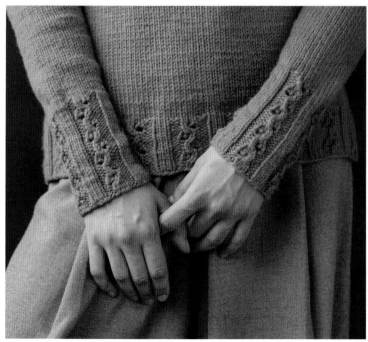

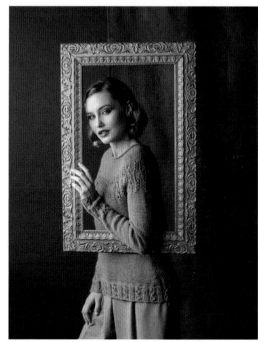

Sleeves (make 2)

With smaller dpn, CO 40 (40, 40, 40, 50, 50) sts. Pm and join for working in the rnd, being careful not to twist.

Next rnd: *K3, p2; rep from * to end.

Rep this rnd twice more.

Work in Lace Rib patt (see Stitch Guide) for 32 rnds.

Change to larger dpn and knit 1 rnd.

Inc rnd: K1, M1L, knit to 1 st before m, M1R, k1.

Rep Inc rnd every 12 (10, 8, 6, 8, 6)th rnd 5 (2, 4, 11, 8, 13) more times, then every 0 (8, 6, 0, 0, 0) rnds 0 (5, 5, 0, 0, 0) times—52 (56, 60, 64, 68, 78) sts.

Work even in St st until piece measures 18 (18, 18½, 19, 19½, 19¾)" (45.5 [45.5, 47, 48.5, 49.5, 50] cm) from CO edge. Transfer first and last 4 (5, 6, 7, 8, 8) sts of rnd to stitch holder or waste yarn, removing m—44 (46, 48, 50, 52, 62) sts rem. Place these sts on a separate holder.

Body

With smaller 32" (80 cm) cir needle and using the long-tail cast-on (page 40), CO 150 (170, 190, 210, 230, 250) sts. Pm and join for working in the rnd, being careful not to twist.

Next rnd: *K3, p2; rep from * to end.

Rep this rnd twice more.

Work in Lace Rib patt for 16 rnds.

Change to larger 32" (80 cm) cir needle.

Next rnd: K75 (85, 95, 105, 115, 125), pm for side, knit to end.

Knit 7 rnds.

SHAPE WAIST

Dec rnd: *K1, k2tog, knit to 3 sts before m, ssk, k1; rep from * to end—4 sts dec'd.

Rep Dec rnd every 8th rnd 3 more times— 134 (154, 174, 194, 214, 234) sts.

Knit 10 rnds.

Inc rnd: *K1, M1L, knit to 1 st before m, M1R, k1; rep from * to end—4 sts inc'd.

Rep Inc rnd every 8th rnd 3 more times— 150 (170, 190, 210, 230, 250) sts.

Work even in St st until piece measures 15 (15½, 15½, 16, 16, 16)" (38 [39.5, 39.5, 40.5, 40.5, 40.5] cm) from CO edge, stopping 4 (5, 6, 7, 8, 8) sts before the end of the final rnd.

Join Sleeves and Body

Next rnd: Transfer next 8 (10, 12, 14, 16, 16) sts to stitch holder or waste yarn, removing BOR m; k44 (46, 48, 50, 52, 62) sleeve sts, pm; k2tog, k65 (73, 81, 89, 97, 107) front sts, transfer next 8 (10, 12, 14, 16, 16) sts to stitch holder or waste yarn, pm, k44 (46, 48, 50, 52, 62) sleeve sts; k2tog, k65 (73, 81, 89, 97, 107) back sts—220 (240, 260, 280, 300, 340) sts. Pm for BOR and join for working in the rnd.

Knit 1 rnd.

 No marker is placed at right back shoulder. This will ensure the short-row shaping is worked from front to front.

SHAPE BACK

Shape back using yo short-rows as folls:

Short-row 1: (RS) Knit to m, sl m, k5, turn.

Short-row 2: (WS) Byo (see Stitch Guide), p5, sl m, [purl to m, sl m] 2 times, p5, turn.

Short-row 3: (RS) Yo, k5, sl m, [knit to m, sl m] 2 times, turn.

Short-row 4: (WS) Byo, sl m, [purl to m, sl m] 2 times, turn.

Short-row 5: (RS) Yo, sl m, knit to m, sl m, knit to 5 sts before m, turn.

Short-row 6: (WS) Byo, purl to m, sl m, purl to 5 sts before m, turn.

Next row: (RS) Yo, knit to end.

Next rnd: [Knit to yo, k2tog] 3 times, [knit to 1 st before yo, sl 1 kwise, return st to left needle, k2tog tbl] 3 times, knit to end.

Knit 0 (0, 2, 3, 3, 5) rnds.

Sizes XS (–, M, L, –, –) Only

Remove BOR m, k10 (–, 2, 8, –, –), pm for new BOR.

Sizes – (S, –, –, XL, 2XL) Only

Knit to last – (4, –, –, 6, 11) sts, pm for new BOR. Remove original BOR m on the next rnd.

All Sizes

Work Rnds 1–22 of Lace Rib Chart—176 (192, 208, 224, 240, 272) sts after chart is completed.

Knit 3 rnds.

Dec rnd: *K2, k2tog; rep from * to end— 132 (144, 156, 168, 180, 204) sts.

Knit 6 rnds.

Rep Dec rnd—99 (108, 117, 126, 135, 153) sts.

Knit 6 rnds.

LACE RIB CHART

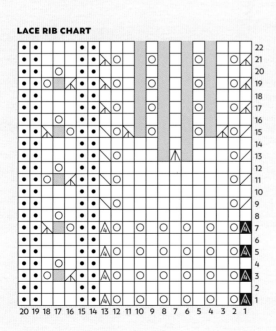

	knit
•	purl
◺	sl2 knitwise (one at a time), k2tog, p2sso
◣	k4tog
O	yo
◿	k3tog
◺	sssk
╱	k2tog
╲	ssk
◬	cdd
▨	no stitch

Sizes XS (–, –, –, –, 2XL) Only

Next rnd: *K3 (–, –, –, –, 2), k2tog, k4 (–, –, –, –, 3), k2tog; rep from * to end—81 (–, –, –, –, 119) sts.

Sizes – (S, M, L, XL, –) Only

Next rnd: *K – (2, 2, 2, 3, –), k2tog; rep from * to last – (0, 1, 2, 0, –) st(s), k – (0, 1, 2, 0, –)— – (81, 88, 95, 108, –) sts.

All Sizes

Change to smaller 16" (40 cm) cir needle. Knit 2 rnds.

SHAPE FRONT NECK

Shape front neck with short-rows as folls:

Short-row 1: (RS) Knit to m, sl m, k2, turn.

Short-row 2: (WS) Byo, p2, sl m, [purl to m, sl m] 2 times, p2, turn.

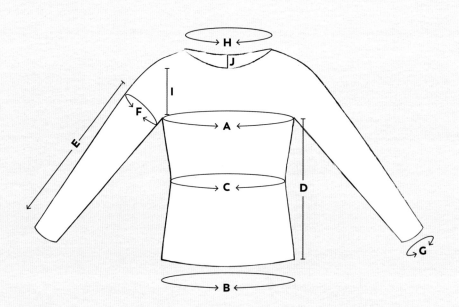

A: 33¼ (37¾, 42¼, 46¾, 51, 55½)" (84.5 [96, 107.5, 118.5, 129.5, 141] cm)

B: Same as A

C: 29¾ (34¼, 38¾, 43, 47½, 52)" (75.5 [87, 98.5, 109, 120.5, 132] cm)

D: 15 (15½, 15½, 16, 16, 16)" (38 [39.5, 39.5, 40.5, 40.5, 40.5] cm)

E: 18 (18, 18½, 19, 19½, 19¾)" (45.5 [45.5, 47, 48.5, 49.5, 50] cm)

F: 11½ (12½, 13¼, 14¼, 15, 17¼)" (29 [31.5, 33.5, 36, 38, 44] cm)

G: 7½ (7½, 7½, 7½, 9½, 9½)" (19 [19, 19, 19, 24, 24] cm)

H: 18 (18, 19½, 21, 24, 26½)" (45.5 [45.5, 49.5, 53.5, 61, 67.5] cm)

I: 6½ (6½, 6¾, 7, 7, 7¾)" (16.5 [16.5, 17, 18, 18, 19.5] cm)

J: 1¾" (4.5 cm)

Short-row 3: (RS) Yo, k2, sl m, knit to m, sl m, knit to 3 sts before m, turn.

Short-row 4: (WS) Byo, purl to m, sl m, purl to 3 sts before m, turn.

Short-row 5: (RS) Yo, knit to m, sl m, knit to 8 sts before m, turn.

Short-row 6: (WS) Byo, purl to m, sl m, purl to 8 sts before m, turn.

Next row: (RS) Yo, knit to end.

Next rnd: [Knit to yo, k2tog] 3 times, [knit to 1 st before yo, sl 1 kwise, return st to left needle, k2tog tbl] 3 times, knit to end.

Knit 1 (1, 2, 2, 4) rnds. BO all sts kwise.

COLLAR

Pick up and knit 1 st in each bound-off st— 81 (81, 88, 95, 108, 119) sts. Join for working in the round.

Knit 1 rnd. BO all sts kwise.

Finishing

Graft underarms closed using Kitchener stitch (see Glossary).

Block to measurements.

Weave in ends.

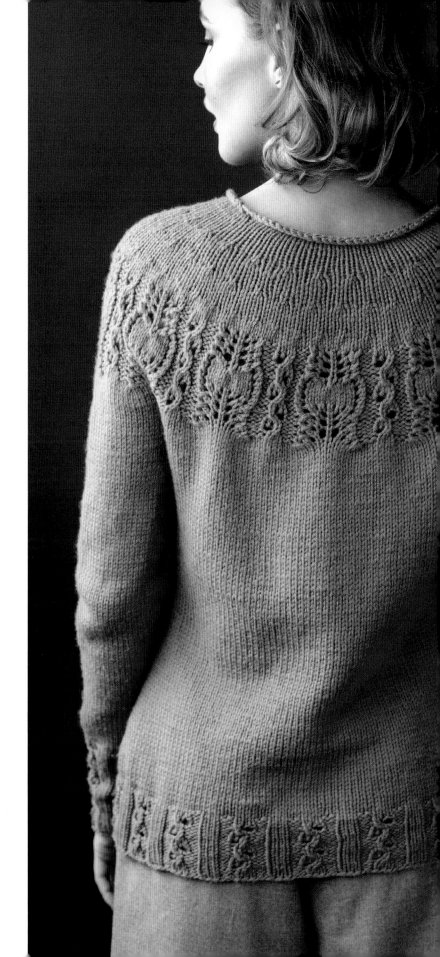

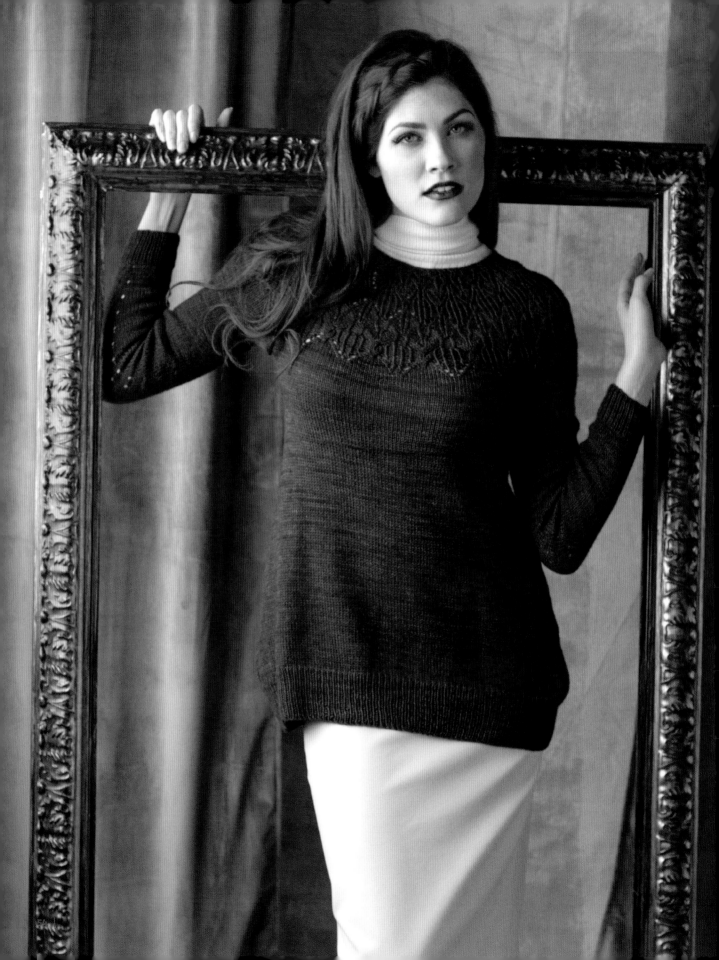

Frosty Flowers

The body of this sweater hangs in a flattering way and features a complex lace-and-cables yoke. Women with toddlers often find that lace shawls don't fit into their lifestyles, but a lace yoke that's just as complex as a shawl is a perfect match. | **BY JENISE HOPE**

FINISHED SIZE

Sizes: XS (S, M, L, XL, 2XL).

Bust circumference: about 28 (32, 36, 40, 44, 48)" (71 [81.5, 91.5, 101.5, 112, 122] cm).

Designed to fit busts 28–32 (32–36, 36–40, 40–44, 44–48, 48–52)" (71–81 [81–91, 91–102, 102–112, 112–122, 122–132] cm).

Sweater shown measures 32" (81.5 cm), modeled with 2½" (6.5 cm) of negative ease.

YARN

Fingering weight (#1 Super Fine).

About 1200 (1350, 1550, 1600, 1750, 1900) yd (1097 [1234, 1417, 1463, 1600, 1737] m).

Shown here: Hazel Knits Artisan Sock (90% superwash Merino wool, 10% nylon; 400 yd [366 m]/4¼ oz [120 g]): viviane, 3 (4, 4, 4, 5, 5) skeins.

NEEDLES

Size U.S. 6 (4 mm): 24–36" (40–60 cm) circular (cir); preferred needle for working small circumferences (double-pointed, cir for Magic Loop, etc.).

Adjust needle size if necessary to obtain the correct gauge.

NOTIONS

Stitch markers (m); stitch holders or waste yarn; 2 cable needles (cn); tapestry needle.

GAUGE

24 sts and 32 rnds = 4" (10 cm) in St st.

NOTE

— When working the yoke, you may want to use lifelines in the lace and cables.

STITCH GUIDE
1/1/1 RPC

Sl 1 st to 1st cn and hold in back, sl 1 st to 2nd cn and hold in back; k1, p1 from 2nd cn, k1 from 1st cn.

2/1/2 RPC

Sl 2 sts to 1st cn and hold in back, sl 1 st to 2nd cn and hold in back; k2, p1 from 2nd cn, k2 from 1st cn.

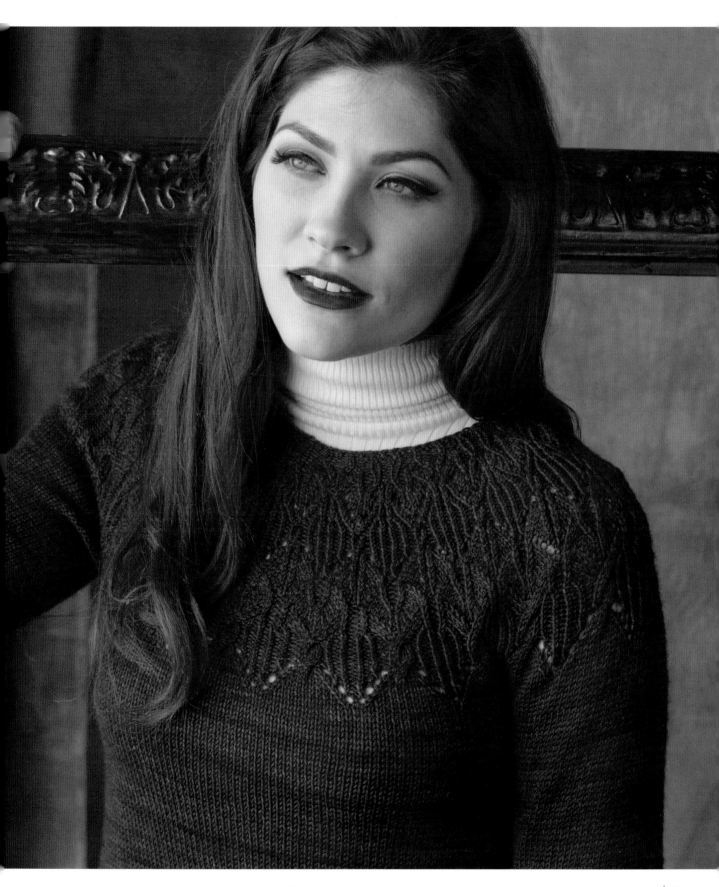

Sleeves (make 2)

Using small-circumference needle, CO 44 (48, 52, 56, 60, 64) sts. Pm and join for working in the round, being careful not to twist.

Rib rnd: *K1, p1; rep from * to end.

Rep this rnd 15 more times.

Next rnd: K3, pm, knit to end.

Inc rnd: Knit to 1 st before m, yo, k1, sl m, k1, yo, knit to end—2 sts inc'd.

Knit 6 rnds.

Rep prev 7 rnds 10 (11, 12, 13, 14, 15) more times—66 (72, 78, 84, 90, 96) sts.

Work even in St st until sleeve measures 19" (48.5 cm) from CO edge.

Next rnd: Knit to last 6 (7, 8, 9, 10, 11) sts. Break yarn, leaving a 36" (90 cm) tail for grafting, and transfer next 12 (14, 16, 18, 20, 22) sts to stitch holder or waste yarn.

Body

CO 264 (288, 312, 336, 360, 384) sts. Pm and join for working in the round, being careful not to twist.

Rib rnd: *K1, p1; rep from * to end.

Rep this rnd until ribbing measures 3" (7.5 cm) from CO edge.

Next rnd: K30 (31, 32, 33, 34, 35), pm, k132 (144, 156, 168, 180, 192), pm, knit to end.

Dec rnd: *Knit to 3 sts before m, k2tog, k1, sl m, k1, ssk; rep from * once more, knit to end—4 sts dec'd.

Knit 4 rnds.

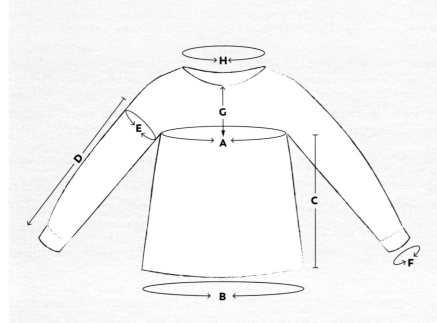

A: 28 (32, 36, 40, 44, 48)"
(71 [81.5, 91.5, 101.5, 112, 122] cm)

B: 44 (48, 52, 56, 60, 64)"
(112 [122, 132, 142, 152.5, 162.5] cm)

C: 18¼" (46.5 cm)

D: 19" (48.5 cm)

E: 11 (12, 13, 14, 15, 16)"
(28 [30.5, 33, 35.5, 38, 40.5] cm)

F: 7¼ (8, 8¾, 9¼, 10, 10¾)"
(18.5 [20.5, 22, 23.5, 25.5, 27.5] cm)

G: 7¾" (19.5 cm)

H: 12 (13¼, 14¾, 16, 17¼, 18¾)"
(30.5 [33.5, 37.5, 40.5, 44, 47.5] cm)

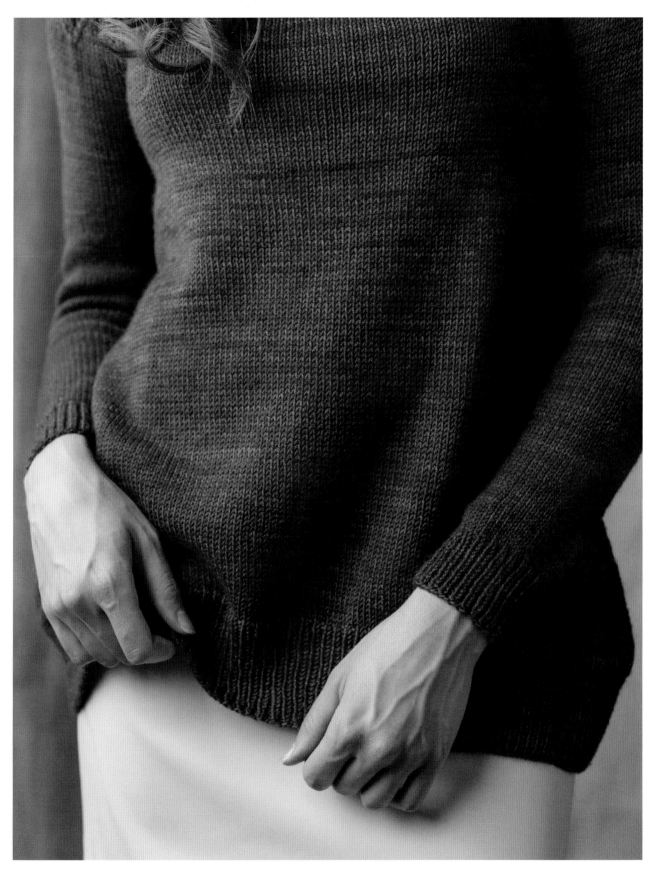

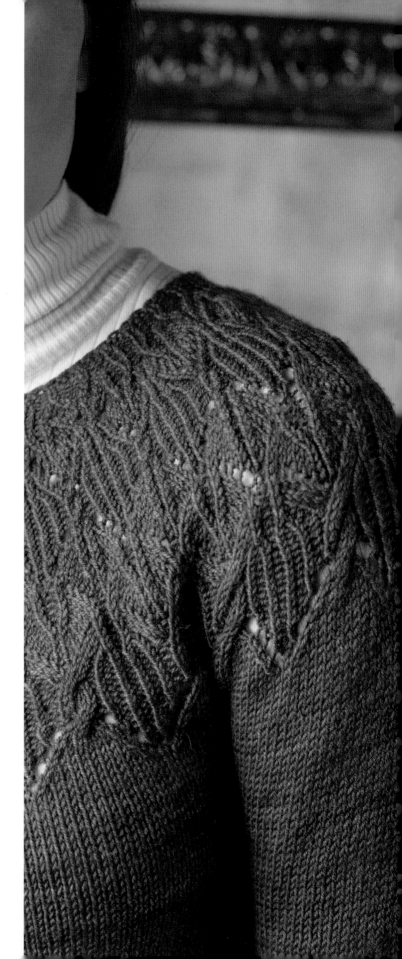

Rep prev 5 rnds 23 more times, stopping 6 (7, 8, 9, 10, 11) sts before the end of the final rnd—168 (192, 216, 240, 264, 288) sts. Piece should measure 18¼" (46.5 cm) from CO edge.

Join Sleeves and Body

Next rnd: *Transfer next 12 (14, 16, 18, 20, 22) body sts to stitch holder or waste yarn, k54 (58, 62, 66, 70, 74) sleeve sts, k72 (82, 92, 102, 112, 122) body sts; rep from * once more—252 (280, 308, 336, 364, 392) sts.

Sizes XS (–, M, L, –, 2XL) Only
Next rnd: Remove BOR m, sl 9 (–, 19, 9, –, 19) sts back to left needle, pm for new BOR, return 9 (–, 19, 9, –, 19) sl sts to right needle, knit to BOR.

All Sizes
Work Frosty Flowers Chart, beginning with Rnd 2.

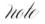 | *On Rnds 38 and 42, work the first 6 sts as charted, then rep only the center portion of the chart (outlined in red) until 6 sts rem. Work the cable at the far left of the chart using the first 2 stitches of Rnds 39 and 43. You may need to remove the BOR m while you work the cable, then put it back afterward (after the first st of cable just worked, so as not to move BOR).*

After completing all rnds of chart, BO all sts using the tubular bind-off (see Glossary).

Finishing

Graft underarms closed using Kitchener stitch (see Glossary).

Block to measurements and weave in ends.

FROSTY FLOWERS CHART

Legend:
- no stitch
- knit
- purl
- k tbl
- yo
- k2tog
- ssk
- 2/1/2 RPC
- 1/1/1 RPC
- repeat (on rows where no repeat is specified, repeat the whole row)

Row numbers (right side, bottom to top): 1–63

Column numbers (bottom): 30 29 28 27 26 25 24 23 22 21 20 19 18 17 16 15 14 13 12 11 10 9 8 7 6 5 4 3 2 1

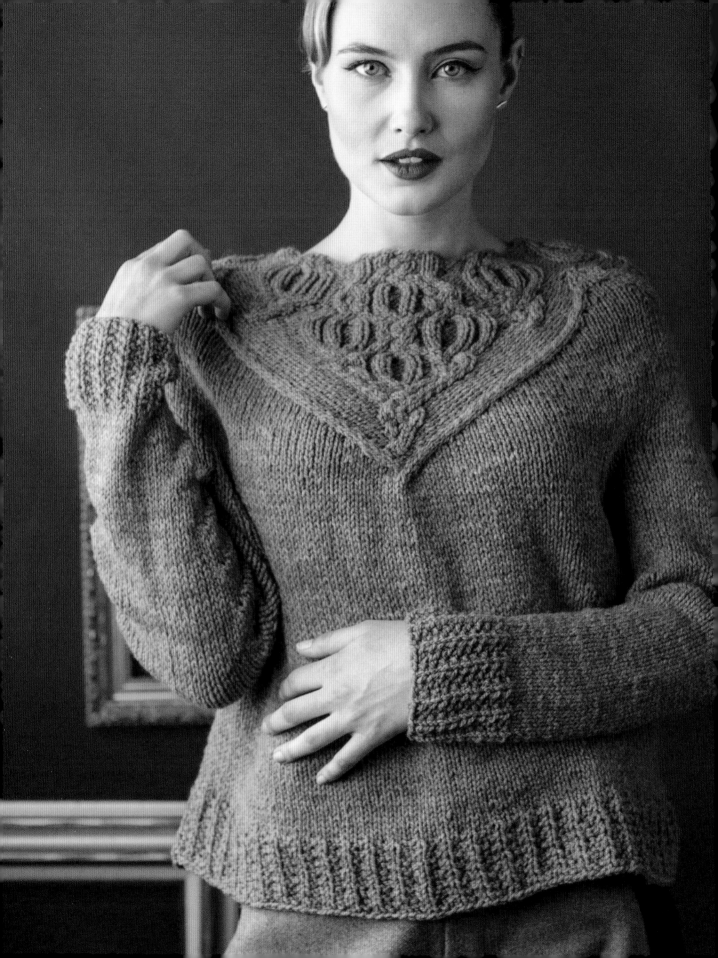

Morris

Cables particularly capture the allure of circular yokes. Their relief pattern adds texture and depth to the yoke. The beautifully ornate yoke on this sweater draws attention to the head and shoulders like a framed portrait. In this frame, the cable lines curve in and out and around each other as the circle grows outward like a flower blooming. This pullover is named after William Morris because the cable motifs are reminiscent of his beautiful interlacing leaves and flowers. The motifs are based on cables from Norah Gaughan's *Knitted Cable Sourcebook.* | **BY JENNIFER WOOD**

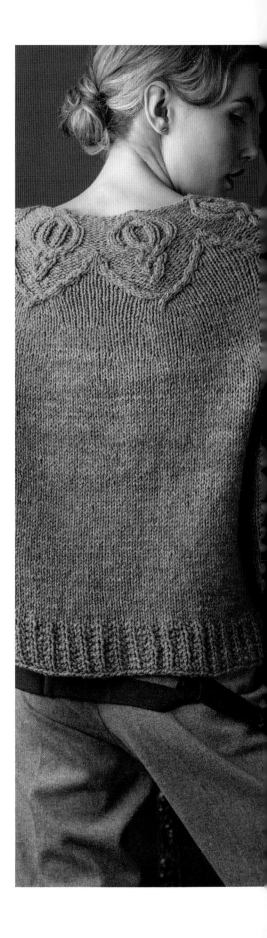

FINISHED SIZE

Sizes: XS (S, M, L, XL, 2XL).

Bust circumference: about 38 (42, 46, 50, 54, 58)" (96.5 [106.5, 117, 127, 137, 147.5] cm).

Sweater shown measures 42" (106.5 cm), modeled with 10" (25.5 cm) positive ease.

YARN

Worsted weight (#4 Medium).

About 895 (990, 1120, 1230, 1370, 1505) yd (820 [905, 1025, 1125, 1255, 1375] m).

Shown here: Swans Island All American Collection Worsted (75% wool, 25% alpaca; 210 yd [192 m]/2¾ oz [80 g]): lichen, 5 (5, 6, 6, 7, 8) skeins.

NEEDLES

Size U.S. 7 (4.5 mm): 16" (40 cm) circular needle (cir); 32" (80 cm) cir; preferred needle for working small circumferences (double-pointed, cir for Magic Loop, etc.).

Adjust needle size if necessary to obtain the correct gauge.

NOTIONS

Stitch markers (m); cable needle; stitch holders or waste yarn; tapestry needle.

GAUGE

16 sts and 24 rnds = 4" (10 cm) in St st.

NOTE

— This pullover is constructed from the top down in one piece with a deep circular yoke and raglan increases to shape the bodice. It's designed with positive ease in the bust. There's no body shaping past the armholes. The length of the body and sleeves are easily adjusted.

STITCH GUIDE

Rib Stitch (multiple of 3 sts)

Rnd 1: *K1, p1, k1; rep from * to end.

Rnd 2: *P1, k2; rep from * to end.

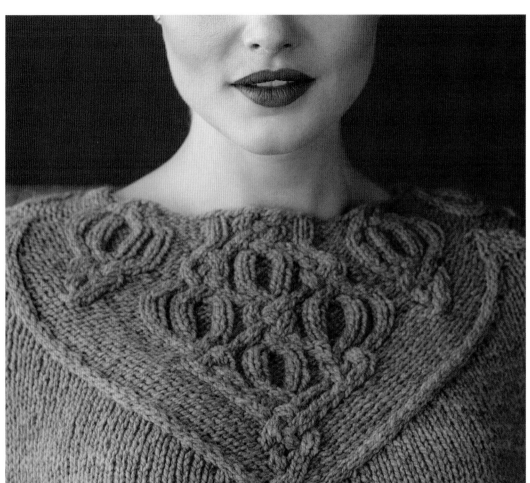
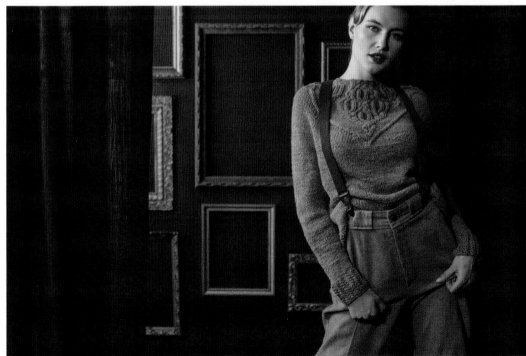

Yoke

With shorter cir needle, CO 86 (86, 97, 97, 108, 108) sts. Pm and join for working in the rnd, being careful not to twist.

Next rnd: Knit to end.

Set-up rnd 1: Work Rnd 1 of Front Chart 1, pm, work Cable Chart 4 (4, 5, 5, 6, 6) times.

Cont in patt through Rnd 31 of Front Chart 1.

Set-up rnd 2: Remove BOR m, k5, pm for new BOR, work Rnd 1 of Front Chart 2 (page 69), pm, k4, sl m, work Rnd 32 of Cable Chart to last 5 sts, pm, k5—153 (153, 174, 174, 195, 195) sts.

Work in patt through Rnd 36 of Cable Chart, working sts between chart markers in St st.

Next rnd: Work Rnd 6 of Front Chart 2, sl m, knit to end, removing m on either side of Cable Chart.

Work as est'd through Rnd 10 of Front Chart 2.

Next rnd (inc): Work Rnd 11 of Front Chart 2, sl m, k5 (5, 8, 8, 12, 12), [M1, k6 (6, 7, 7, 8, 8)] 14 times, M1, k4 (4, 8, 8, 11, 11)—15 sts inc'd; 168 (168, 189, 189, 210, 210) sts.

Work even through Rnd 20 of Front Chart 2.

Sizes XS (S, –, –, XL, 2XL) Only
Next rnd (inc): Work Rnd 21 of Front Chart 2, sl m, k9 (9, –, –, 8, 8), [M1, k6 (6, –, –, 9, 9)] 15 times, M1, k9 (9, –, –, 7, 7)—16 sts inc'd; 184 (184, –, –, 226, 226) sts.

Sizes – (–, M, L, –, –) Only
Next rnd (inc): Work Rnd 21 of Front Chart 2, sl m, k9, [M1, k8] 15 times—15 sts inc'd; – (–, 204, 204, –, –) sts.

All Sizes
Work Rnds 22–29 of Front Chart 2, maintaining all other sts in St st.

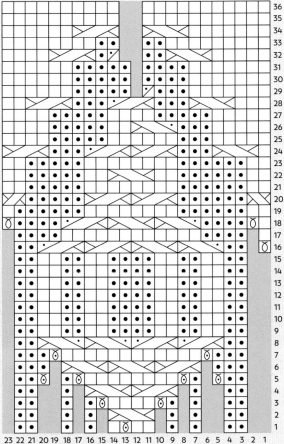

CABLE CHART

Legend:
- ☐ knit
- • purl
- ▨ no stitch
- Ⓞ M1
- Ⓞ M1P
- ⊿ p2tog
- ⬓ 2/2 RC
- ⬓ 2/2 LC
- ⬓ 2/2 RPC
- ⬓ 2/2 LPC
- ⬓ 1/1 LC
- ⬓ 1/1 RC

FRONT CHART 1

Legend:
- □ knit
- • purl
- ▨ no stitch
- ⊘ M1
- ⊗ M1P
- ⟋ p2tog
- 2/2 RC
- 2/2 LC
- 2/2 RPC
- 2/2 LPC
- 1/1 LC
- 1/1 RC

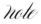 *Chart markers will now denote front body sts.*

Sizes XS (S, –, –, –, –) Only

Set-up rnd: K60 to chart m (this now becomes a raglan m), sl m, k32 for left sleeve, pm for raglan, k60 back sts, pm for raglan, k32 for right sleeve—32 sleeve sts; 60 sts each for front and back.

Sizes – (–, M, L, XL, 2XL) Only

Set-up rnd: Remove BOR m, k60 to chart m, rm, k – (–, 3, 3, 6, 6), pm for raglan, k – (–, 36, 36, 41, 41) for left sleeve, pm for raglan, k – (–, 66, 66, 72, 72) back sts, pm for raglan, k – (–, 36, 36, 41, 41) for right sleeve, pm for new beg of rnd— – (–, 36, 36, 41, 41) sleeve sts; – (–, 66, 66, 72, 72) sts each for front and back.

All Sizes

Raglan inc rnd: RLI, knit across front sts to m, LLI, sl m, k1, RLI, knit across sleeve sts to 1 st before m, LLI, k1, sl m, RLI, knit across back sts to m, LLI, sl m, k1, RLI, knit across sleeve sts to 1 st before m, LLI, k1—8 sts inc'd.

Next rnd: Knit to end.

Rep these 2 rnds 3 (4, 5, 6, 7, 8) more times—40 (42, 48, 50, 57, 59) sleeve sts; 68 (70, 78, 80, 88, 90) sts each for front and back.

FRONT CHART 2

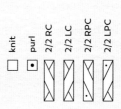

knit

□ · purl

◺ 2/2 RC

◹ 2/2 LC

◺· 2/2 RPC

◹· 2/2 LPC

Divide for Sleeves and Body

Dividing rnd: Knit across front sts, rm, transfer left sleeve sts to stitch holder or waste yarn, rm, CO 8 (14, 14, 20, 20, 26) sts, knit across back sts, rm, transfer right sleeve sts to stitch holder or waste yarn, rm, CO 4 (7, 7, 10, 10, 13) sts, pm for new beg of rnd, CO 4 (7, 7, 10, 10, 13) sts—152 (168, 184, 200, 216, 232) body sts.

Lower Body

Work even in St st until body measures 8½ (9, 9, 9½, 9½, 10)" (21.5 [23, 23, 24, 24, 25.5] cm) from underarm, or 2½" (6.5 cm) less than total desired length.

Hem set-up rnd: Knit to end, decreasing 2 (0, 1, 2, 0, 1) st(s) evenly.

Work Rib Stitch (see Stitch Guide) until ribbing measures 2½" (6.5 cm). BO sts in patt.

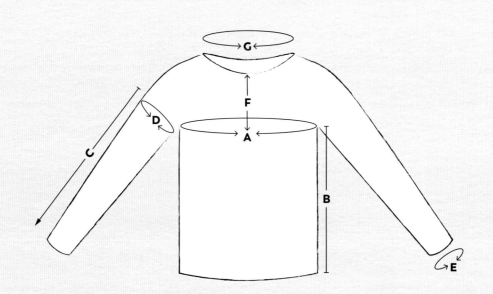

A: 38 (42, 46, 50, 54, 58)" (96.5 [106.5, 117, 127, 137, 147.5] cm)

B: 11 (11½, 11½, 12, 12, 12½)" (28 [29, 29, 30.5, 30.5, 31.5] cm)

C: 15 (15½, 16, 16, 16½, 17)" (38 [39.5, 40.5, 40.5, 42, 43] cm)

D: 12 (14, 15½, 17½, 19¼, 21¼)" (30.5 [35.5, 39.5, 44.5, 49, 54] cm)

E: 8½ (9, 9, 10, 9¾, 10¾)" (21.5 [23, 23, 25.5, 25, 27.5] cm)

F: 11½ (11¾, 12¼, 12½, 12¾, 13¼)" (29 [30, 31, 31.5, 32, 33.5] cm)

G: 21½ (21½, 24¼, 24¼, 27, 27)" (54.5 [54.5, 61.5, 61.5, 68.5, 68.5] cm)

Sleeves (make 2)

With small-circumference needle, RS facing, and beg at center of underarm, pick up and knit 4 (7, 7, 10, 10, 13) sts along CO sts, k40 (42, 48, 50, 57, 59) held sleeve sts, pick up and knit 4 (7, 7, 10, 10, 13) sts along CO sts to center of underarm, pm and join for working in the rnd—48 (56, 62, 70, 77, 85) sts.

*Knit 9 (6, 5, 4, 3, 3) rnds.

Dec rnd: K1, k2tog, work to last 2 sts, ssk.

Rep from * 6 (9, 12, 14, 18, 20) more times—34 (36, 36, 40, 39, 43) sts.

Knit 5 (8, 3, 6, 8, 3) more rnds even, or until sleeve measures 2½" (6.5 cm) less than total desired length, decreasing 1 (–, –, 1, –, 1) st on the last rnd.

Work Rib Stitch until ribbing measures 2½" (6.5 cm). BO sts in patt.

Finishing

Block to measurements and weave in ends.

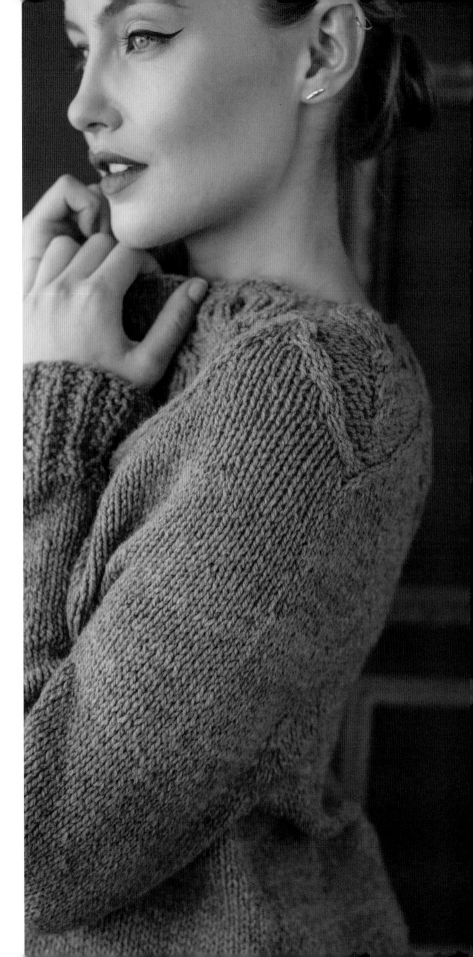

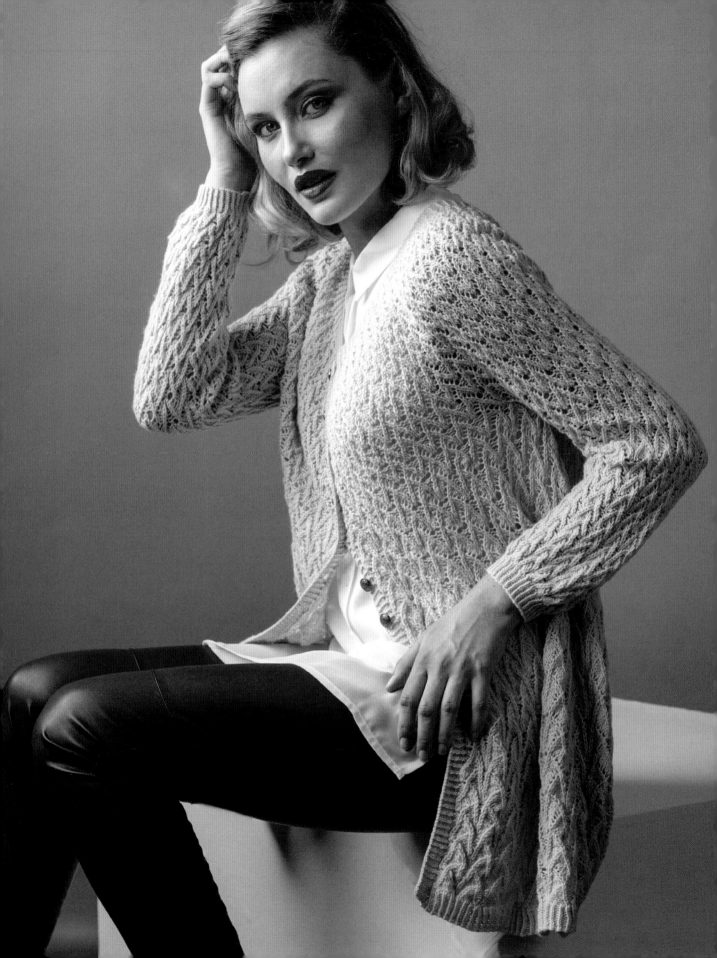

Lace Columns

A single lace pattern with diminishing stitch counts per repeat results in a cardigan that seems to transform seamlessly into a shaped garment. The lace pattern is worked every row, so there are no wrong-side rest rows. But the movement of it is intuitive, regular, and easy to memorize, allowing you to take this project with you anywhere you go as you knit it. | **BY AMY GUNDERSON**

FINISHED SIZE

Sizes: XS (S, M, L, XL, 2XL, 3XL).

Bust circumference: about 33¾ (37½, 41, 44¾, 48½, 52¼, 55¾)" (85.5 [95, 104, 113.5, 123, 132.5, 141.5] cm]).

Sweater shown measures 37½" (95 cm), modeled with 5½" (14 cm) of positive ease.

YARN

Sportweight (#2 Fine).

About 1840 (2070, 2300, 2530, 2760, 2990, 3220) yd (1680 [1890, 2100, 2310, 2520, 2730, 2940] m).

Shown here: Universal Yarn Bella Cash (60% fine superwash Merino wool, 30% nylon, 10% cashmere; 230 yd [210 m]/1¾ oz [50 g]): #120 pistachio, 8 (9, 10, 11, 12, 13, 14) balls.

NEEDLES

Size U.S. 3 (3.25 mm): 32" (80 cm) circular (cir); set of double-pointed (dpn).

Size U.S. 2 (2.75 mm): 16" (40 cm) or longer cir; dpn.

Adjust needle size if necessary to obtain the correct gauge.

NOTIONS

Stitch markers (m); stitch holders or waste yarn; tapestry needle; 7 (7, 7, 8, 8, 8, 9) ½" (13 mm) buttons; sewing needle; coordinating thread.

GAUGE

26 sts and 37 rows = 4" (10 cm) in any of the charted patts with larger needle.

28 sts and 38 rows = 4" (10 cm) in Twisted Ribbing with smaller needle.

NOTES

— This cardigan is worked seamlessly from the bottom up. Decreases occur within stitch patterns for a flowing and uninterrupted look. Due to the nature of the stitch patterns, the front edging will be wavy after knitting. Do not block this out, as the stitch patterns look best left relaxed. After you pick up stitches for buttonbands, the waviness at the front opening will relax on its own.

— Take a moment to look over the charts; they all represent the same general shape, but are worked over different numbers of stitches to make the shape larger or smaller.

Throughout the pattern you'll be instructed to work from the chart that corresponds to a particular stitch count (e.g., "Work from the 16-st Chart" or "Work from the 12-st Chart").

— The stitch patterns are very stretchy, so you can be fairly flexible in choosing which size to knit.

STITCH GUIDE

Twisted Ribbing (even number of sts, worked in the rnd)

Rnd 1: *K1 tbl, p1; rep from * to end.

Rep Rnd 1 for patt.

Twisted Ribbing (odd number of sts, worked flat)

Row 1: (RS) K1, *p1, k1 tbl; rep from * to last 2 sts, p1, k1.

Row 2: (WS) P1, k1, *p1 tbl, k1; rep from * to last st, p1.

Rep Rows 1 and 2 for patt.

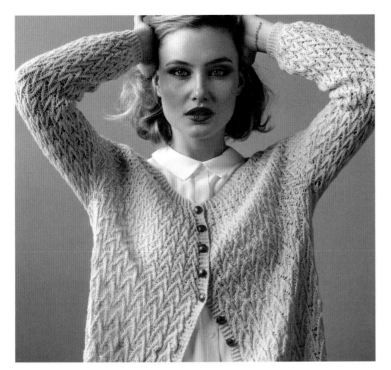

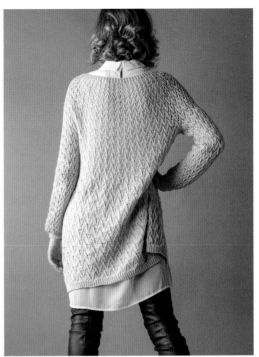

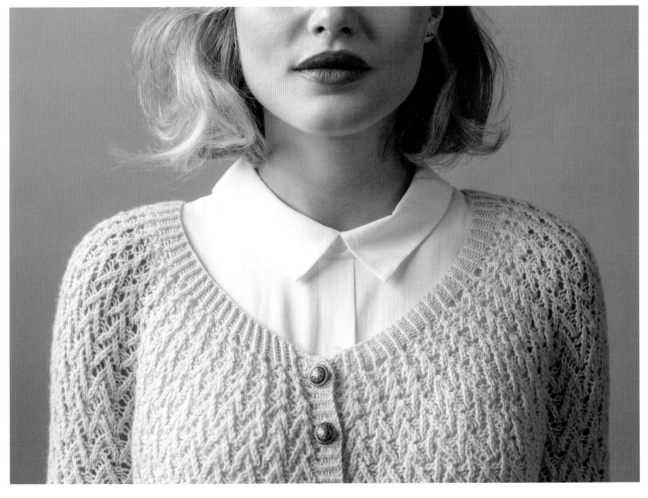

Sleeves (make 2)

With smaller dpns, CO 56 (56, 64, 64, 72, 72, 80) sts. Pm and join for working in the round, being careful not to twist. Work in Twisted Ribbing (see Stitch Guide) for 10 rnds. Switch to larger needle.

Set-up rnd 1: *K3, M1, p1, M1, k3, p1, pm; rep from * to end—7 (7, 8, 8, 9, 9, 10) patt sections; 2 sts inc'd per section; 70 (70, 80, 80, 90, 90, 100) sts.

Set-up rnd 2: *K4, yo, p1, yo, k4, p1, sl m; rep from * to end—2 sts inc'd per section; 84 (84, 96, 96, 108, 108, 120) sts.

Work Rnds 2–8 of 12-st Chart, then work Rnds 1–8 of the same chart 14 more times. Piece measures about 14¼" (36 cm).

Sizes – (S, –, L, –, 2XL, –) Only

Place first and last 6 sts on stitch holder or waste yarn.

Sizes XS (–, M, –, XL, –, 3XL) Only

Place first 12 sts on stitch holder or waste yarn.

All Sizes

Set aside rem 72 (72, 84, 84, 96, 96, 108) sts.

Body

With larger cir needle, CO 291 (323, 355, 387, 419, 451, 483) sts. Work flat in Twisted Ribbing for 1" (2.5 cm), ending with a RS row.

Set-up row: (WS) P1, pm, *[k1, p7] 2 times, pm; rep from * to last 2 sts, k1, p1—18 (20, 22, 24, 26, 28, 30) sections.

Row 1: (RS) K1, p1, sl m, *work Row 1 of 16-st Chart to m, sl m; rep from * to last st, k1.

Row 2: (WS) P1, sl m, *work Row 2 of 16-st Chart to m, sl m; rep from * to last 2 sts, k1, p1.

Cont as est'd through Row 12 of chart.

Rep Rows 1–12 of 16-st Chart 8 more times, then work Rows 1–11 of the same chart once more—9 full reps plus 11 rows of 16-st Chart.

Dec row: (WS) P1, sl m, *k1, p2tog, p3, yo, ssp, k1, p2tog, yo, p3, ssp, sl m; rep from * to last 2 sts, k1, p1—2 sts dec'd each section; 255 (283, 311, 339, 367, 395, 423) sts rem.

Work Rows 1–10 of 14-st Chart 2 times, then work Rows 1–9 of the same chart once more.

Dec row: (WS) P1, sl m, *k1, p2tog, p2, yo, ssp, k1, p2tog, yo, p2, ssp, sl m; rep from * to last 2 sts, k1, p1—2 sts dec'd each section; 219 (243, 267, 291, 315, 339, 363) sts rem.

Join Sleeves and Body

Next row: (RS) K1, p1, work 12-st Chart across 4 (4.5, 5, 5.5, 6, 6.5, 7) patt reps (48 [54, 60, 66, 72, 78, 84] sts) from right front, place next 12 sts on holder or waste yarn for underarm, cont working 12-st Chart across sleeve, work 12-st Chart across 8 (9, 10, 11, 12, 13, 14) patt reps (96 [108, 120, 132, 144, 156, 168] sts) from back, place next 12 sts on holder or waste yarn for underarm, work 12-st Chart across sleeve, work 12-st Chart across 4 (4.5, 5, 5.5, 6, 6.5, 7) reps (48 [54, 60, 66, 72, 78, 84] sts) from left front, k1—339 (363, 411, 435, 483, 507, 555) sts; 28 (30, 34, 36, 40, 42, 46) patt reps.

Work Rows 2–8 of 12-st Chart, work Rows 1–8 of the same chart twice more, then work Rows 1–7 once more.

Dec row: (WS) P1, sl m, *k1, p2tog, p1, yo, ssp, k1, p2tog, yo, p1, ssp, sl m; rep from * to last 2 sts, k1, p1—2 sts dec'd each section; 283 (303, 343, 363, 403, 423, 463) sts rem.

Work Rows 1–6 of 10-st Chart 2 (2, 3, 3, 4, 4, 5) times, then rep Rows 1–5 once more.

Dec row: (WS) P1, sl m, *k1, p2, ssp, k1, p2tog, p2, sl m; rep from * to last 2 sts, k1, p1—2 sts dec'd each section; 227 (243, 275, 291, 323, 339, 371) sts rem.

Work Rows 1–4 of 8-st Chart once, then rep Rows 1–3 once more.

Dec row: (WS) P1, sl m, *k1, p1, ssp, k1, p2tog, p1, sl m; rep from * to last 2 sts, k1, p1—2 sts dec'd each section; 171 (183, 207, 219, 243, 255, 279) sts rem.

Work Rows 1 and 2 of 6-st Chart 1 (2, 1, 2, 1, 2, 1) time(s).

Dec row: (WS) Removing markers as you go, k1, p1, k5 (3, 2, 4, 1, 3, 3), [k2tog, k10 (7, 4, 3, 2, 2, 2)] 13 (19, 33, 41, 59, 61, 67) times, k2tog, k4 (3, 1, 4, 0, 2, 2), p1, k1— 14 (20, 34, 42, 60, 62, 68) sts dec'd; 157 (163, 173, 177, 183, 193, 211) sts rem.

Switch to smaller cir needle and work in Twisted Ribbing for ¾" (2 cm), ending with a WS row. BO all sts firmly in patt.

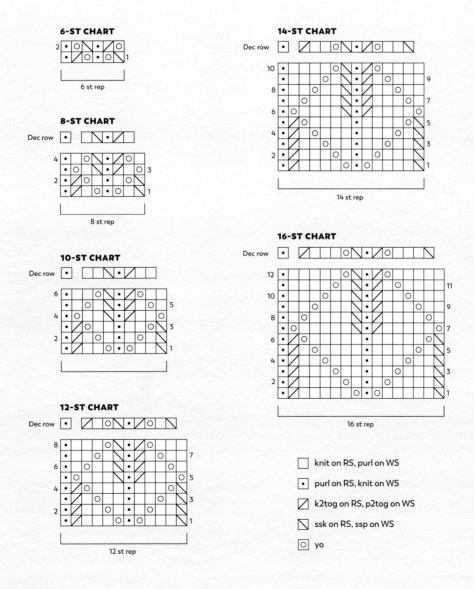

knit on RS, purl on WS

purl on RS, knit on WS

k2tog on RS, p2tog on WS

ssk on RS, ssp on WS

yo

Finishing

Place underarm sts on separate needles with RS together (WS facing you) and join using three-needle bind-off (see Glossary). Block to finished measurements.

BUTTONBAND

With smaller cir needle and RS facing, pick up and knit 167 (171, 175, 177, 181, 183, 187) sts evenly along left front. Work in Twisted Ribbing for 6 rows. BO all sts in patt over the next WS row.

BUTTONHOLE BAND

With smaller cir needle and RS facing, pick up and knit 167 (171, 175, 177, 181, 183, 187) sts evenly along right front. Work in Twisted Ribbing for 2 rows.

Buttonhole row: (WS) P1, k1, p1 tbl, *work 3-st 1-row buttonhole (see Glossary), work 9 sts in est'd rib; rep from * 5 (5, 5, 6, 6, 6, 7) more times, work 3-st 1-row buttonhole, work in est'd rib to end—7 (7, 7, 8, 8, 8, 9) buttonholes. Work in Twisted Ribbing for 3 more rows. BO all sts in patt over the next WS row.

Using sewing needle and coordinating thread, sew buttons to buttonband opposite buttonholes. Weave in ends.

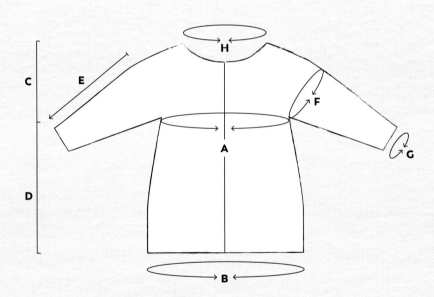

A: 33¾ (37½, 41, 44¾, 48½, 52¼, 55¾)" (85.5 [95, 104, 113.5, 123, 132.5, 141.5] cm)

B: 44¾ (49¾, 54½, 59½, 64½, 69½, 74¼)" (113.5 [126.5, 138.5, 151, 164, 176.5, 188.5] cm)

C: 7¼ (7½, 8, 8¼, 8¾, 9, 9½)" (18.5 [19, 20.5, 21, 22, 23, 24] cm)

D: 17¼" (44 cm) *We recommend blocking to this measurement, although the finished sweater will likely hang 3–4" (7.5–10 cm) longer due to its weight.*

E: 14¼" (36 cm)

F: 13 (13, 14¾, 14¾, 16½, 16½, 18½)" (33 [33, 37.5, 37.5, 42, 42, 47] cm)

G: 8½ (8½, 9¾, 9¾, 11, 11, 12¼)" (21.5 [21.5, 25, 25, 28, 28, 31] cm)

H: 22½ (23¼, 24¾, 25¼, 26¼, 27½, 30¼)" (57 [59, 63, 64, 66.5, 70, 77] cm)

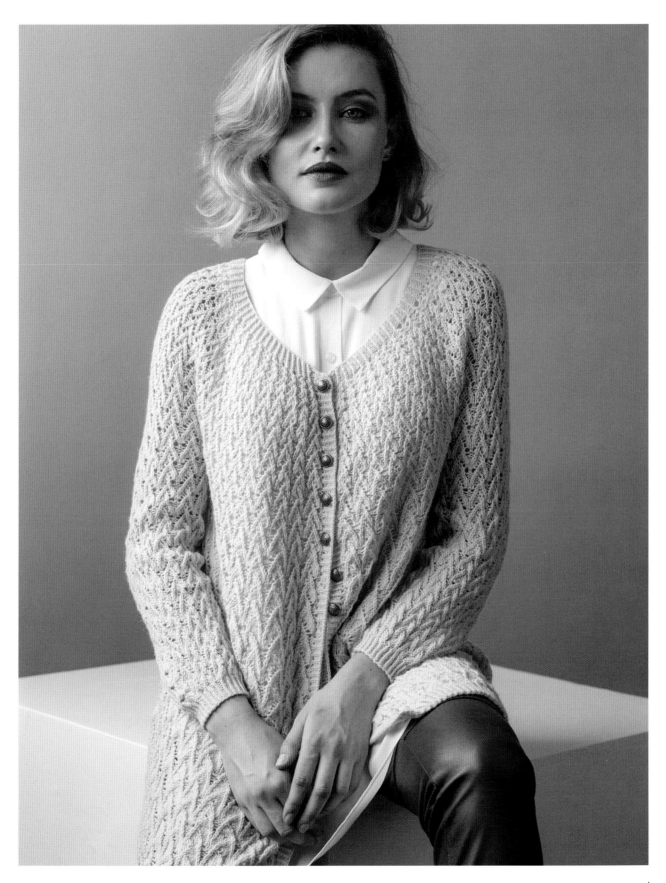

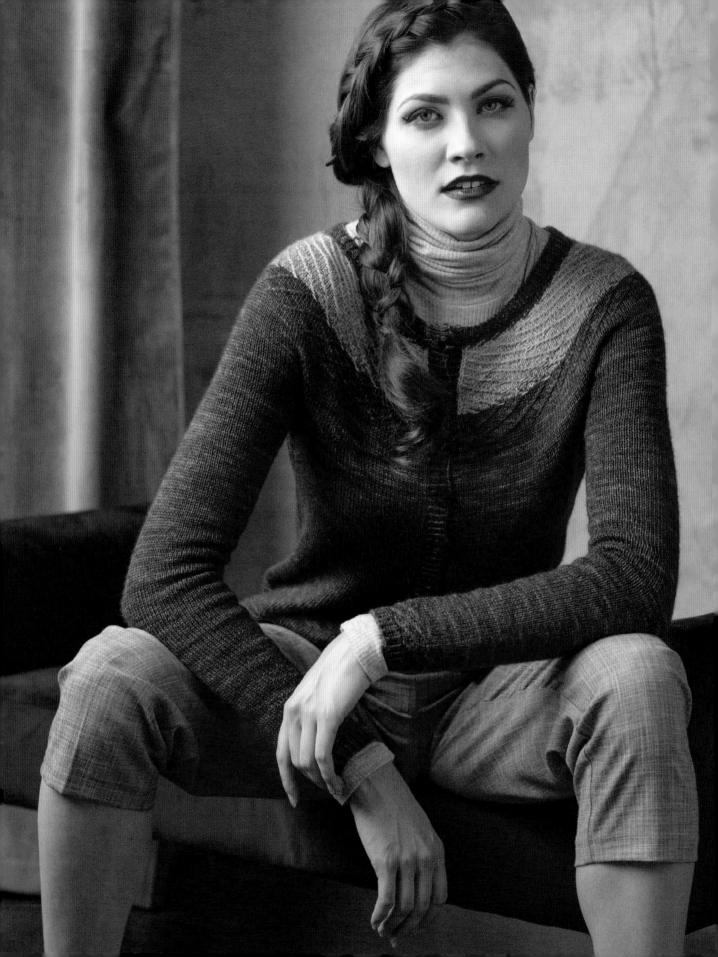

Twill

With a slip-stitch pattern echoing woven fabric, this yoke motif makes great use of a gradient set of mini skeins. The textured stitch pattern would look equally attractive in a solid-color yarn. This cardigan is worked flat from the bottom up in one piece. Sleeves (worked in the round) are joined at the beginning of the circular yoke. After some raglan shaping to create a comfortable fit and short-rows to raise the back neckline, the fun begins with the colorful woven stitch pattern that provides structure through the shoulders and back neck. False seams are worked at the body sides and on the sleeves and later sewn together with mattress stitch to further create a structured construction. | **BY HOLLI YEOH**

FINISHED SIZE

Sizes: XS (S, M, L, XL) (2XL, 3XL, 4XL, 5XL, 6XL).

Bust circumference: about 33 (35¾, 37¾, 40½, 44½) (49¼, 53, 57, 60¾, 64½)" (84 [90.5, 96, 103, 113][125, 134.5, 145, 154.5, 164] cm).

Designed to be worn with 0–2" (0–10 cm) of positive ease.

Sweater shown measures 35¾" (90.5 cm), modeled with 1¼" (3.2 cm) of positive ease.

YARN

Fingering weight
(#1 Super Fine).

MC: about 1085 (1170, 1245, 1365, 1505)(1655, 1800, 1905, 1975, 2045) yd (995 [1070, 1140, 1250, 1375][1515, 1650, 1745, 1805, 1870] m).

CC1: about 25 (30, 30, 30, 35) (40, 45, 45, 50, 50) yd (25 [25, 30, 30, 35][40, 40, 45, 45, 45] m).

CC2: about 25 (25, 25, 25, 30) (35, 40, 40, 40, 45) yd (20 [25, 25, 25, 30][35, 35, 35, 40, 40] m).

CC3: about 20 (25, 25, 25, 30) (35, 35, 35, 40, 40) yd (20 [20, 25, 25, 30][30, 35, 35, 35, 35] m).

CC4: about 20 (20, 20, 20, 25) (30, 30, 30, 35, 35) yd (15 [20, 20, 20, 25][25, 30, 30, 30, 30] m).

CC5: about 15 (20, 20, 20, 25) (25, 25, 30, 30, 30) yd (15 [15, 15, 15, 20][25, 25, 25, 25, 30] m).

Shown here: Julie Asselin Leizu Fingering (90% super-wash Merino wool, 10% silk; 420 yd [385 m]/4 oz [115 g]): midnight oil (MC), 3 (3, 3, 4, 4) (4, 5, 5, 5, 5) skeins; øresund gradient set (CC), 1 set.

NEEDLES

Size U.S. 3 (3.25 mm): 32" (80 cm) or longer circular (cir).

Size U.S. 2 (2.75 mm): 32" (80 cm) cir; preferred small-circumference needles (double-pointed, cir for Magic Loop, etc.).

Adjust needle size if necessary to obtain the correct gauge.

NOTIONS

Stitch markers (m); stitch holders or waste yarn; tapestry needle; 10 (10, 10, 11, 11)(11, 11, 11, 11, 11) ¾" (18 mm) buttons; sewing needle; coordinating thread.

GAUGE

25 sts and 36 rows = 4" (10 cm) in St st with larger needle, worked flat and blocked.

24 sts and 53.5 rows = 4" (10 cm) in Twill Hem Pattern with larger needle, blocked.

NOTES

— This cardigan is worked from the bottom up, back and forth in one piece to the armholes. The sleeves are worked in the round separately and then joined to the body to work the circular yoke, which is worked flat.

— Circular needles are used to accommodate the large number of stitches.

— For the sleeves, use your favorite method for knitting small circumferences in the round: two circular needles, Magic Loop with one long circular needle, or double-pointed needles.

— Slip all stitches as if to purl, unless otherwise noted.

— The Twill Pattern is a slip-stitch pattern, which greatly condenses the rows.

— A slipped-stitch selvedge is recommended on the rows that are worked in the Twill Pattern. There are 2 stitches in each selvedge, and each of the stitches is slipped on alternate rows. Do not work a slipped-stitch selvedge on other edges.

— False seams are included to provide structure. A single stitch, worked in reverse St st, creates a recessed column that is later sewn closed with mattress stitch. The false seams are optional and may be omitted. Note that your stitch counts will differ from the pattern if you omit the false seams.

Twill Hem Patt (worked flat over 6 sts)

Row 1: (RS) K4, sl 2 wyf.

Row 2: (WS) P1, sl 2 wyb, p3.

Row 3: K2, sl 2 wyf, k2.

Row 4: P3, sl 2 wyb, p1.

Row 5: Sl 2 wyf, k4.

Row 6: Sl 1 wyb, p4, sl 1 wyb.

Rep Rows 1–6 for patt.

Twill Cuff Patt (worked in the round over 6 sts)

Rnd 1: K4, sl 2 wyf.

Rnd 2: K3, sl 2 wyf, k1.

Rnd 3: K2, sl 2 wyf, k2.

Rnd 4: K1, sl 2 wyf, k3.

Rnd 5: Sl 2 wyf, k4.

Rnd 6: Sl 1 wyf, k4, sl 1 wyf.

Rep Rnds 1–6 for patt.

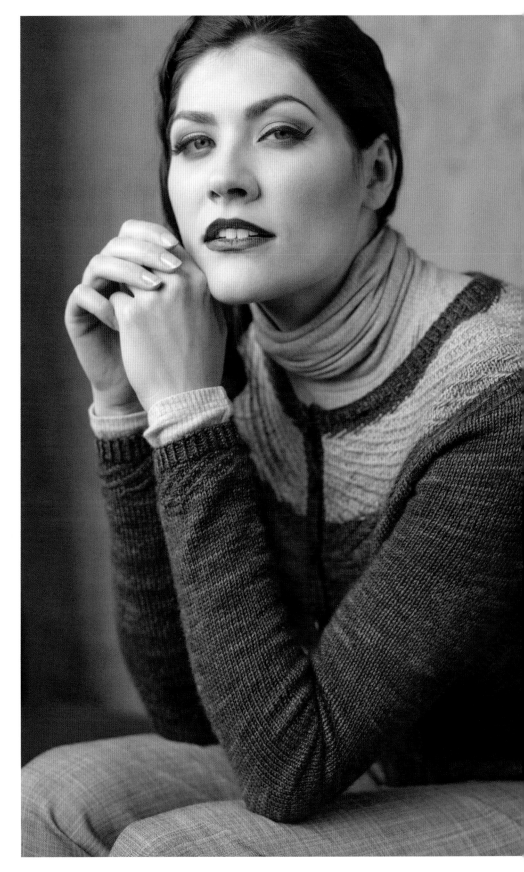

Sleeves (make 2)

With MC and smaller small-circumference needle, CO 48 (48, 48, 48, 48)(54, 54, 54, 54, 54) sts. Pm and join for working in the round, being careful not to twist.

Rnd 1: *K1 tbl, p1; rep from * to end.

Rep last rnd 6 more times.

Change to larger needle.

Knit 2 rnds.

Next rnd: Work Twill Cuff Patt (see Stitch Guide) to end.

Cont in patt as est'd for 11 more rnds.

Inc rnd: Knit to end, M1P—49 (49, 49, 49, 49)(55, 55, 55, 55, 55) sts.

Next rnd: Knit to last st, p1.

Remainder of sleeve is worked in St st with purled false seam st adjacent to m as est'd. Beg sleeve shaping as folls:

Inc rnd: K1, RLI, knit to last 2 sts, LLI, k1, p1—2 sts inc'd.

Rep Inc rnd every 13 (11, 9, 7, 6)(5, 4, 4, 4)th rnd 4 (10, 6, 8, 15)(12, 3, 15, 21, 29) more times, then every 14 (12, 10, 8, 7)(6, 5, 5, 5, –)th rnd 5 (1, 7, 9, 6)(11, 24, 14, 8, –) time(s)—69 (73, 77, 85, 93)(103, 111, 115, 115, 115) sts.

Work even until sleeve measures 19¼ (19¼, 19½, 20, 20¼)(19¾, 20¼, 20, 19½, 18½)" (49 [49, 49.5, 51, 51.5] [50, 51.5, 51, 49.5, 47] cm) from beg.

Sl 1, pass previous st on right needle over sl st, transfer previous 5 (7, 8, 10, 10)(10, 12, 13, 14, 15) sts to stitch holder or waste yarn, transfer next 3 (5, 6, 8, 8)(8, 10, 11, 12, 13) sts to same holder, transfer rem sts to a spare needle—8 (12, 14, 18, 18)(18, 22, 24, 26, 28) underarm sts; 60 (60, 62, 66, 74)(84, 88, 90, 88, 86) sleeve sts. Break yarn and set aside.

Body

With MC and smaller cir needle, CO 197 (215, 227, 245, 269)(299, 323, 347, 371, 395) sts.

Row 1: (RS) K1, *k1 tbl, p1; rep from * to last 2 sts, k1 tbl, k1.

Row 2: (WS) P1, *p1 tbl, k1; rep from * to last 2 sts, p1 tbl, p1.

Rep last 2 rows 5 more times.

Change to larger cir needle.

Inc row: (RS) K13 (13, 13, 15, 17)(19, 19, 21, 23, 25), RLI, k24 (28, 28, 30, 34)(36, 40, 42, 46, 48), RLI, k11 (13, 13, 15, 15)(17, 19, 21, 21, 23), pm, k51 (53, 59, 63, 69)(77, 83, 89, 95, 101), RLI, k50 (54, 60, 62, 68)(78, 84, 90, 96, 102), pm, k12 (12, 12, 14, 16)(18, 18, 20, 22, 24), RLI, k24 (28, 28, 30, 34)(36, 40, 42, 46, 48), RLI, knit rem 12 (14, 14, 16, 16)(18, 20, 22, 22, 24) sts—202 (220, 232, 250, 274)(304, 328, 352, 376, 400) sts. Markers indicate side seams.

Next row: (WS) Purl to end.

 note | There are 2 sts in each selvedge; due to the condensed st pattern, each of the sts is slipped on alternate rows.

Row 1: (RS) Sl 1 kwise, k1, work Twill Hem Patt (see Stitch Guide) to last 2 sts, k1, sl 1 kwise.

Row 2: (WS) P1, sl 1 wyf, work Twill Hem Patt to last 2 sts, sl 1 wyf, p1.

Cont in patt as est'd for 16 more rows.

Next row: (RS) *Knit to 12 (13, 13, 15, 16)(18, 19, 21, 22, 24) sts before side m, pm, knit to side m, sl m, M1P, k12 (13, 13, 15, 16)(18, 19, 21, 22, 24), pm; rep from * once more, knit to end—204 (222, 234, 252, 276)(306, 330, 354, 378, 402) sts; 6 markers total: 4 shaping markers and 2 side markers.

Next row: (WS) *Purl to 1 st before side m, k1; rep from * once more, purl to end.

Work remainder of Body in St st, maintaining false seam sts adjacent to side markers in reverse St st, while working waist and bust shaping as folls:

SHAPE WAIST

Dec row: (RS) *Knit to 2 sts before next shaping m, ssk, work to next shaping m, k2tog; rep from * once more, knit to end—4 sts dec'd.

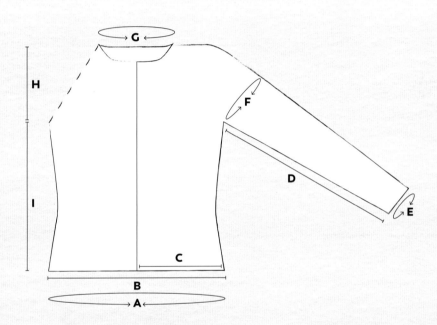

A: 33 (35¾, 37¾, 40½, 44½)
(49¼, 53, 57, 60¾, 64½)"
(84 [90.5, 96, 103, 113][125, 134.5, 145, 154.5, 164] cm)

B: 16¼ (17¼, 19¼, 20¼, 22)
(25, 27, 28¾, 30¾, 32¾)"
(41.5 [44, 49, 51.5, 56][63.5, 68.5, 73, 78, 83] cm)

C: 8 (9, 9, 10, 11)(11¾, 12¾, 13¾, 14¾, 15¾)"
(20.5 [23, 23, 25.5, 28][30, 32.5, 35, 37.5, 40] cm)

D: 19¼ [19¼, 19½, 20, 20¼)
(19¾, 20¼, 20, 19½, 18½)"
(49 [49, 49.5, 51, 51.5]
[50, 51.5, 51, 49.5, 47] cm)

E: 7¾ (7¾, 7¾, 7¾, 7¾)
(8¾, 8¾, 8¾, 8¾, 8¾)"
(19.5 [19.5, 19.5, 19.5, 19.5]
[22, 22, 22, 22, 22] cm)

F: 11 (11½, 12¼, 13½, 14¾)
(16¼, 17½, 18¼, 18¼, 18¼)"
(28 [29, 31, 34.5, 37.5]
[41.5, 44.5, 46.5, 46.5, 46.5] cm)

G: 14¾ (15½, 16½, 17¼, 18½)(19¾, 20¾, 22, 22¾, 23½)"
(37.5 [39.5, 42, 44, 47]
[50, 52.5, 56, 58, 59.5] cm)

H: 7¼ (7½, 7¾, 8, 8¼)
(8½, 8¾, 9, 9¼, 9½)"
(18.5 [19, 19.5, 20.5, 21]
[21.5, 22, 23, 23.5, 24] cm)

I: 14¼ (14½, 14¾, 15¼, 15¼)
(15¼, 15½, 15¾, 15½, 15¾)"
(36 [37, 37.5, 38.5, 38.5][38.5, 39.5, 40, 39.5, 40] cm)

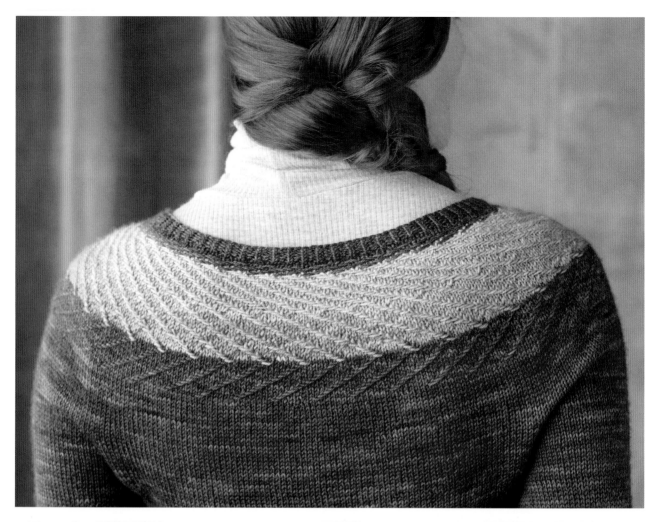

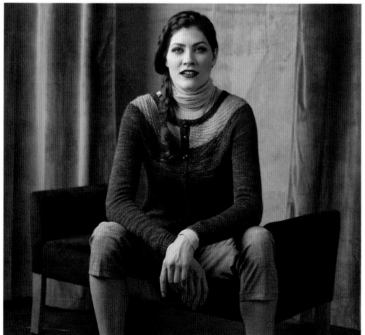

Rep Dec row every 6 (8, 4, 8, 8)(4, 4, 4, 4, 4)th row 4 (3, 3, 1, 1)(1, 1, 1, 3, 3) more time(s), then every – (–, 6, 10, 10)(6, 6, 6, 6, 6)th row – (–, 2, 2, 2)(4, 4, 4, 2, 2) times—184 (206, 210, 236, 260)(282, 306, 330, 354, 378) sts.

Work even in patt until piece measures 7 (7, 7, 7½, 7½) (7½, 7½, 7½, 7, 7)" (18 [18, 18, 19, 19][19, 19, 19, 18, 18] cm) from beg, ending with a WS row.

Inc row: (RS) *Knit to next shaping m, LLI, sl m, work to next shaping m, sl m, RLI; rep from * once more, knit to end—4 sts inc'd.

Rep Inc row every 8 (12, 8, 12, 10)(6, 4, 6, 4, 6)th row 3 (2, 5, 1, 1)(5, 1, 5, 1, 5) more time(s), then every 10 (14, –, 14, 12)(–, 6, –, 6, –)th row 1 (1, –, 2, 2)(–, 4, –, 4, –) time(s)—204 (222, 234, 252, 276)(306, 330, 354, 378, 402) sts.

Shaping markers are no longer required and can be removed; keep the side markers.

Work even in patt until piece measures 14¼ (14½, 14¾, 15¼, 15¼)(15¼, 15½, 15¾, 15½, 15¾)" (36 [37, 37.5, 38.5, 38.5][38.5, 39.5, 40, 39.5, 40] cm) from beg, ending with a RS row.

DIVIDE FOR ARMHOLES

Next row: (WS) *Work to next side m, rm, p1, pass previous st on right needle over last st worked, p3 (5, 6, 8, 8)(8, 10, 11, 12, 13), slip previous 8 (12, 14, 18, 18)(18, 22, 24, 26, 28) underarm sts to holder or waste yarn; rep from * once more, purl to end—46 (50, 49, 53, 59)(65, 69, 74, 79, 84) sts for each front; 94 (96, 106, 108, 120)(138, 146, 156, 166, 176) back sts.

Join Sleeves and Body

Next row: (RS) Knit across right front, pm, knit across one sleeve, pm, knit across back, pm, knit across other sleeve, pm, knit across left front—306 (316, 328, 346, 386)(436, 460, 484, 500, 516) sts; 4 markers.

Next row: (WS) Purl to end.

Sizes - (-, -, -, XL) (2XL, 3XL, 4XL, 5XL, 6XL) Only

Dec row: (RS) *Knit to 4 sts before m, sssk, k2, k3tog; rep from * 3 more times, knit to end—16 sts dec'd.

Next row: (WS) Purl to end.

Rep these 2 rows – (–, –, –, 0)(0, 1, 1, 1, 1) more time(s)— – (–, –, –, 370)(420, 428, 452, 468, 484) sts.

ALL SIZES
Shape Back

Short-rows are worked to raise the back neck concurrent with underarm shaping. When you work past a wrapped st, be sure to pick up the wrap and work it tog with wrapped st.

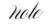 *See Glossary for details on working w&t (wrap & turn) short-rows.*

Size XS Only

Short-row 1: (RS) Knit to 4 sts beyond last m, w&t.

Short-row 2: (WS) Purl to 4 sts beyond last m, w&t.

Sizes - (-, M, L, XL) (2XL, 3XL, 4XL, 5XL, 6XL) Only

Next row: (RS) *Knit to 3 sts before next m, ssk, k2, k2tog; rep from * 3 times more, knit to end—8 sts dec'd.

Next row: (WS) Purl to end.

Rep last 2 rows – (–, 0, 2, 2)(3, 0, 1, 1, 1) more time(s)— – (–, 320, 322, 346)(388, 420, 436, 452, 468) sts.

Sizes - (S, M, L, XL) (2XL, 3XL, 4XL, 5XL, 6XL) Only

Short-row 1: (RS) *Knit to 3 sts before next m, ssk, k2, k2tog; rep from * 3 times more, k2, w&t—8 sts dec'd.

Short-row 2: (WS) Purl to 4 sts beyond last m, w&t.

All Sizes

Short-row 3: *Knit to 3 sts before next m, ssk, k2, k2tog; rep from * 3 times more, knit to 4 (4, 4, 4, 5)(6, 6, 6, 7, 7) sts beyond wrapped st, w&t—8 sts dec'd.

Short-row 4: Purl to 4 (4, 4, 4, 5)(6, 6, 6, 7, 7) sts beyond wrapped st, w&t.

Rep last 2 rows 3 (4, 4, 4, 4)(4, 5, 5, 5, 5) more times—274 (268, 272, 274, 298)(340, 364, 380, 396, 412) sts.

Work 12 (12, 10, 8, 10)(8, 10, 8, 12, 10) rows even in St st.

Sizes XS (S, M, L, -) (-, 3XL, 4XL, -, 6XL) Only

Dec row: (RS) K33 (26, 67, 33, –)(–, 60, 37, –, 102), k2tog, [k66 (52, 134, 66, –)(–, 120, 74, –, 204), k2tog] 3 (4, 1, 3, –)(–, 2, 4, –, 1) time(s), knit to end—270 (263, 270, 270, 298)(340, 361, 375, 396, 410) sts.

Next row: (WS) Purl to end.

Yoke Motif—All Sizes

Beg with Row 3 (3, 1, 1, 1)(13, 13, 13, 13, 13) of Yoke Motif A, work 12 (12, 14, 14, 14)(16, 16, 16, 16, 16) rows of chart.

Work Yoke Motif B for your size, changing colors as indicated—156 (152, 156, 156, 172)(196, 208, 216, 228, 236) sts.

Dec row: (RS) K2 (2, 3, 4, 3)(2, 2, 2, 2, 2), k2tog, [k2 (3, 4, 6, 4)(3, 3, 3, 3, 3), k2tog] 9 (5, 9, 7, 8)(15, 9, 13, 7, 7) times, [k3 (4, 5, 7, 5)(2, 2, 2, 2, 2), k2tog] 15 (16, 5, 3, 9)(9, 27, 19, 37, 39) times, [k2 (3, 4, 6, 4)(3, 3, 3, 3, 3), k2tog] 10 (5, 10, 8, 9)(16, 10, 14, 8, 8) times, k1 (2, 2, 3, 2)(1, 1, 1, 1, 1)—121 (125, 131, 137, 145)(155, 161, 169, 175, 181) sts.

Next row: (WS) Purl to end.

Neckband

Change to smaller needle.

Row 1: (RS) K1, *k1 tbl, p1; rep from * to last 2 sts, k1 tbl, k1.

Row 2: (WS) P1, *p1 tbl, k1; rep from * to last 2 sts, p1 tbl, p1.

Rep last 2 rows once more. BO in patt.

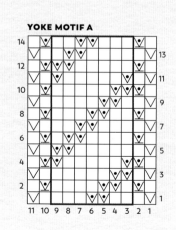

YOKE MOTIF A

YOKE MOTIF B, SIZE XS

SIZES S, M, L

SIZES XL, 2XL, 3XL, 4XL, 5XL, 6XL

RS: knit; WS: purl

RS: slip knitwise

RS: Slip purlwise with yarn in front
WS: Slip purlwise with yarn in back

RS: Slip purlwise with yarn in back
WS: Slip purlwise with yarn in front

RS: K2tog

repeat

MC

CC1

CC2

CC3

CC4

CC5

no stitch

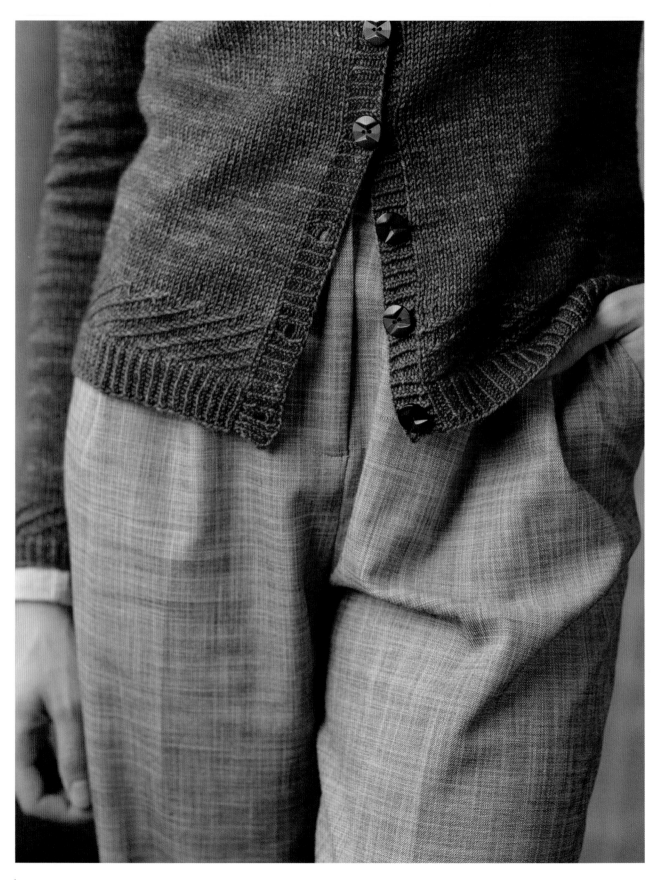

Finishing

Block to schematic measurements.

Using mattress stitch (see Glossary), sew up false seams on body and sleeves by seaming together the knit sts on either side of the purled st.

Graft underarms closed using Kitchener stitch (see Glossary).

Weave in ends, closing any holes at grafted sts.

BUTTONBAND

Starting at top of left front with RS facing, using MC and smaller needle, pick up and knit 133 (137, 139, 145, 149)(149, 151, 153, 153, 153) sts.

Inc row: (WS) P1f&b, *k1, p1 tbl; rep from * to last 2 sts, k1, p1f&b—2 sts inc'd.

Row 1: (RS) K1, *k1 tbl, p1; rep from * to last 2 sts, k1 tbl, k1.

Row 2: P1, *p1 tbl, k1; rep from * to last 2 sts, p1 tbl, p1.

Rep last 2 rows twice more. BO in patt.

BUTTONHOLE BAND

Starting at bottom of right front with RS facing, work as for buttonband through the end of Row 2.

Size XS Only

Row 3 (buttonhole row): (RS) Work 6 sts in rib as est'd, [yo, k2tog, k12] 8 times, yo, k2tog, k8, yo, k2tog, work rib to end—10 buttonholes.

Sizes - (S, M, -, XL) (2XL, 3XL, 4XL, 5XL, 6XL) Only

Row 3 (buttonhole row): (RS) Work – (6, 8, –, 6)(6, 6, 8, 8, 8) sts in rib as est'd, [yo, k2tog, k– (12, 12, –, 12) (12, 12, 12, 12, 12)] – (9, 9, –, 10)(10, 10, 10, 10, 10) times, yo, k2tog, work rib to end— – (10, 10, –, 11)(11, 11, 11, 11, 11) buttonholes.

Size L Only

Row 3 (buttonhole row): (RS) Work 6 sts in rib as est'd, yo, k2tog, k10, [yo, k2tog, k12] 8 times, yo, k2tog, k10, yo, k2tog, rib to end—11 buttonholes.

All Sizes

Row 4: (WS) P1, *p1 tbl, k1; rep from * to last 2 sts, p1 tbl, p1.

Row 5: K1, *k1 tbl, p1; rep from * to last 2 sts, k1 tbl, k1.

Rows 6–8: Rep Rows 4 and 5, ending with a WS row.

BO in patt.

Using sewing needle and coordinating thread, sew on buttons to correspond with buttonholes.

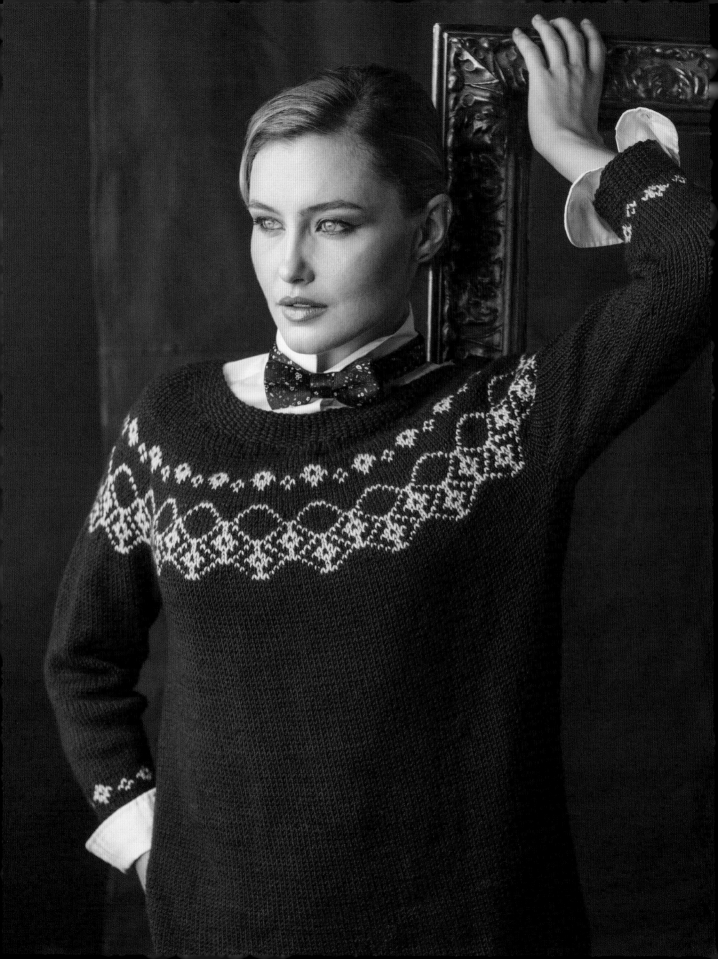

Sashiko

The clean simplicity of sashiko embroidery is enchanting. It's elegant and modern with its repeating geometric forms, yet reaches back to a traditional fiber art. This pullover was inspired by sashiko and is worked from the top down, featuring a colorwork motif and linen stitch to keep the open, free-flowing design. The sleeves are worked to three-quarter length and embellished with a section of the yoke motif. This beautiful sweater is intended to have a generous fit in the Japanese fashion and is perfect for a day in the galleries. The collar, cuffs, and bottom edge are worked in linen stitch, and the bind-off creates a lovely, almost picot-like finish. | **BY MONA ZILLAH**

FINISHED SIZE

Sizes: XS (S, M, L, XL).

Bust circumference: about 31¼ (36, 40, 44¾, 48)" (79.5 [91.5, 101.5, 113.5, 122] cm).

Designed to be worn with 2–4" (5–10 cm) of positive ease.

Sweater shown measures 40" (101.5 cm), modeled with 8" (20.5 cm) of positive ease.

YARN

Worsted weight (#4 Medium).

MC: 750 (950, 975, 1175, 1260) yd (685 [868, 891, 1074, 1152] m).

CC: about 80 (85, 90, 100, 115) yd (73 [77, 82, 91, 105] m).

Shown here: Hazel Knits Cadence (100% Merino wool; 200 yd [183 m]/3¾ oz [110 g]): MC: collegiate, 4 (5, 5, 6, 7) balls; CC: thistle, 1 ball.

NEEDLES

Size U.S. 7 (4.5 mm): 16" (40 cm) circular (cir); 32" (80 cm) cir; set of double-pointed (dpn).

Size U.S. 8 (5 mm): 32" (80 cm) cir; dpn.

Adjust needle size if necessary to obtain the correct gauge.

NOTIONS

Stitch marker (m); stitch holders or waste yarn; tapestry needle.

GAUGE

20 sts and 27 rnds = 4" (10 cm) in St st with smaller needle.

20 sts and 26 rnds = 4" (10 cm) in colorwork St st with larger needle.

20 sts and 32 rnds = 4" (10 cm) in linen st with smaller needle.

NOTES

— If necessary, change needle size to keep gauge throughout.

— The charts are worked using the stranded method. With regions of large floats, tack no more than 5 sts, but alternate tacks over the following round.

STITCH GUIDE
Linen Stitch

Rnd 1: K1, sl 1 with yarn held to RS.

Rnd 2: Sl 1 with yarn held to RS, k1.

Repeat Rnds 1 and 2 for patt.

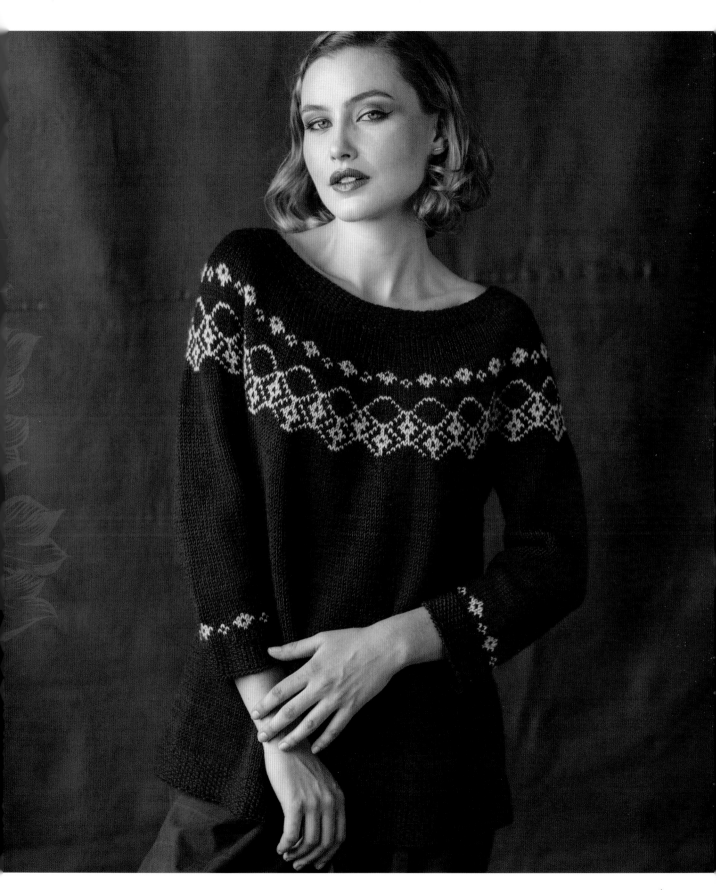

Yoke

With MC and smaller needle, CO 115 (119, 123, 123, 131) sts. Pm and join for working in the rnd, being careful not to twist. Work in Linen St (see Stitch Guide) for 1¾" (4.5 cm).

Knit 1 rnd.

Inc rnd: *K23 (17, 5, 10, 6), LLI; rep from * 4 (6, 20, 11, 18) more times, knit any rem sts—120 (126, 144, 135, 150) sts.

SHAPE NECK

Shape neck using short-rows as folls:

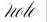 See Glossary for details on working a DS (double stitch).

Short-row 1: K45 (48, 54, 51, 57), turn.

Short-row 2: DS, purl to BOR m, p45 (48, 54, 51, 57), turn.

Short-row 3: DS, knit to 4 sts past prev DS, knitting both legs of DS together as one; turn.

Short-row 4: DS, purl to 4 sts past prev DS, purling both legs of DS together as one; turn.

DS, knit to BOR m. On next rnd, work both legs of rem DS together as one.

Work Chart 1, beginning with Rnd 5 (4, 4, 1, 1). Join CC as needed, and change to larger needle if necessary to maintain gauge in colorwork. Chart is repeated 20 (21, 24, 27, 30) times around—240 (252, 288, 324, 360) sts after completing Chart 1. Break CC, change to smaller needle and cont in MC only.

 Not all chart rnds will be worked. Skip the rnd(s) as noted for your size.

Size S Only

Inc rnd: [K12, LLI] 3 times, k3, pm, k9, LLI, k24, LLI, k16, pm, k8, LLI, [k12, LLI] twice, k13, [LLI, k12] twice, LLI, k8, pm, k16, LLI, k24, LLI, k9, pm, k3, [LLI, k12] 2 times, LLI, k11—268 sts.

Size M Only

Inc rnd: K12, LLI, k34, pm, k14, LLI, k24, LLI, k15, pm, k33, LLI, k25, LLI, k33, pm, k15, LLI, k24, LLI, k14, pm, k34, LLI, k11—296 sts.

Size L Only

Inc rnd: K53, pm, k31, LLI, k26, pm, k105, pm, k26, LLI, k31, pm, k52—326 sts.

Size XL Only

Inc rnd: K57, pm, k27, LLI, k24, LLI, k16, pm, k113, pm, k16, LLI, k24, LLI, k27, pm, k56—364 sts.

All Sizes

Work even in St st until yoke measures about 7 (7¾, 8, 8½, 9)" (18 [19.5, 20.5, 21.5, 23] cm) from CO edge at center front—240 (268, 296, 326, 364) sts: 142 (166, 186, 210, 226) sts for body; 49 (51, 55, 58, 69) sts for each sleeve.

Divide for Sleeves and Body

Next rnd: K36 (42, 47, 53, 57) back sts, transfer next 49 (51, 55, 58, 69) sleeve sts to stitch holder or waste yarn, backward-loop CO (see page 32) 7 sts, k71 (83, 93, 105, 113) front sts, transfer next 49 (51, 55, 58, 69) sleeve sts to stitch holder or waste yarn, backward-loop CO 7 sts, k35 (41, 46, 52, 56) back sts—156 (180, 200, 224, 240) sts; 78 (90, 100, 112, 120) sts for each front and back.

Work even in St st until body measures 13½" (34.5 cm) from underarm; on final rnd, inc 1 st—157 (181, 201, 225, 241) sts.

Work in Linen St for 2" (5 cm). BO all sts using the k2tog tbl method (see Glossary).

Sleeves (make 2)

Transfer sleeve sts from holder onto smaller dpn. With MC and beg at center underarm, pick up and knit 4 sts, k49 (51, 55, 58, 69) sleeve sts, pick up and knit 4 sts to center underarm—57 (59, 63, 66, 77) sts.

Knit 7 (7, 8, 7, 7) rnds.

Dec rnd: K1, ssk, knit to last 3 sts, k2tog, k1.

Work the above 8 (8, 9, 8, 8) rnds 6 (7, 5, 6, 6) more times—43 (43, 51, 52, 63) sts.

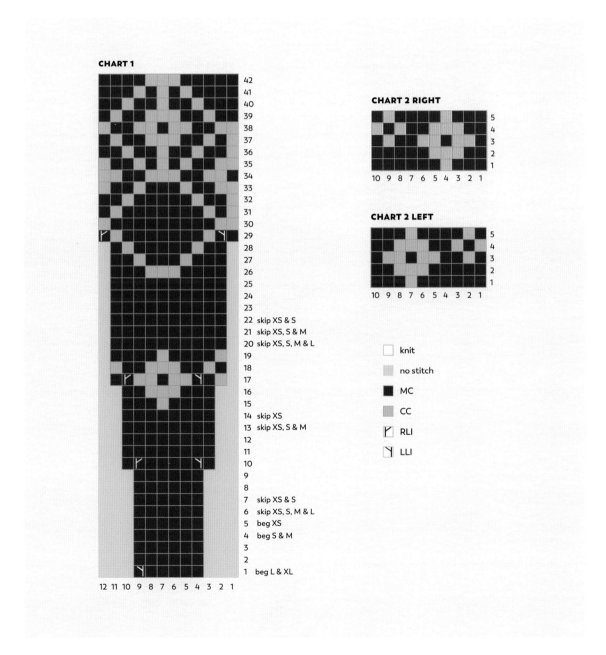

CHART 1

42
41
40
39
38
37
36
35
34
33
32
31
30
29
28
27
26
25
24
23
22 skip XS & S
21 skip XS, S & M
20 skip XS, S, M & L
19
18
17
16
15
14 skip XS
13 skip XS, S & M
12
11
10
9
8
7 skip XS & S
6 skip XS, S, M & L
5 beg XS
4 beg S & M
3
2
1 beg L & XL

12 11 10 9 8 7 6 5 4 3 2 1

CHART 2 RIGHT

5
4
3
2
1

10 9 8 7 6 5 4 3 2 1

CHART 2 LEFT

5
4
3
2
1

10 9 8 7 6 5 4 3 2 1

☐ knit

▨ no stitch

■ MC

▨ CC

⅄ RLI

⅄ LLI

Work even until sleeve measures 10½ (11, 11½, 12, 12½)" (26.5 [28, 29, 30.5, 31.5] cm) from center underarm.

Knit 1 more rnd and dec 3 (3, 1, 2, 3) sts evenly around—40 (40, 50, 50, 60) sts.

RIGHT SLEEVE

Work Chart 2 Right, repeating chart 4 (4, 5, 5, 6) times around.

Work 2 rnds even.

Knit 1 rnd, decreasing 1 st—39 (39, 49, 49, 59) sts.

Work Linen St for 1¾" (4.5 cm). Using the k2tog tbl method, BO all sts.

LEFT SLEEVE

Work Chart 2 Left, repeating chart 4 (4, 5, 5, 6) times around.

Work 2 rnds even.

Knit 1 rnd, decreasing 1 st—39 (39, 49, 49, 59) sts.

Work Linen St for 1¾" (4.5 cm). Using the k2tog tbl method, BO all sts.

Finishing

Weave in all ends and block to measurements in schematic.

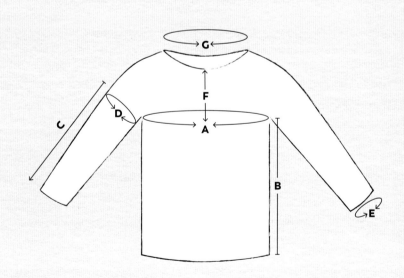

A: 31¼ (36, 40, 44¾, 48)" (79.5 [91.5, 101.5, 113.5, 122] cm)

B: 15½" (39.5 cm)

C: 13½ (14, 14½, 15, 15½)" (34.5 [35.5, 37, 38, 39.5] cm)

D: 11½ (11¾, 12½, 13¼, 15½)" (29 [30, 31.5, 33.5, 39.5] cm)

E: 8 (8, 10, 10, 12)" (20.5 [20.5, 25.5, 25.5, 30.5] cm)

F: 7 (7¾, 8, 8½, 9)" (18 [19.5, 20.5, 21.5, 23] cm)

G: 23 (23¾, 24½, 24½, 26¼)" (58.5 [60.5, 62, 62, 66.5] cm)

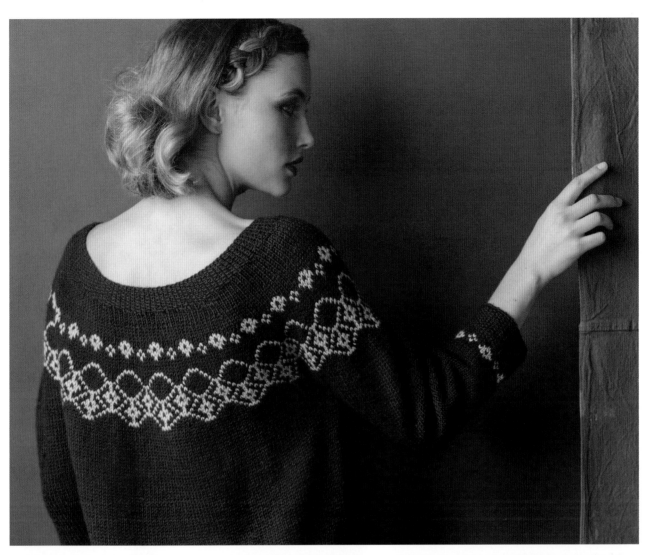

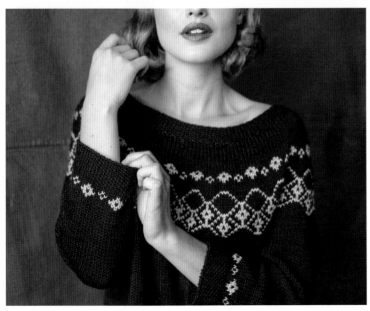

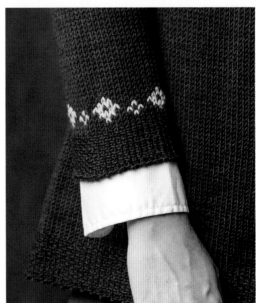

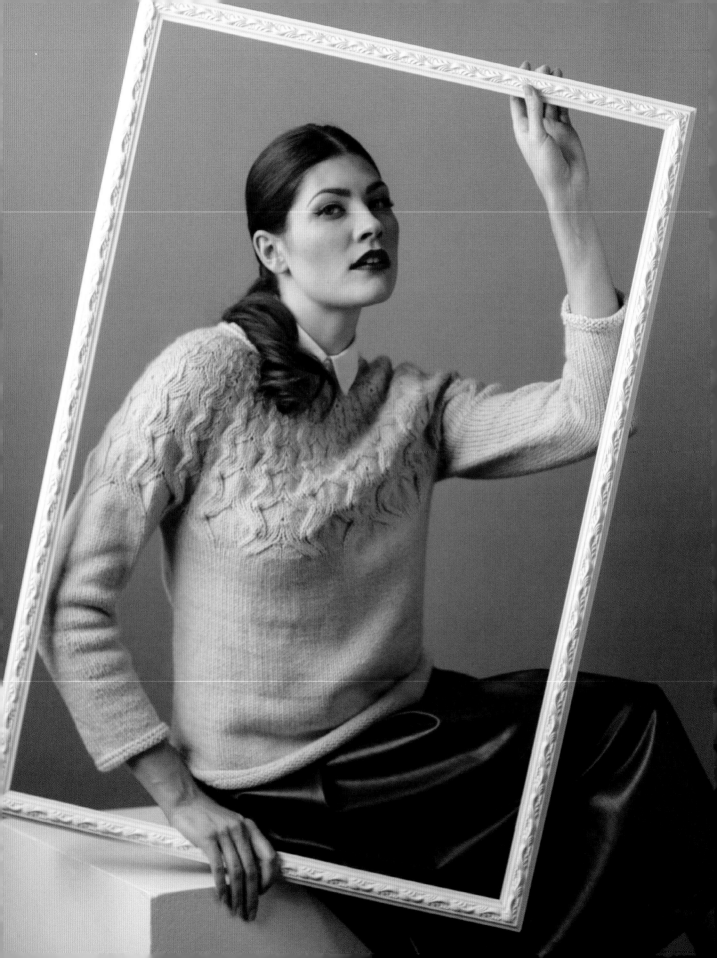

l'Heure Verte

This sweater's color recalls the silvery green foliage of the artemisia plant, used to make the storied spirit absinthe. Drinking absinthe became so popular in French cafés that by the mid-nineteenth century, happy hour there was called *l'heure verte* ("the green hour"). Deeply textured waves flow from the neckline, expanding along with the yoke until they reach the stockinette body and disappear. The transition gives a slight A-line shape to the cropped body, while short-rows shape the back neck and back for a good fit and create the rounded hems. Simple rolled edges at the neckline, hem, and cuffs are clean and practical. | **BY JENNIFER DASSAU**

FINISHED SIZE

Sizes: XS (S, M, L, XL).

Bust circumference:
about 36 (40, 44, 48, 52)"
(91.5 [101.5, 112, 122, 132] cm).

*Sweater shown measures
40" (101.5 cm), modeled with
5½" (14 cm) of positive ease.*

YARN

Worsted weight (#4 Medium).

About 850 (950, 1050, 1125,
1225) yd (777 [869, 960, 1029,
1120] m).

Shown here: Purl Soho Worsted
Twist (100% Merino wool;
164 yd [150 m]/3½ oz [100 g]):
artemisia green, 6 (6, 7, 7, 8)
skeins.

NEEDLES

Size U.S. 7 (4.5 mm):
16" (40 cm) circular (cir);
32" (80 cm) cir.

*Adjust needle size if necessary
to obtain the correct gauge.*

NOTIONS

10 (11, 12, 12, 13) stitch markers
(m); stitch holders or waste
yarn; tapestry needle.

GAUGE

18 sts and 28 rnds =
4" (10 cm) in yoke pattern.

17 sts and 24 rnds =
4" (10 cm) in St st.

NOTE

— This sweater is worked
seamlessly in one piece from
the top down.

*"The increase rate was pretty set in stone for
this design, so I had to work around that, as opposed
to calculating all the increases and rates first, then
fitting the patterning into it. I love a challenge!"*
—JENNIFER DASSAU

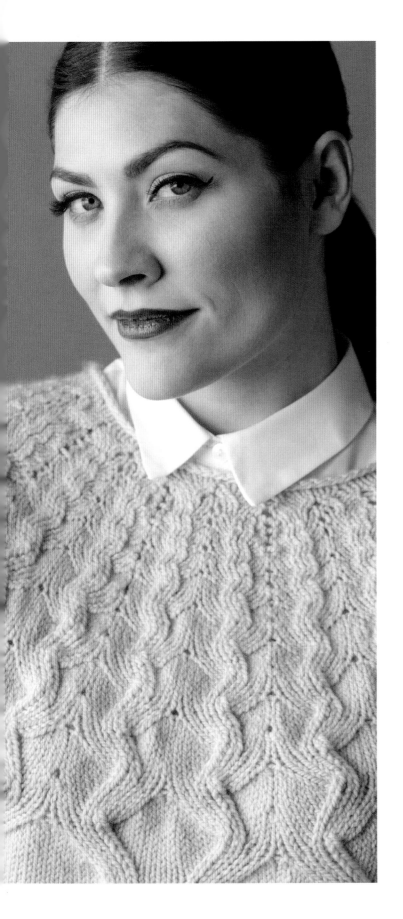

Yoke

With shorter cir needle, CO 66 (70, 74, 78, 82) sts using long-tail cast-on (see page 40). Pm for center back and join for working in the round. Knit 3 rounds for rolled neck edge.

Size XS Only
Inc rnd: [K4, M1] 4 times, [k5, M1] 10 times.

Size S Only
Inc rnd: [K4, M1] 16 times, [k3, M1] twice.

Size M Only
Inc rnd: [K3, M1] 14 times, [k4, M1] 8 times.

Size L Only
Inc rnd: [K4, M1] 12 times, [k5, M1] 6 times.

Size XL Only
Inc rnd: [K3, M1] 6 times, [k4, M1] 16 times.

14 (18, 22, 18, 22) sts inc'd; 80 (88, 96, 96, 104) sts.

SHAPE BACK NECK
Shape back neck with short-rows as folls:

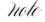 *note* | *See Glossary for details on working a DS (double stitch).*

Short-row 1: (RS) K28 (30, 33, 33, 35), turn.

Short-row 2: (WS) DS, purl to m, sl m, p28 (30, 33, 33, 35), turn.

Short-row 3: DS, knit to 10 (10, 11, 11, 11) sts before prev DS, turn.

Short-row 4: DS, purl to 10 (10, 11, 11, 11) sts before prev DS, turn.

Inc set-up rnd: DS, knit to m, [M1R, k8, M1L, pm] 10 (11, 12, 12, 13) times, working both legs of each DS together as one—20 (22, 24, 24, 26) sts inc'd; 100 (110, 120, 120, 130) sts.

SHAPE YOKE

Work Yoke Chart between m according to your size.

Size XS Only

Work Yoke Chart Rows 1–60.

Size S Only

Work Yoke Chart Rows 1–10; rep Rows 7–10 once, omitting increases at each edge of chart, then work Rows 11–60.

Size M Only

Work Yoke Chart Rows 1–16; rep Rows 11–16 once, omitting increases at each edge of chart, then work Rows 17–60.

Size L Only

Work Yoke Chart Rows 1–24; rep Rows 17–24 once, omitting increases at each edge of chart, then work Rows 25–60.

Size XL Only

Work Yoke Chart Rows 1–34; rep Rows 25–34 once, omitting increases at each edge of chart, then work Rows 35–60.

160 (176, 192, 192, 208) sts inc'd; 260 (286, 312, 312, 338) sts.

Divide for Sleeves and Body

On the following dividing round, *at the same time* evenly decrease 0 (0, 0, 10, 10) sts total—5 from front and 5 from back—removing all m.

Next rnd: K38 (43, 47, 47, 51) sts for right back, place next 54 (58, 62, 57, 62) sts on holder or waste yarn for right sleeve, CO 0 (0, 0, 4, 4) sts using backward-loop method, pm, CO 0 (0, 0, 4, 4) sts using backward-loop method, k76 (85, 94, 94, 102) sts for front, place next 54 (58, 62, 57, 62) sts on holder or waste yarn for left sleeve, CO 0 (0, 0, 4, 4) sts using backward-loop method, pm for new beg of round, CO 0 (0, 0, 4, 4) sts using backward-loop method—152 (170, 188, 204, 220) sts rem for body.

SHAPE BACK

Shape back with short-rows as folls:

Short-row 1: (RS) K71 (80, 89, 93, 101), turn.

Short-row 2: (WS) DS, p65 (74, 83, 91, 99), turn.

Short-row 3: DS, knit to 5 sts before prev DS, turn.

Short-row 4: DS, purl to 5 sts before prev DS, turn.

Knit 65 rnds, working both legs of each rem DS together as you come to it; sweater measures about 11" (28 cm) from bottom of underarm.

SHAPE BACK HEM

Shape back hem with short-rows as folls:

Short-row 1: (RS) Knit to 2 sts before m, turn.

Short-row 2: (WS) DS, purl to 2 sts before m, turn.

Short-row 3: DS, knit to 1 st before prev DS, turn.

Short-row 4: DS, purl to 1 st before prev DS, turn.

Rep Short-rows 3 and 4 six more times.

SHAPE FRONT HEM

Shape front hem with short-rows as folls:

Short-row 1: (RS) DS, knit to m, working both legs of each DS together as one; sl m, knit to 2 sts before m, turn.

Short-row 2: (WS) DS, purl to 2 sts before m, turn.

Short-row 3: DS, knit to 1 st before prev DS, turn.

Short-row 4: DS, purl to 1 st before prev DS, turn.

Rep Short-rows 3 and 4 six more times.

YOKE CHART

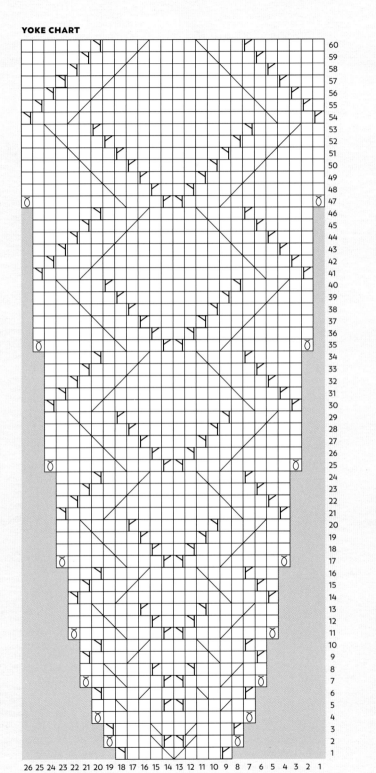

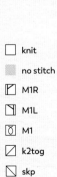	

knit

no stitch

M1R

M1L

M1

k2tog

skp

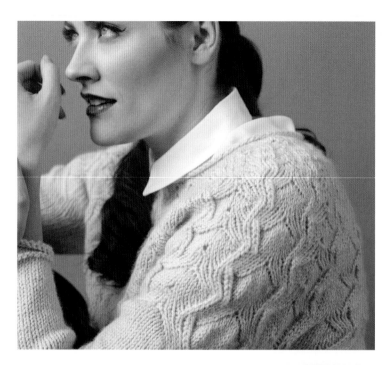

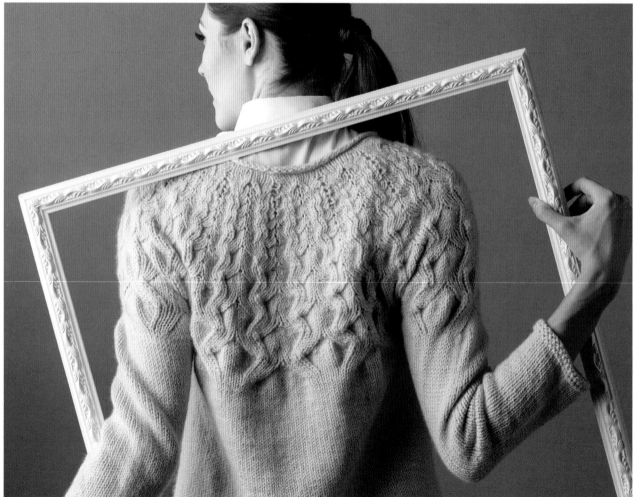

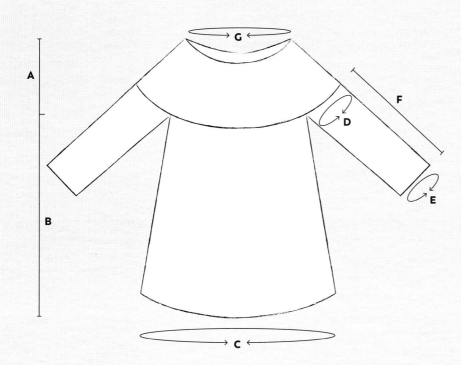

A: 9 (9¾, 9¾, 10¼, 10½)"
(23 [25, 25, 26, 26.5] cm)

B: 14¼" (36 cm)

C: 35¾ (40, 44¼, 48, 51¾)"
(90.5 [101.5, 112.5, 122,
131.5] cm)

D: 12¾ (13¾, 14½, 15¼, 16½)"
(32 [35, 37, 38.5, 42] cm)

E: 9 (9, 9, 9¼, 9½)"
(23 [23, 23, 23.5, 24] cm)

F: 14" (35.5 cm)

G: 15½ (16½, 17½, 18¼, 19¼)"
(39.5 [42, 44.5, 46.5,
49] cm)

Knit to end of rnd, working both legs of
each DS together.

Knit 1 rnd, working both legs of rem DS together.

Purl 1 rnd.

Knit 4 rnds.

BO all sts kwise.

Sleeves (make 2)

Beg in middle of CO underarm sts, pick up and knit
0 (0, 0, 4, 4) sts, k54 (58, 62, 57, 62) sts from holder,
pick up and knit 0 (0, 0, 4, 4) sts from CO sts of
underarm, pm and join for working in the round—
54 (58, 62, 65, 70) sts.

Knit 9 (7, 5, 5, 4) rnds.

Dec rnd: K1, k2tog, knit to last 3 sts, ssk, k1—2 sts dec'd.

Rep Dec rnd every 10 (8, 6, 6, 5)th rnd 6 (8, 2, 9, 8)
more times, then every 11 (9, 7, 7, 6)th rnd 1 (1, 9, 3, 6)
time(s)—38 (38, 38, 39, 40) sts.

Purl 1 rnd.

Knit 4 rnds.

BO all sts kwise.

Finishing

Weave in ends and block, taking care not to
flatten yoke texture.

Scallops

This cardigan is knit from the top down with a cabled yoke. The cables start small and get wider with each yoke increase. This shows how you can shape a yoke simply by shaping each cable or element in it. | **BY MONE DRÄGER**

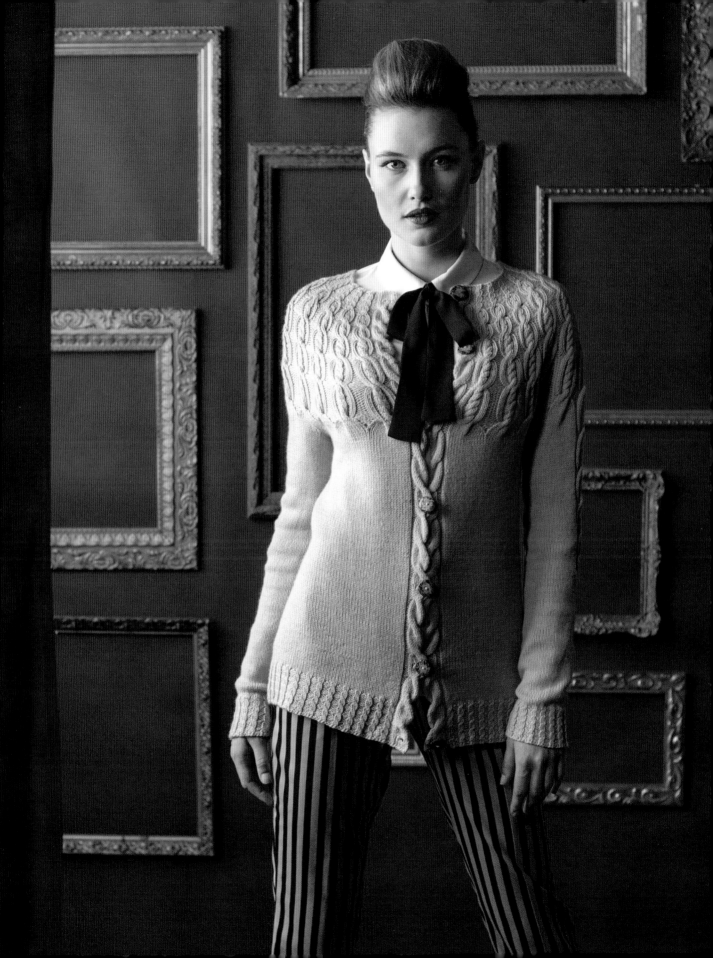

FINISHED SIZE

Sizes: XS (S, M, L, XL, 2XL).

Bust circumference: about 30 (34, 38, 42, 46, 50)" (76 [86.5, 96.5, 106.5, 117, 127] cm).

Sweater shown measures 38" (96.5 cm), modeled with 6" (15 cm) positive ease.

YARN

Sportweight (#2 Fine).

About 1090 (1364, 1579, 1798, 2026, 2317) yd (996 [1247, 1444, 1644, 1853, 2117] m).

Shown here: O-Wool O-Wash Sport (100% Merino wool; 336 yd [307 m]/3½ oz [100 g]): barn owl, 4 (5, 5, 6, 7, 7) skeins.

NEEDLES

Size U.S. 4 (3.5 mm): 32" (80 cm) or longer circular needle (cir); preferred needle for small-circumference knitting (set of double-pointed, cir for Magic Loop, etc.).

Adjust needle size if necessary to obtain the correct gauge.

NOTIONS

Stitch markers (m); cable needle (cn); stitch holders or waste yarn; 7 (7, 7, 8, 8, 8) 1" (2.5 cm) buttons.

GAUGE

22 sts and 36 rows = 4" (10 cm) in St st, blocked.

NOTES

— The cardigan is worked top down. Collar and front bands are worked with the main body. Buttonholes are worked into the right front band.

— To adjust for the negative ease of cables in the yoke, this part is worked with an increased number of stitches. These stitches are decreased before the St st section is started. There are individual instructions for each size to work this part.

STITCH GUIDE

Knitted Cast-on

Place slipknot on left needle if there are no established stitches. *With right needle, knit into first stitch (or slipknot) on left needle **(FIG. 1)**, then place new stitch onto left needle **(FIG. 2)**. Repeat from *, always knitting into last stitch made.

FIG. 1

FIG. 2

Left Front Band (right-leaning cable, over 8 sts)

Row 1: (RS) Knit.

Row 2: (WS) Purl.

Rep Rows 1 and 2 four more times.

Row 11: 4/4 RC.

Row 12: Purl.

Rep Rows 1–12 for patt.

Right Front Band (left-leaning cable, over 8 sts)

Row 1: (RS) Knit.

Row 2: (WS) Purl.

Rep Rows 1 and 2 once more.

Row 5: Knit to end; or, if buttonhole is desired, k2, work 3-st 1-row buttonhole (see Glossary), k2.

Row 6: Purl.

Rep Rows 1 and 2 two more times.

Row 11: 4/4 LC.

Row 12: Purl.

Rep Rows 1–12 for patt.

Left-Leaning Cable Cuff (multiple of 4 sts)

Rnd 1: *K2, p2; rep from * to end.

Rnd 2: Rep Rnd 1.

Rnd 3: *1/1 LC, p2; rep from * to end.

Rnd 4: Rep Rnd 1.

Rep Rnds 1–4 for patt.

Right-Leaning Cable Cuff (multiple of 4 sts)

Rnd 1: *K2, p2; rep from * to end.

Rnd 2: Rep Rnd 1.

Rnd 3: *1/1 RC, p2; rep from * to end.

Rnd 4: Rep Rnd 1.

Rep Rnds 1–4 for patt.

Cables

1/1 LC (2/2 LC, 3/3 LC, 4/4 LC, 6/6 LC, 7/7 LC): On RS: Slip 1 (2, 3, 4, 6, 7) st(s) to cable needle (cn) and place at front of work, k1 (2, 3, 4, 6, 7), then k1 (2, 3, 4, 6, 7) from cn. On WS: Slip 1 (2, 3, 4, 6, 7) st(s) to cn and place at front of work, p1 (2, 3, 4, 6, 7), then p1 (2, 3, 4, 6, 7) from cn.

1/1 RC (2/2 RC, 3/3 RC, 4/4 RC, 6/6 RC, 7/7 RC): On RS: Slip 1 (2, 3, 4, 6, 7) st(s) to cn and place at back of work, k1 (2, 3, 4, 6, 7), then k1 (2, 3, 4, 6, 7) from cn. On WS: Slip 1 (2, 3, 4, 6, 7) st(s) to cable needle (cn) and place at back of work, p1 (2, 3, 4, 6, 7), then p1 (2, 3, 4, 6, 7) from cn.

3/3 LC rib: Slip 3 sts to cn and place at front of work, k1, p1, k1, then [k1, p1, k1] from cn.

3/3 RC rib: Slip 3 sts to cn and place at back of work, k1, p1, k1, then [k1, p1, k1] from cn.

Increase Cables

All increases are made in the middle of the cable with lifted increases.

1/1 LC rib inc: Slip 1 st to cn and place at front of work, RLI, p1, then k1 from cn.

4/4 LC rib inc: Slip 4 sts to cn and place at front of work, k1, p2, k1, LLI, then [RLI, k1, p2, k1] from cn.

5/5 LC rib inc: Slip 5 sts to cn and place at front of work, k2, p2, k1, LLI, then [RLI, k1, p2, k2] from cn.

6/6 LC rib inc: Slip 6 sts to cn and place at front of work, k2, p2, k2, LLI, then [RLI, k2, p2, k2] from cn.

7/7 LC rib inc: Slip 7 sts to cn and place at front of work, k3, p2, k2, LLI, then [RLI, k2, p2, k3] from cn.

1/1 RC rib inc: Slip 1 st to cn and place at back of work, k1, then [p1, LLI] from cn.

4/4 RC rib inc: Slip 4 sts to cn and place at back of work, k1, p2, k1, LLI, then [RLI, k1, p2, k1] from cn.

5/5 RC rib inc: Slip 5 sts to cn and place at back of work, k2, p2, k1, LLI, then [RLI, k1, p2, k2] from cn.

6/6 RC rib inc: Slip 6 sts to cn and place at back of work, k2, p2, k2, LLI, then [RLI, k2, p2, k2] from cn.

7/7 RC rib inc: Slip 7 sts to cn and place at back of work, k3, p2, k2, LLI, then [RLI, k2, p2, k3] from cn.

Decrease Cables

3/3 LC rib dec: Slip 3 sts to cn and place at front of work, p2tog, k1, then [k1, p2tog] from cn.

5/5 LC rib dec: Slip 5 sts to cn and place at front of work, ssk, p2, k1, then [k1, p2, k2tog] from cn.

6/6 LC rib dec: Slip 6 sts to cn and place at front of work, ssk, p2, k2, then [k2, p2, k2tog] from cn.

7/7 LC rib dec: Slip 7 sts to cn and place at front of work, ssk, k1, p2, k2, then [k2, p2, k1, k2tog] from cn.

8/8 LC rib dec: Slip 8 sts to cn and place at front of work, ssk, k1, p2, k3, then [k3, p2, k1, k2tog] from cn.

3/3 RC rib dec: Slip 3 sts to cn and place at back of work, p2tog, k1, then [k1, p2tog] from cn.

5/5 RC rib dec: Slip 5 sts to cn and place at back of work, ssk, p2, k1, then [k1, p2, k2tog] from cn.

6/6 RC rib dec: Slip 6 sts to cn and place at back of work, ssk, p2, k2, then [k2, p2, k2tog] from cn.

7/7 RC rib dec: Slip 7 sts to cn and place at back of work, ssk, k1, p2, k2, then [k2, p2, k1, k2tog] from cn.

8/8 RC rib dec: Slip 8 sts to cn and place at back of work, ssk, k1, p2, k3, then [k3, p2, k1, k2tog] from cn.

Calculate Buttonholes

Buttonholes are worked into the cables on the right front band as you knit the sweater. Choose the spacing of the buttonholes according to the number of buttons desired; front band cable patt will be repeated (vertically) 17 (18, 19, 20, 21, 21) times total. In the sample, a buttonhole is worked in the first rep of front band cable patt, then in every 3rd rep, then in the last rep. Keep track of your chosen spacing and remember to work buttonholes as appropriate; specific buttonhole placement *is not* specified below.

Collar

Using 32" (80 cm) or longer cir needle, CO 90 (90, 106, 106, 122, 122) sts.

Set-up row: (WS) P8, pm, [k2, p2] 9 (9, 11, 11, 13, 13) times, k1, pm (center back), k1, [p2, k2] 9 (9, 11, 11, 13, 13) times, pm, p8.

Row 1: (RS) Work to first m in Left Front Band patt (see Stitch Guide), [p2, k2] 18 (18, 22, 22, 26, 26) times, p2, work to end in Right Front Band patt (see Stitch Guide).

Row 2: (WS) Work Right Front Band patt, [k2, p2] 18 (18, 22, 22, 26, 26) times, k2, work Left Front Band patt.

Row 3: Work Left Front Band patt, [p2, 1/1 RC] 9 (9, 11, 11, 13, 13) times, p2, [1/1 LC, p2] 9 (9, 11, 11, 13, 13) times, work Right Front Band patt.

Row 4: Rep Row 2.

Rep Rows 1–4 once more.

SHAPE BACK NECK

To raise the back neck, work short-rows as folls:

note | See Glossary for details on working a DS (double stitch).

Short-row 1: (RS) Work 62 (62, 74, 74, 86, 86) sts in est'd patt, turn work.

Short-row 2: (WS) DS, work 29 (29, 37, 37, 45, 45) sts in est'd patt, turn work.

Short-row 3: DS, p1, 1/1 RC, [p2, 1/1 RC] 2 (2, 3, 3, 4, 4) times, p2, [1/1 LC, p2] 3 (3, 4, 4, 5, 5) times, turn.

Short-row 4: DS, k1, [p2, k2] 7 (7, 9, 9, 11, 11) times, turn.

Next row: DS, work in est'd patt to end.

Working over all sts, rep Rows 2–4 of collar.

Yoke

Row 1: (RS) Work Left Front Band patt, p1, work Row 1 of Right-Leaning Yoke Cable Chart 9 (9, 11, 11, 13, 13) times, work Row 1 of Left-Leaning Yoke Cable Chart 9 (9, 11, 11, 13, 13) times, p1, work Right Front Band patt.

Continue in est'd pattern through Row 50 (50, 66, 66, 66, 66) of charts—306 (342, 414, 458, 486, 538) sts.

note | Increases on Rows 29 and 41 are only worked for sizes – (S, –, L, –, 2XL).

1/1 LC	knit
2/2 LC	purl
3/3 LC	no stitch
3/3 LC Rib	M1P
1/1 RC	sizes S, L, and 2XL only
2/2 RC	
3/3 RC	
3/3 RC Rib	
1/1 LC Rib inc	
4/4 LC Rib inc	
5/5 LC Rib inc	
6/6 LC Rib inc	
7/7 LC Rib inc	
1/1 RC Rib inc	
4/4 RC Rib inc	
5/5 RC Rib inc	
6/6 RC Rib inc	
7/7 RC Rib inc	

LEFT-LEANING YOKE CABLE CHART

RIGHT-LEANING YOKE CABLE CHART

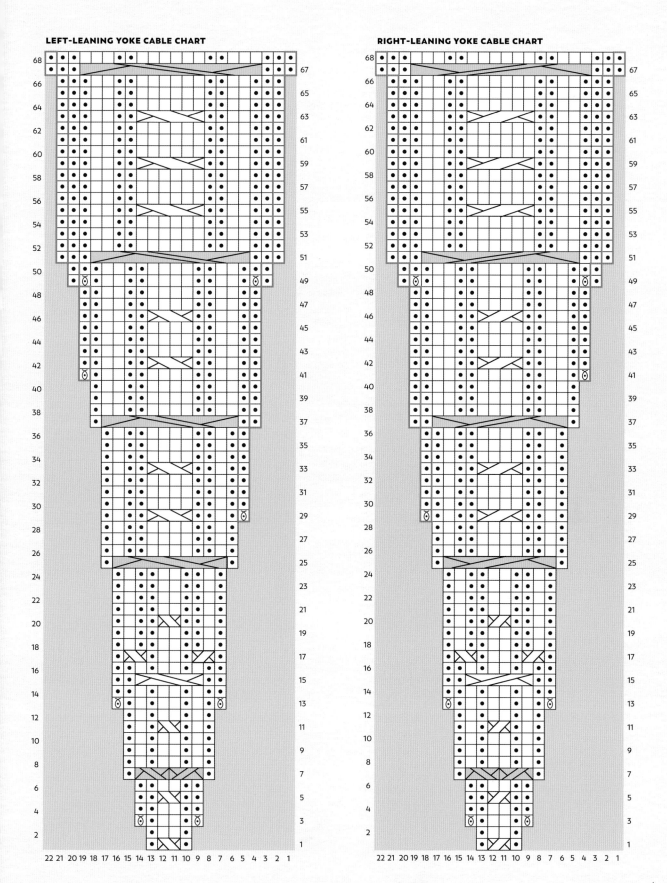

LEFT-LEANING SLEEVE CABLE CHART (RIGHT SLEEVE)

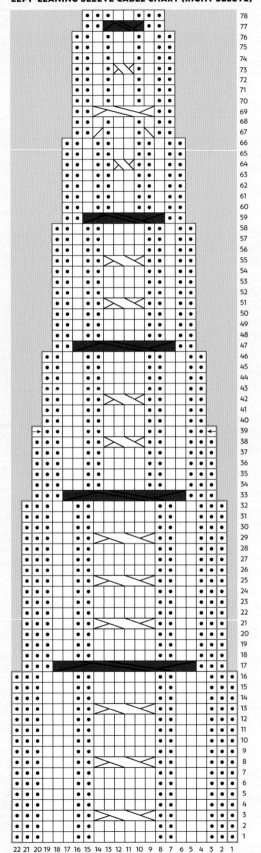

RIGHT-LEANING SLEEVE CABLE CHART (LEFT SLEEVE)

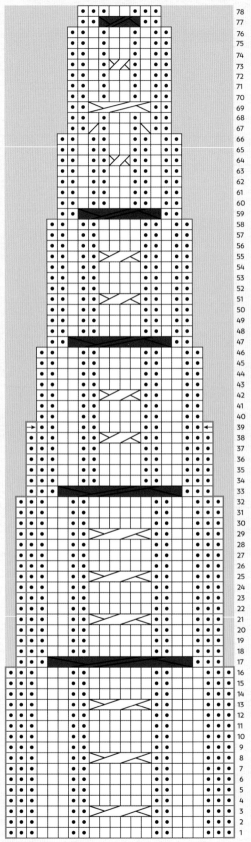

Prepare for dividing body and sleeves by working the following final yoke rows for your size, ending with a WS row. In this section, you will switch from working from the yoke charts to working from the sleeve charts; pay attention to which chart (and which row number) is called for.

Size XS Only

Row 1: (RS) Work Left Front Band patt, p1, [p2, 6/6 RC, p2] 4 times, pm, work Row 51 of Right-Leaning Yoke Cable Chart (page 113) over next 16 sts, pm, [p2, 6/6 RC, p2] 4 times, [p2, 6/6 LC, p2] 4 times, pm, work Row 51 of Left-Leaning Yoke Cable Chart over next 16 sts, pm, [p2, 6/6 LC, p2] 4 times, p1, work Right Front Band patt—310 sts.

Row 2 and all WS rows: Work sts as they appear.

Row 3: Work Left Front Band patt, p1, [p1, 1/1 RC, k10, 1/1 LC, p1] 4 times, work Row 19 of Right-Leaning Sleeve Cable Chart to m, [p1, 1/1 RC, k10, 1/1 LC, p1]

8 times, work Row 19 of Left-Leaning Sleeve Yoke Cable Chart to m, [p1, 1/1 RC, k10, 1/1 LC, p1] 4 times, p1, work Right Front Band patt.

Row 5 (dec row): Work Left Front Band patt, p2, k13, ssk, [k2tog, k12, ssk] 3 times, work to m in sleeve cable patt, [k2tog, k12, ssk] 8 times, work to m in sleeve cable patt, [k2tog, k12, ssk] 3 times, k2tog, k13, p2, work Right Front Band patt—280 sts.

Size S Only

Row 1: (RS) Work Left Front Band patt, p1, [p3, 6/6 RC, p3] 4 times, pm, work Row 51 of Right-Leaning Yoke Cable Chart (page 113) over next 18 sts, pm, [p3, 6/6 RC, p3] 4 times, [p3, 6/6 LC, p3] 4 times, pm, work Row 51 of Left-Leaning Yoke Cable Chart over next 18 sts, pm, [p3, 6/6 LC, p3] 4 times, p1, work Right Front Band patt—346 sts.

Row 2 and all WS rows: Work sts as they appear.

Row 3: Work Left Front Band patt, p1, [p2, 1/1 RC, k10, 1/1 LC, p2] 4 times, work Row 19 of Right-Leaning Sleeve Cable Chart, [p2, 1/1 RC, k10, 1/1 LC, p2] 8 times, work Row 19 of Left-Leaning Sleeve Cable Chart, [p2, 1/1 RC, k10, 1/1 LC, p2] 4 times, p1, work Right Front Band patt.

Row 5: Work Left Front Band patt, p1, [p1, 1/1 RC, k12, 1/1 LC, p1] 4 times, work to m in sleeve cable patt, [p1, 1/1 RC, k12, 1/1 LC, p1] 8 times, work to m in sleeve cable patt, [p1, 1/1 RC, k12, 1/1 LC, p1] 4 times, p1, work Right Front Band patt.

Row 7 (dec row): Work Left Front Band patt, p2, k2tog, k13, ssk, [k2tog, k14, ssk] 3 times, work to m in sleeve cable patt, *[k2tog, k14, ssk] twice, [k2tog, k6] twice, ssk; rep from * once more, [k2tog, k14, ssk] twice, work to m in sleeve cable patt, [k2tog, k14, ssk] 3 times, k2tog, k13, ssk, p2, work Right Front Band patt—312 sts.

Size M Only

Row 1: (RS) Work Left Front Band patt, p1, [p2, 7/7 RC, p2] 5 times, pm, work Row 67 of Right-Leaning Yoke Cable Chart (page 113), pm, [p2, 7/7 RC, p2] 5 times, [p2, 7/7 LC, p2] 5 times, pm, work Row 67 of Left-Leaning Yoke Cable Chart, pm, [p2, 7/7 LC, p2] 5 times, p1, work Right Front Band patt—418 sts.

⊠ 1/1 LC	☐ knit
⊠ 2/2 LC	⊡ purl
⊠ 3/3 LC	▨ no stitch
⊠ 3/3 LC Rib	▨ k2tog
⊠ 1/1 RC	◨ ssk
⊠ 2/2 RC	☐ sizes S, L, and 2XL only
⊠ 3/3 RC	→ ptog with p st to right
⊠ 3/3 RC Rib	← ptog with p st to left

8/8 LC Rib dec

7/7 LC Rib dec

6/6 LC Rib dec

5/5 LC Rib dec

3/3 LC Rib dec

8/8 RC Rib dec

7/7 RC Rib dec

6/6 RC Rib dec

5/5 RC Rib dec

3/3 RC Rib dec

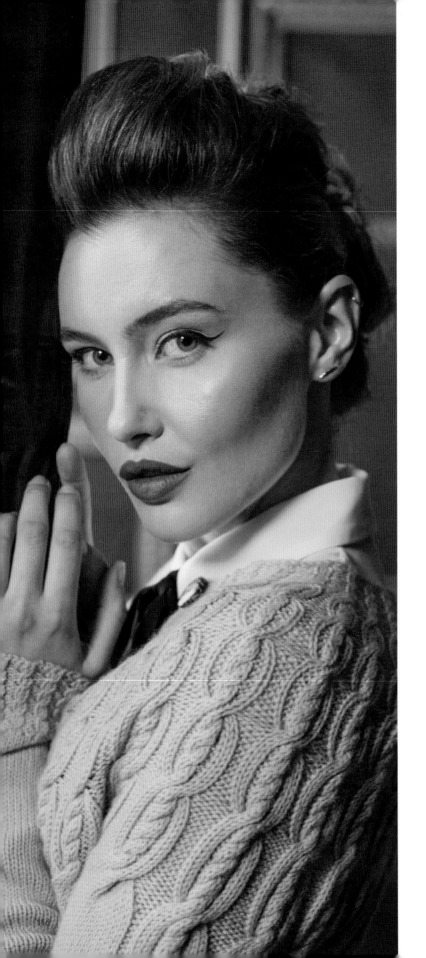

Row 2 and all WS rows: Work sts as they appear.

Row 3 (dec row): Work Left Front Band patt, p1, [p1, k2tog, k12, ssk, p1] 5 times, work Row 1 of Right-Leaning Sleeve Cable Chart (page 114) to m, [p1, k2tog, k12, ssk, p1] 10 times, work Row 1 of Left-Leaning Sleeve Cable Chart to m, [p1, k2tog, k12, ssk, p1] 5 times, p1, work Right Front Band patt—378 sts.

Row 5 (dec row): Work Left Front Band patt, p2, k13, ssk, [k2tog, k12, ssk] 4 times, work to m in sleeve cable patt, [k2tog, k12, ssk] 10 times, work to m in sleeve cable patt, [k2tog, k12, ssk] 4 times, k2tog, k13, p2, work Right Front Band patt—340 sts.

Size L Only

Row 1: (RS) Work Left Front Band patt, p1, [p3, 7/7 RC, p3] 5 times, pm, work Row 67 of Right-Leaning Yoke Cable Chart (page 113), pm, [p3, 7/7 RC, p3] 5 times, [p3, 7/7 LC, p3] 5 times, pm, work Row 67 of Left-Leaning Yoke Cable Chart, pm, [p3, 7/7 LC, p3] 5 times, p1, work Right Front Band patt—462 sts.

Row 2 and all WS rows: Work sts as they appear.

Row 3: Work Left Front Band patt, p1, [p2, 1/1 RC, k12, 1/1 LC, p2] 5 times, work Row 1 of Right-Leaning Sleeve Cable Chart (page 114), [p2, 1/1 RC, k12, 1/1 LC, p2] 10 times, work Row 1 of Left-Leaning Sleeve Cable Chart, [p2, 1/1 RC, k12, 1/1 LC, p2] 5 times, p1, work Right Front Band patt.

Row 5 (dec row): Work Left Front Band patt, p1, [p1, k2tog, k14, ssk, p1] 5 times, work to m in sleeve cable patt, [p1, k2tog, k14, ssk, p1] 10 times, work to m in sleeve cable patt, [p1, k2tog, k14, ssk, p1] 5 times, p1, work Right Front Band patt—422 sts.

Row 7 (dec row): Work Left Front Band patt, p2, k15, ssk, [k2tog, k14, ssk] 4 times, work to m in sleeve cable patt, [k2tog, k14, ssk] 10 times, work to m in sleeve cable patt, [k2tog, k14, ssk] 4 times, k2tog, k15, p2, work Right Front Band patt—384 sts.

Size XL Only

Row 1: (RS) Work Left Front Band patt, p1, [p2, 7/7 RC, p2] 6 times, pm, work Row 67 of Right-Leaning Yoke Cable Chart (page 113), pm, [p2, 7/7 RC, p2] 6 times, [p2, 7/7 LC, p2] 6 times, pm, work Row 67 of Left-Leaning Yoke Cable Chart, pm, [p2, 7/7 LC, p2] 6 times, p1, work Right Front Band patt—490 sts.

Row 2 and all WS rows: Work sts as they appear.

Row 3 (dec row): Work Left Front Band patt, p1, [p1, k2tog, k12, ssk, p2, 1/1 RC, k12, 1/1 LC, p2, k2tog, k12, ssk, p1] 2 times, work Row 1 of Right-Leaning Sleeve Cable Chart (page 114) to m, [p1, k2tog, k12, ssk, p2, 1/1 RC, k12, 1/1 LC, p2, k2tog, k12, ssk, p1] 4 times, work Row 1 of Left-Leaning Sleeve Cable Chart to m, [p1, k2tog, k12, ssk, p2, 1/1 RC, k12, 1/1 LC, p2, k2tog, k12, ssk, p1] 2 times, p1, work Right Front Band patt—458 sts.

Row 5 (dec row): Work Left Front Band patt, p2, k13, ssk, k2tog, k14, [ssk, k2tog, k5, k2tog, k5] twice, ssk, k2tog, k14, ssk, k2tog, k12, ssk, work to m in sleeve cable patt, [k2tog, k12, ssk, k2tog, k14, ssk, k2tog, k12, ssk] 4 times, work to m in sleeve cable patt, k2tog, k12, ssk, k2tog, k14, [ssk, k2tog, k5, k2tog, k5] twice, ssk, k2tog, k14, ssk, k2tog, k13, p2, work Right Front Band patt—408 sts.

Size 2XL Only

Row 1: (RS) Work Left Front Band patt, p1, [p3, 7/7 RC, p3] 6 times, pm, work Row 67 of Right-Leaning Yoke Cable Chart (page 113), pm, [p3, 7/7 RC, p3] 6 times, [p3, 7/7 LC, p3] 6 times, pm, work Row 67 of Left-Leaning Yoke Cable Chart, pm, [p3, 7/7 LC, p3] 6 times, p1, work Right Front Band patt—542 sts.

Row 2 and all WS rows: Work sts as they appear.

Row 3: Work Left Front Band patt, p1, [p2, 1/1 RC, k12, 1/1 LC, p2] 6 times, work Row 1 of Right-Leaning Sleeve Cable Chart (page 114), [p2, 1/1 RC, k12, 1/1 LC, p2] 12 times, work Row 1 of Left-Leaning Sleeve Cable Chart, [p2, 1/1 RC, k12, 1/1 LC, p2] 6 times, p1, work Right Front Band patt.

Row 5 (dec row): Work Left Front Band patt, p1, [p1, k2tog, k14, ssk, p1] 6 times, work to m in sleeve cable patt, [p1, k2tog, k14, ssk, p1] 12 times, work to m in sleeve cable patt, [p1, k2tog, k14, ssk, p1] 6 times, p1, work Right Front Band patt—494 sts.

Row 7 (dec row): Work Left Front Band patt, p2, k15, ssk, [k2tog, k14, ssk] 5 times, work to m in sleeve cable patt, [k2tog, k14, ssk] 12 times, work to m in sleeve cable patt, [k2tog, k14, ssk] 5 times, k2tog, k15, p2, work Right Front Band patt—448 sts.

All Sizes

Remove center back m.

Next row: Work Left Front Band patt, p2, *knit to m, work in sleeve patt to m; rep from * once, knit to last 10 sts, p2, work Right Front Band patt.

Next row: Work Right Front Band patt, k2, *purl to m, work in sleeve patt to m; rep from * once, purl to last 10 sts, k2, work Left Front Band patt.

Rep last 2 rows 2 (4, 2, 4, 6, 7) more times.

Divide for Sleeves and Body

Row 1: (RS) Work Left Front Band patt, p2, k34 (38, 43, 49, 53, 59), transfer next 60 (68, 72, 82, 85, 93) sts to waste yarn or stitch holder for left sleeve, use the knitted cast-on method to CO 9 (9, 11, 11, 14, 14) sts, k72 (80, 90, 102, 112, 124), transfer next 60 (68, 72, 82, 85, 93) sts to waste yarn or stitch holder for right sleeve, use the knitted cast-on method to CO 9 (9, 11, 11, 14, 14) sts, k34 (38, 43, 49, 53, 59), p2, work Right Front Band patt—178 (194, 218, 242, 266, 290) body sts.

Row 2: (WS) Work Right Front Band patt, k2, purl to last 10 sts, k2, work Left Front Band patt.

Row 3: Work Left Front Band patt, p2, knit to last 10 sts, p2, work Right Front Band patt.

Row 4: Rep Row 2.

Rep Rows 3 and 4 53 (56, 57, 60, 65, 63) more times for a total of 108 (114, 116, 122, 132, 128) rows.

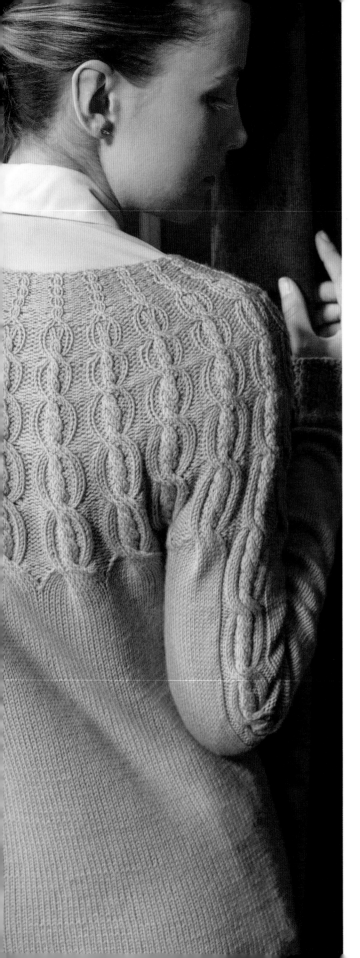

BOTTOM EDGE

Row 1: (RS) Work Left Front Band patt, [p2, k2] to last 10 sts, p2, work Right Front Band patt.

Row 2: (WS) Work Right Front Band patt, [k2, p2] to last 10 sts, k2, work Left Front Band patt.

Row 3: Work Left Front Band patt, [p2, 1/1 RC] 20 (22, 25, 28, 31, 34) times, [p2, 1/1 LC] 20 (22, 25, 28, 31, 34) times, p2, work Right Front Band patt.

Row 4: Rep Row 2.

Rep Rows 1–4 four more times. BO all sts kwise using the suspended bind-off (see Glossary).

Left Sleeve

Place 60 (68, 72, 82, 85, 93) held sts on small-circumference needle. With RS facing, join yarn in center of sts at base of armhole CO. Pick up and knit 5 (5, 6, 6, 7, 7) sts across half of armhole CO, knit to m, work Right-Leaning Sleeve Cable Chart Row 23 (25, 5, 7, 5, 7) to next m, knit to end, pick up and knit 4 (4, 5, 5, 7, 7) sts from other half of armhole CO, pm for BOR—69 (77, 83, 93, 99, 107) sts.

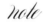 *note* | *Decreases on Row 39 are only worked for sizes – (S, –, L, –, 2XL).*

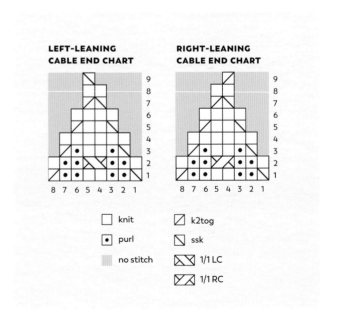

LEFT-LEANING CABLE END CHART

RIGHT-LEANING CABLE END CHART

	knit		k2tog
•	purl		ssk
	no stitch		1/1 LC
			1/1 RC

A: 7½ (7½, 9, 9, 10¼, 10¼)"
(19 [19, 23, 23, 26, 26] cm)

B: 6¾ (7½, 8½, 9¼, 9½, 10)"
(17 [19, 22, 23.5, 24, 25.5] cm)

C: 14¼ (15, 15¼, 16, 17, 16¼)"
(36 [38, 38.5, 40.5, 43, 42] cm)

D: 15 (16½, 18, 18½, 19½, 20½)"
(38 [42, 45.5, 47, 49.5, 52] cm)

E: 7¾ (8¼, 9¼, 10, 11, 11)"
(19.5 [21, 23.5, 25.5, 28, 28] cm)

F: 11 (12½, 13¾, 15, 16½, 17¾)"
(28 [31.5, 35, 38, 42, 45] cm)

G: 7¾ (8½, 9½, 10½, 11½, 12½)"
19 (21.5, 24, 26.5, 29, 31.5) cm

H: 30 (34, 38, 42, 46, 50)"
(76 [86.5, 96.5, 106.5, 117, 127] cm)
(*plus overlap of front bands*)

Next rnd: Knit to m, work in sleeve patt to next m, knit to end.

Cont as est'd until all rnds of Right-Leaning Sleeve Cable Chart have been worked—59 (65, 71, 79, 87, 93) sts.

Next rnd: Knit to 1 st before m, pm, work Right-Leaning Cable End Chart over next 10 sts, removing additional markers within this section, pm, knit to end.

Next rnd: Knit to m, work cable end patt to m, knit to end.

Cont as est'd until all rnds of Right-Leaning Cable End Chart have been worked—50 (56, 62, 70, 78, 84) sts.

*Work 12 (10, 9, 8, 7, 6) rnds in St st.

Dec rnd: K1, k2tog, knit to last 3 sts, ssk, k1—2 sts dec'd.

Rep from * 2 (4, 4, 6, 7, 10) more times—44 (46, 52, 56, 62, 62) sts.

Work 10 (10, 8, 2, 8, 6) more rnds in St st, or to desired length to cuff.

Work 20 rnds in Right-Leaning Cable Cuff pattern. BO all sts kwise using the suspended bind-off.

Right Sleeve

Works as for Left Sleeve, using Left-Leaning charts in place of Right-Leaning.

Finishing

Block to measurements and weave in ends. Sew buttons onto left front band opposite buttonholes.

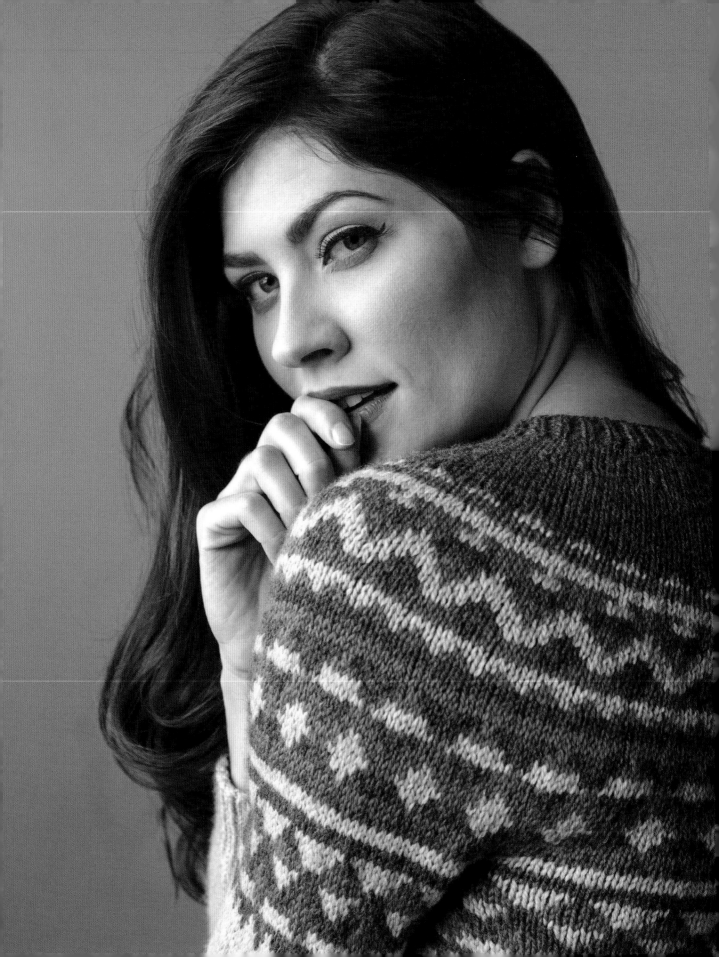

Nonpareil

The highlight of this pullover is its geometric stranded-colorwork yoke. The body and sleeves are knit in the round from the bottom up, and the stranded-colorwork pattern begins 2 inches (5 cm) before the join at the yoke. Short-rows shape the neck after the colorwork is complete. Use two neutrals and a pop of color as shown here, keep things more subtle with three neutrals, or go wild with three bold colors— the possibilities are endless! | **BY KATE GAGNON OSBORN**

FINISHED SIZE

Sizes: 2XS (XS, S, M, L, XL, 2XL).

Bust circumference: about 35 (37¾, 42¼, 46½, 49½, 53¾, 58¼)" (89 [96, 107.5, 118, 125.5, 136.5, 148] cm).

Designed to be worn with 4–6" (10–15 cm) of positive ease.

Sweater shown measures 37¾" (96 cm), modeled with 3¼" (8.5 cm) of positive ease.

YARN

DK weight (#3 Light).

MC: about 822 (822, 1096, 1096, 1370, 1370, 1644) yd (753 [753, 100⅙, 100⅙, 1255, 1255, 1506] m).

CC1: about 274 (274, 274, 548, 548, 548, 548) yd (251 [251, 251, 502, 502, 502, 502] m).

CC2: about 274 (274, 274, 548, 548, 548, 548) yd (251 [251, 251, 502, 502, 502, 502] m).

Shown here: Kelbourne Woolens Scout (100% wool; 274 yd [251 m]/3½ oz [100 g]): #058 gray heather (MC), 3 (3, 4, 4, 5, 5, 6) skeins; #034 graphite heather (CC1), 1 (1, 1, 2, 2, 2, 2) skein(s); #519 orchid heather (CC2), 1 (1, 1, 2, 2, 2, 2) skein(s).

NEEDLES

Size U.S. 4 (3.5 mm): 16" (40 cm) circular (cir); 24–40" (60–100 cm) cir; set of double-pointed (dpn).

Size U.S. 6 (4 mm): 24–40" (60–100 cm) cir; dpn.

Adjust needle size if necessary to obtain the correct gauge.

NOTIONS

4 stitch markers (m); stitch holders or waste yarn; tapestry needle.

GAUGE

22 sts and 28 rnds = 4" (10 cm) in colorwork and St st with larger needle.

NOTES

— The body and sleeves of this pullover are worked in the round from the bottom up. The sleeve cuffs and hem begin with a long-tail cast-on, followed by 1x1 ribbing.

— 2" (5 cm) before finishing the sleeves and body, a 14-round colorwork pattern is worked. The pieces are then joined to work the yoke. A few raglan decreases shape the yoke, and the colorwork pattern is worked with integrated decreases. Short-rows shape the back neck, and the collar is finished in 1x1 ribbing.

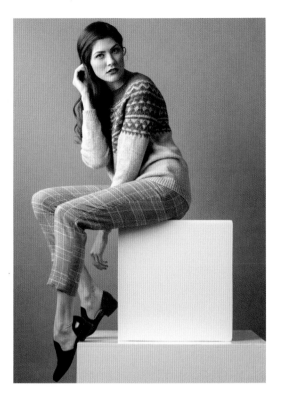

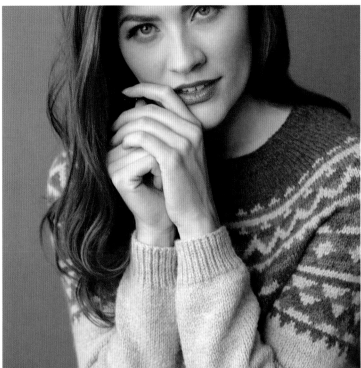

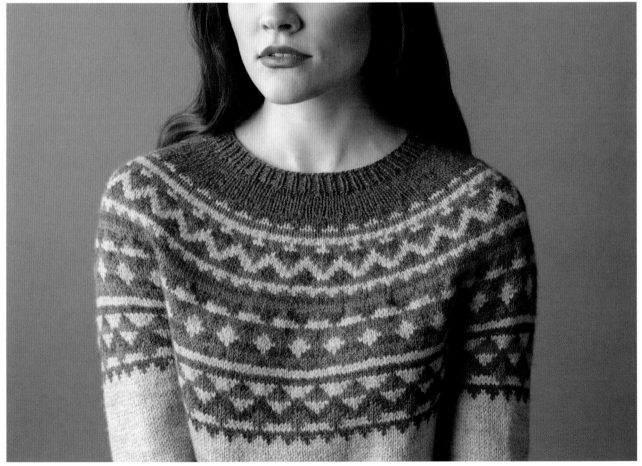

Sleeves (make 2)

Using MC and smaller dpn, CO 44 (44, 46, 52, 52, 54, 54) sts. Pm and join for working in the rnd, being careful not to twist.

Next rnd: *K1, p1; rep from * to end.

Rep this rnd until work measures 2" (5 cm).

Change to larger dpn.

Knit 1 rnd.

Inc rnd: K1, M1L, knit to last 2 sts, M1R, k2—2 sts inc'd.

Rep Inc rnd every 7 (6, 5, 6, 5, 5, 4)th rnd 11 (13, 14, 13, 15, 16, 18) more times—68 (72, 76, 80, 84, 88, 92) sts.

Work straight in St st until sleeve measures 16" (40.5 cm) from CO.

Work Rows 1–14 of Lower Sleeve Chart, beg and ending as indicated for your size.

Next rnd: Using CC1, k5 (6, 6, 8, 9, 9, 9). Break yarns.

Transfer prev 9 (11, 11, 15, 17, 17, 17) sts to stitch holder or waste yarn—59 (61, 65, 65, 67, 71, 75) sts rem.

Body

Using MC and smaller cir, CO 192 (208, 232, 256, 272, 296, 320) sts. Pm and join for working in the rnd, being careful not to twist.

Next rnd: *K1, p1; rep from * to end.

Rep this rnd until work measures 2" (5 cm). Change to larger cir.

Work in St st until body measures 14" (35.5 cm) from CO.

Work Rows 1–14 of Lower Body Chart; chart is repeated 24 (26, 29, 32, 34, 37, 40) times around.

Next rnd: Remove BOR m. Using CC1, k5 (6, 6, 8, 9, 9, 9), replace BOR m.

Join Sleeves and Body

With CC1, k87 (93, 105, 113, 119, 131, 143) back sts, transfer next 9 (11, 11, 15, 17, 17, 17) body sts to holder for underarm, pm, k59 (61, 65, 65, 67, 71, 75) sleeve sts, pm, k87 (93, 105, 113, 119, 131, 143) front sts, transfer next 9 (11, 11, 15, 17, 17, 17) body sts to holder for underarm, pm, k59 (61, 65, 65, 67, 71, 75) sleeve sts—292 (308, 340, 356, 372, 404, 436) sts. Join for working in the rnd. BOR is now located at back right underarm.

RAGLAN DECREASES

Next rnd: Using CC1, *k1, k2tog, knit to 3 sts before m, ssk, k1, sl m; rep from * 3 more times—284 (300, 332, 348, 364, 396, 428) sts.

Next rnd: Using CC1, knit all sts.

Next rnd: Using MC, *k1, k2tog, knit to 3 sts before m, ssk, k1, remove m; rep from * 3 more times, leaving BOR m in place—276 (292, 324, 340, 356, 388, 420) sts.

Yoke

Rnd 1: Working from Rnd 1 of Yoke Chart 1, *work 67 [71, 79, 83, 87, 95, 103] sts in patt, k2tog in patt (working the decrease with the charted color); rep from * to end—272 (288, 320, 336, 352, 384, 416) sts.

Work Rnds 2–16 of Yoke Chart 1.

Next rnd: Using CC1, *k6 (4, 3, 4, 3, 4, 4), k2tog, k7 (4, 3, 4, 4, 4, 5), k2tog; rep from * to end—240 (240, 256, 280, 288, 320, 352) sts.

Work Rnds 1–17 of Yoke Chart 2.

Next rnd: Using CC2, *k1, k2tog; rep from * to last 0 (0, 4, 4, 0, 8, 4) sts, knit to end—160 (160, 172, 188, 192, 216, 236) sts.

Work Rnds 1–4 of Yoke Chart 3.

Switch to CC1 and use for remainder of yoke.

Work 0 (0, 2, 2, 4, 5, 8) rnds in St st.

SHAPE NECKLINE

Shape neckline using short-rows as folls:

note | *See Glossary for details on working w&t (wrap & turn) short-rows.*

Short-row 1: (RS) K42 (42, 45, 48, 49, 53, 57), w&t.

Short-row 2: (WS) P35, w&t.

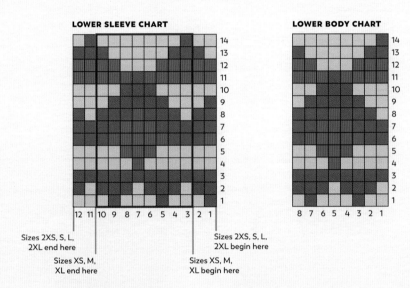

LOWER SLEEVE CHART

Sizes 2XS, S, L, 2XL end here

Sizes XS, M, XL end here

Sizes 2XS, S, L, 2XL begin here

Sizes XS, M, XL begin here

LOWER BODY CHART

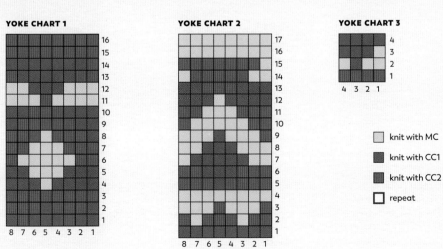

YOKE CHART 1

YOKE CHART 2

YOKE CHART 3

knit with MC

knit with CC1

knit with CC2

repeat

Short-row 3: Knit to wrapped st, knit wrap tog with wrapped st, k7 (7, 8, 9, 9, 11, 12), w&t.

Short-row 4: Purl to wrapped st, purl wrap tog with wrapped st, p7 (7, 8, 9, 9, 11, 12), w&t.

Rep Short-rows 3 and 4 four more times—6 sts wrapped and worked at each side of back.

Next row: Knit to BOR.

Next rnd: Knit to end, knitting wraps tog with wrapped sts.

Next rnd: *K2, k2tog; rep from * to end—120 (120, 129, 141, 144, 162, 177) sts.

Work 7 rnds in St st.

Next rnd: *K4 (4, 3, 2, 2, 1, 1), k2tog; rep from * to last 0 (0, 4, 1, 0, 0, 0) st(s), knit to end—100 (100, 104, 106, 108, 108, 118) sts.

Work 0 (0, 0, 0, 4, 5, 6) rnds in St st.

Neckband

Change to smaller cir.

Next rnd: *K1, p1; rep from * to end.

Rep this rnd until ribbing measures 1" (2.5 cm). BO all sts in patt.

Finishing

Weave in ends. Join live sts at underarms using Kitchener stitch (see Glossary). Soak in cool water and wool wash, wrap in a towel and press out as much water as possible, then block to measurements.

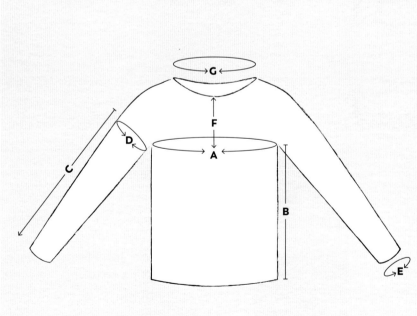

A: 35 (37¾, 42¼, 46½, 49½, 53¾, 58¼)" (89 [96, 107.5, 118, 125.5, 136.5, 148] cm)

B: 16" (40.5 cm)

C: 18" (45.5 cm)

D: 12¼ (13, 13¾, 14½, 15¼, 16, 16¾)" (89 [96, 107.5, 118, 125.5, 136.5, 148] cm)

E: 8 (8, 8¼, 9½, 9½, 9¾, 9¾)" (20.5 [20.5, 21, 24, 24, 25, 25] cm)

F: 7½ (7½, 7¾, 7¾, 8½, 8¾, 9½)" (19 [19, 19.5, 19.5, 21.5, 22, 24] cm)

G: 18¼ (18¼, 19, 19¼, 19¾, 19¾, 21½)" (46.5 [46.5, 48.5, 49, 50, 50, 54.5] cm)

Back neck is 2" (5 cm) higher than front neck.

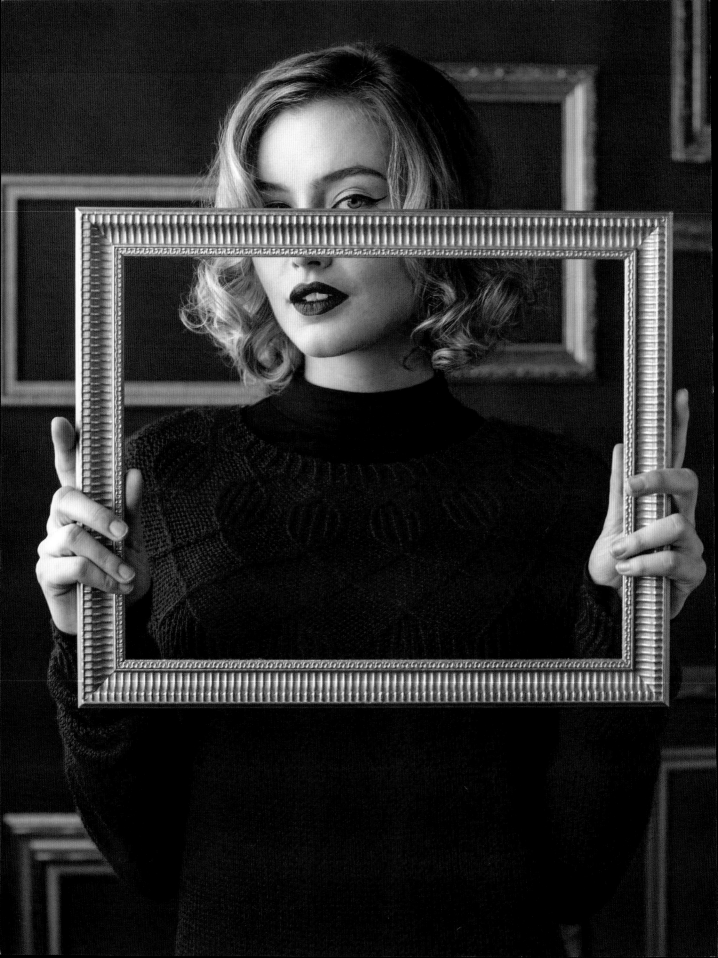

Dover

The Dover Pullover features a mesmerizing yoke of traveling, twisted Bavarian stitches. Worked from the bottom up in one piece, the pullover's sleeves are joined to the body, and the yoke is worked— with or without a cable needle, as desired—up to the collar. | **BY MARGARET HOLZMANN**

FINISHED SIZE

Sizes: XS (S, M, L, XL).

Bust circumference: about 34½ (38¾, 43, 47¼, 51¼)" (87.5 [98.5, 109, 120, 130] cm).

Sweater shown measures 38¾" (98.5 cm), modeled with 6¾" (17 cm) of positive ease.

YARN

DK weight (#3 Light).

About 957 (1074, 1210, 1337, 1490) yd (875 [982, 1106, 1223, 1362] m).

Shown here: Berroco Ultra Wool DK (100% superwash wool; 292 yd [267 m]/3½ oz [100 g]): #83145 sour cherry, 4 (4, 5, 5, 6) skeins.

NEEDLES

Size U.S. 5 (3.75 mm): 24" (60 cm) circular (cir); set of double-pointed (dpn).

Size U.S. 6 (4 mm): 24" (60 cm) cir; dpn.

Adjust needle size if necessary to obtain the correct gauge.

NOTIONS

Waste yarn; stitch markers (m); cable needle (cn) (optional); tapestry needle.

GAUGE

19 sts and 26 rnds = 4" (10 cm) in St st with larger needle.

NOTE

— The body of this pullover is worked in the round from the lower edge to the underarm. Sleeves are worked from cuff to underarm. Sleeves and body are joined at underarm and the circular yoke is worked in the round to the neck.

STITCH GUIDE

Tubular Cast-on for 1x1 Twisted Ribbing

Using waste yarn and smaller circular needle, CO number of sts specified (*Note: This is half the number of your finished tubular cast-on*). Cut waste yarn. Turn. Using project yarn, *k1, bring yarn to the front to form a yo; rep from * to end. Pm and join for working in the round, being careful not to twist and to keep the last yo worked on the needle.

Rnd 1: *Sl 1 wyb, p1; rep from * to end.

Rnd 2: *K1 tbl, sl 1 wyf; rep from * to end.

Rep Rnds 1 and 2 once more. Ravel and remove waste yarn.

Working Bavarian Twists Without a Cable Needle

Left twists (1/1 LC and 1/1 LPC): Sl 2 sts to right needle, insert left needle into the front of the first (rightmost) slipped st from left to right, drop both sts from right needle. Pinch the sts with thumb and forefinger of the left hand and retrieve the loose stitch with the right needle from behind the held stitch (so that the cable crosses to the left). Sl the retrieved st to left needle. For 1/1 LC, k2 tbl; for 1/1 LPC, p1, k1 tbl.

Right twists (1/1 RC and 1/1 RPC): Insert right needle into second st on left needle; drop both the first and second sts from left needle. Pinch the sts with thumb and forefinger of the left hand and retrieve the loose stitch with the left needle from behind the held st (so that the cable crosses to the right). Sl 1 st from right to left needle. For 1/1 RC, k2 tbl; for 1/1 RPC, k1 tbl, p1.

1/1 LC: Sl 1 to cn and hold to front, k1, k1 from cn.

1/1 LPC: Sl 1 to cn and hold to front, p1, k1 from cn.

1/1 RC: Sl 1 to cn and hold to back, k1, k1 from cn.

1/1 RPC: Sl 1 to cn and hold to back, k1, p1 from cn.

2/1 RPC dec: Sl 1 to cn and hold to back, k2tog, p1 from cn.

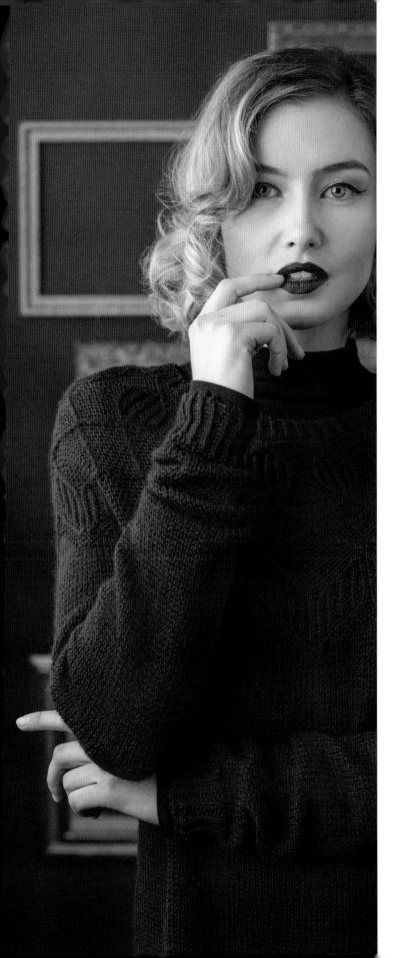

Body

With smaller circular needle, CO 83 (88, 99, 110, 121) sts using the tubular cast-on for 1x1 twisted ribbing (see Stitch Guide)—166 (176, 198, 220, 242) sts.

Rib rnd: *K1 tbl, p1; rep from * to end.

Rep this rnd until work measures 2" (5 cm) from CO.

Change to larger needle.

Size XS Only
Inc row: K2, *k11, M1, k12, M1; rep from * to last 3 sts, k3—180 sts.

Sizes – (S, M, L, XL) Only
Inc row: K6, *M1, k11; rep from * to last 5 sts, M1, k5—
– (192, 216, 240, 264) sts.

All Sizes
Next rnd: K90 (96, 108, 120, 132), pm to mark center of underarm, knit to end.

Work even in St st until piece measures 5 (6, 5, 5, 4)" (12.5 [15, 12.5, 12.5, 10] cm).

Dec rnd: *K1, ssk, knit to 3 sts before m, k2tog, k1, sl m; rep from * once—176 (188, 212, 236, 260) sts.

Work Dec rnd every 12 (20, 14, 12, 10)th rnd 3 (1, 2, 3, 4) more times—164 (184, 204, 224, 244) sts.

Work even until piece measures 16¼ (16½, 16¾, 17, 17¼)" (41.5 [42, 42.5, 43, 44] cm), ending 4 (5, 5, 6, 7) sts before end of last rnd.

SHAPE UNDERARMS
Inc rnd: *BO next 8 (10, 10, 12, 14) sts for left underarm, k2 (2, 1, 1, 0), [k10 (11, 30, 14, 36), M1] 6 (6, 2, 6, 2) times, k12 (14, 31, 15, 36) for front; rep from * for right underarm and back—80 (88, 94, 106, 110) sts remain each for front and back. Place sts on holders and set aside.

Sleeves (make 2)

With smaller circular needle, CO 17 (18, 19, 20, 21) sts using the tubular cast-on for 1x1 twisted ribbing—34 (36, 38, 40, 42) sts.

Rib rnd: *K1 tbl, p1; rep from * to end.

Rep this rnd until work measures 2" (5 cm) from CO.

Change to larger needle.

Next rnd: K0 (0, 1, 0, 1), [k11 (12, 7, 8, 8), M1] 2 (2, 4, 4, 4) times, k12 (12, 9, 8, 9)—36 (38, 42, 44, 46) sts.

Knit 8 (8, 7, 6, 5) rnds even.

Inc rnd: K2, M1L, knit to last 2 sts, M1R, k2—38 (40, 44, 46, 48) sts.

Rep Inc rnd every 8 (8, 7, 6, 5)th rnd 9 (10, 11, 13, 17) more times—56 (60, 66, 72, 82) sts.

Work even until sleeve measures 17 (17, 17½, 17½, 18)" (43 [43, 44,5, 44.5, 45.5] cm), ending 4 (5, 5, 6, 7) sts before end of last rnd.

SHAPE UNDERARMS
Inc rnd: BO 8 (10, 10, 12, 14) sts, k4 (5, 56, 7, 7), [k13 (13, 0, 9, 18), M1] 2 (2, 0, 4, 2) times, k18 (19, 0, 17, 25)—50 (52, 56, 64, 70) sts.

Join Sleeves and Body

Next rnd: K50 (52, 56, 64, 70) sleeve sts, k80 (88, 94, 106, 110) front sts, k50 (52, 56, 64, 70) sleeve sts, k40 (44, 47, 53, 55) back sts, ending in center of back—260 (280, 300, 340, 360) sts. Pm for BOR at center back.

YOKE CHART

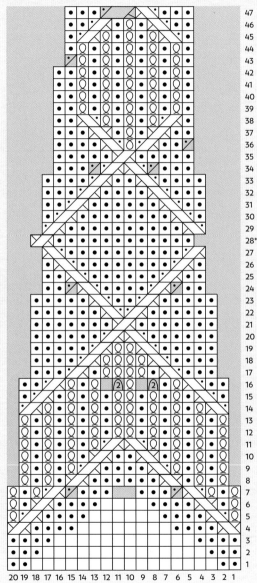

* **Rnd 28:** See note in pattern instructions.
Decreases are highlighted yellow for extra visibility.

Yoke

Work Rnds 1–47 of Yoke Chart, repeating chart 13 (14, 15, 17, 18) times around. *Tip: Pm after every patt rep (every 20 sts); remove m after patt is established.*

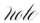 *note* | *For Rnd 28 of Yoke Chart and Rnds 52 (52 and 59) of size L (XL) Extension Charts, sl the first st of the rnd and perform the 1/1 RC at the end of the rnd, using the last st of the rnd and the first st of the next rnd. Replace BOR m in the center of the cable just worked.*

At the beginning of Rnd 52 of size S (M) Extension Charts, work the first k2tog using the last stitch of the previous round and the first stitch of this round.

Work the Extension Chart for your size—91 (98, 105, 102, 108) sts.

Size XS Only
Rnd 49: P2tog, p1, k1 tbl, p3, *p3, k1 tbl, p3; rep from * to end—90 sts.

Size M Only
Rnd 57: *K1 tbl, p2, p2tog, p2, [k1 tbl, p6] twice; rep from * to end—100 sts.

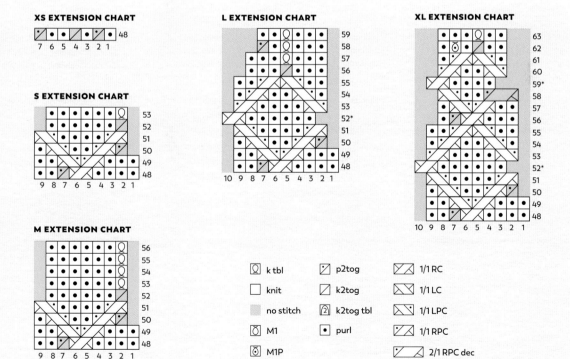

SHAPE BACK NECK

Starting at center back, maintaining patt as set (knit the twisted sts tbl and purl the purl sts), work short-rows as folls:

note | *See Glossary for details on working w&t (wrap & turn) short-rows.*

Short-row 1: (RS) Work 8 (9, 10, 11, 12) sts, w&t.

Short-row 2: (WS) Work 15 (17, 19, 21, 23) sts, w&t.

Short-row 3: (RS) Work 22 (24, 26, 28, 30) sts, working wrapped st tog with its wrap; w&t.

Short-row 4: (WS) Work 29 (31, 33, 35, 37) sts, working wrapped st tog with its wrap; w&t.

Work patt as set to center back (BOR m).

Neckband

Change to smaller needle.

Size L Only

Remove BOR m, p1, replace BOR m.

All Sizes

Rib rnd: *K1 tbl, p1; rep from * to end, working rem wrapped sts tog with their wraps.

Rep this rnd 5 more times.

BO using the sewn tubular bind-off (see Glossary).

Finishing

Seam underarms closed. Weave in ends and block to measurements.

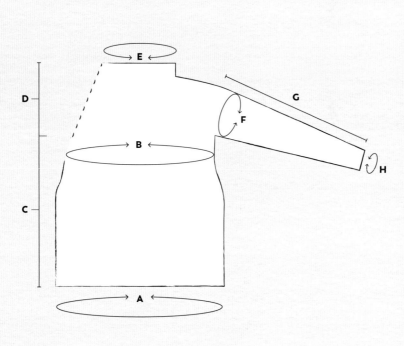

A: 38 (40½, 45½, 50½, 55½)"
(96.5 [103, 115.5, 128.5, 141] cm)

B: 34½ (38¾, 43, 47¼, 51¼)"
(87.5 [98.5, 109, 120, 130] cm)

C: 16¼ (16½, 16¾, 17, 17¼)"
(41.5 [42, 42.5, 43, 44] cm)

D: 7½ (8¼, 8½, 9, 9¾)"
(19 [21, 21.5, 23, 25] cm)

E: 19¼ (20¾, 21, 21½, 22¾)"
(49 [52.5, 53.5, 54.5, 58] cm)

F: 11¾ (12¾, 14, 15¼, 17¼)"
(30 [32, 35.5, 38.5, 44] cm)

G: 17 (17, 17½, 17½, 18)"
(43 [43, 44.5, 44.5, 45.5] cm)

H: 7½ (8, 8¾, 9¼, 9¾)"
(19 [20.5, 22, 23.5, 25] cm)

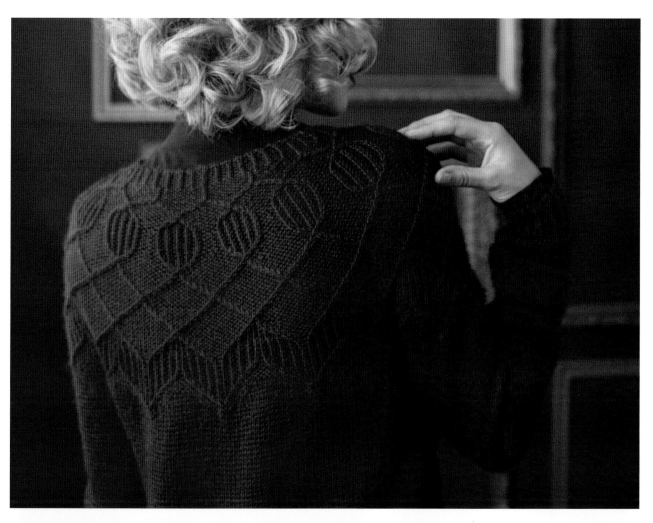

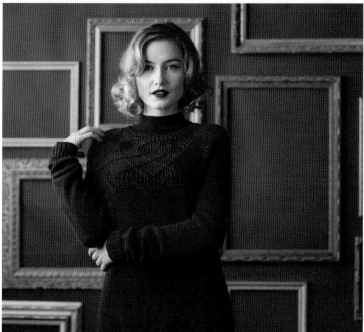

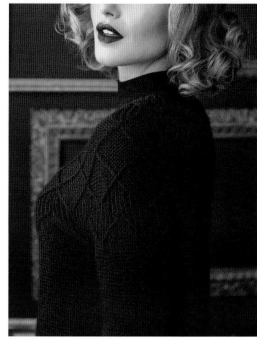

Sigrídur

Sigríður is a circular yoke sweater with a boxy shape;
the body has lots of positive ease while the sleeves are
more fitted. A delicate detail around the cuffs echoes
the colorwork patterning in the yoke. The back neck
and lower back are shaped with short-rows so the
piece will fit comfortably. | **BY PAULA PEREIRA**

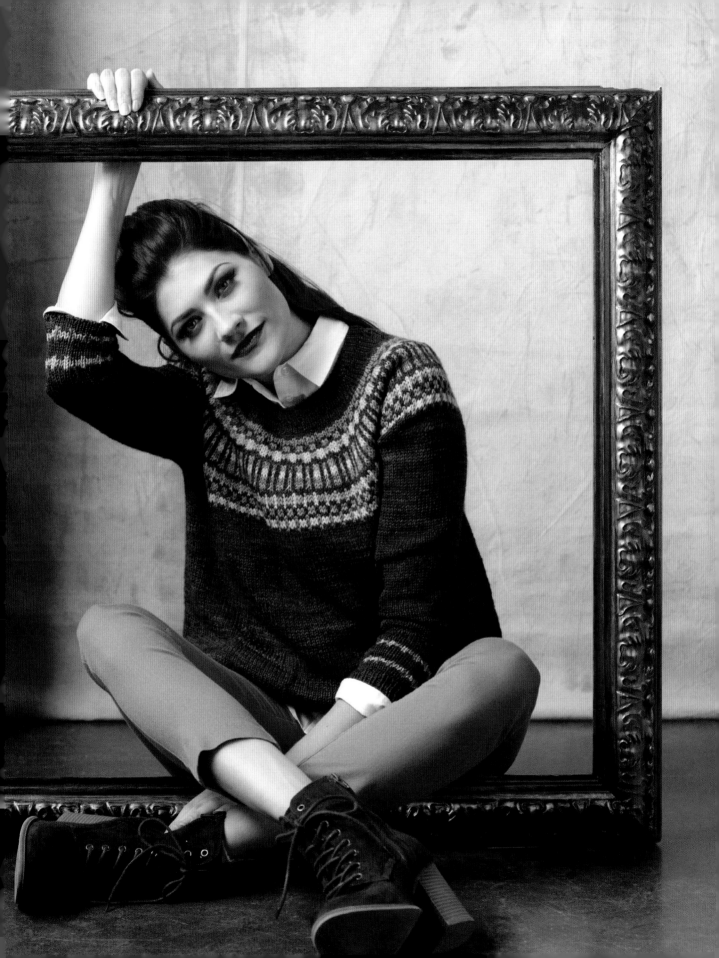

FINISHED SIZE

Sizes: XS (S, M, L, XL, 2XL).

Bust circumference: about
38½ (42½, 46½, 50, 54, 58)"
(98 [108, 118, 127, 137, 147.5] cm).

Designed to be worn with
6" (15 cm) of positive ease.

*Sweater shown measures
42½" (108 cm), modeled with
8" (20.5 cm) of positive ease.*

YARN

DK weight (#3 Light).

MC: about 792 (886, 1026,
1134, 1288, 1418) yd (724 [810,
938, 1037, 1178, 1297] m).

CC1: about 23 (25, 29, 32,
37, 40) yd (21 [23, 27, 29,
34,37] m).

CC2: about 62 (69, 80, 89,
101, 111) yd (57 [63, 73, 81,
92, 101] m).

CC3: about 50 (55, 64, 71, 80, 88)
yd (46 [50, 59, 65, 73, 80] m).

CC4: about 29 (32, 38, 41,
47, 52) yd (27 [29, 35, 37,
43, 48] m).

Shown here: The Uncommon
Thread Polwarth DK (100%
superwash Polwarth; 246 yd
[225 m]/3½ oz [100 g]): naval
officer (MC), 4 (4, 5, 5, 6, 6)
skeins; leaden (CC1), cumulo-
nimbus (CC2), breath (CC3),
golden praline (CC4), 1 skein
each for all sizes.

NEEDLES

Size U.S. 5 (3.75 mm):
16" (40 cm) circular (cir); set
of double-pointed (dpn).

Size U.S. 6 (4 mm):
16" (40 cm) cir; 24" (60 cm) cir;
32" (80 cm) cir; dpn.

Size U.S. 7 (4.5 mm): 24" (60 cm)
cir; 32" (80 cm) cir; dpn.

*Adjust needle size if necessary
to obtain the correct gauge.*

NOTIONS

Stitch markers (m); stitch
holders or waste yarn;
tapestry needle.

GAUGE

20 sts and 28 rows =
4" (10 cm) in St st with middle-
sized needle.

20 sts and 22 rows = 4" (10 cm)
in colorwork with larger needle.

NOTES

— This pullover is worked in
the round from the top down.
Sleeves are also worked in the
round from the top down.

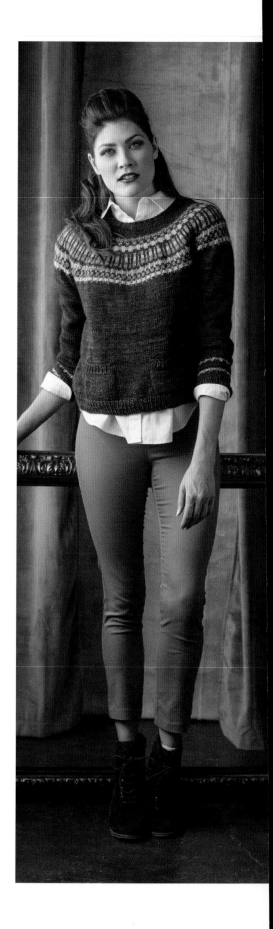

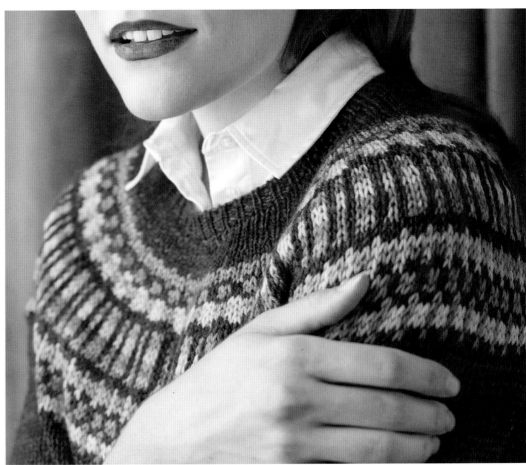
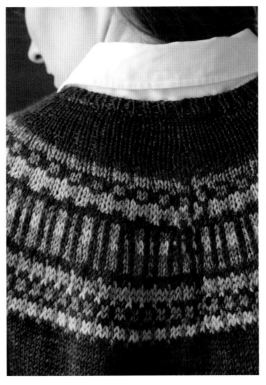
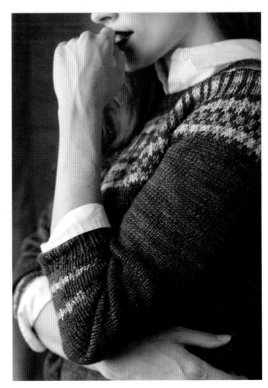

Neckline

With MC, smaller 16" (40 cm) cir needle, and using the long-tail tubular cast-on (see Glossary), CO 90 (90, 96, 98, 108, 110) sts. Pm and join for working in the rnd, being careful not to twist.

Next rnd: *K1, p1; rep from * to end.

Rep this rnd 4 more times.

Change to middle-sized needle.

Next rnd: Knit to end.

SHAPE BACK NECK

note | *See Glossary for details on working w&t (wrap & turn) short-rows. When you encounter a wrapped st, work wrap together with wrapped st.*

Short-row 1: (RS) K6, w&t.

Short-row 2: (WS) Purl to m, sl m, p6, w&t.

Short-row 3: Knit to m, sl m, k10, w&t.

Short-row 4: Purl to m, sl m, p10, w&t.

Short-row 5: Knit to m, sl m, k18, w&t.

Short-row 6: Purl to m, sl m, p18, w&t.

Short-row 7: Knit to m, sl m, k30, w&t.

Short-row 8: Purl to m, sl m, p30, w&t.

Short-row 9: Knit to m, sl m, k42, w&t.

Short-row 10: Purl to m, sl m, p42, w&t.

Short-row 11: Knit to m.

Next rnd: Knit to end.

Sizes – (S, M, L, XL, 2XL) Only
Inc rnd: *K– (15, 12, 7, 9, 5), M1; rep from * to end—
– (96, 104, 112, 120, 132) sts.

Next rnd: Knit to end.

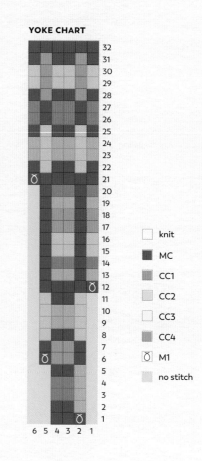

YOKE CHART

| | knit |
| MC |
| CC1 |
| CC2 |
| CC3 |
| CC4 |
| M1 |
| no stitch |

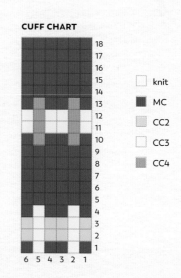

CUFF CHART

| | knit |
| MC |
| CC2 |
| CC3 |
| CC4 |

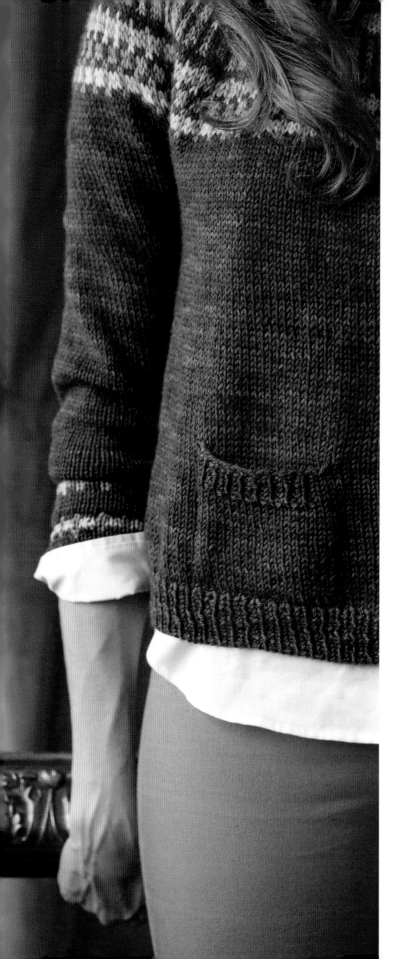

Inc rnd: *K– (–, –, 56, 60, 66) sts, M1; rep from * to end— – (–, –, 114, 122, 134) sts.

All Sizes

Work 3 rnds even in St st.

Yoke

Change to larger needle.

Work 32 rnds of Yoke Chart; chart is repeated 45 (48, 52, 57, 61, 67) times around. 270 (288, 312, 342, 366, 402) sts after chart is finished. Change to middle-sized needle. With MC, work 5 (6, 10, 13, 15, 19) rnds even in St st.

Body

Next rnd: K42 (46, 50, 54, 58, 63) back sts, transfer 51 (52, 56, 62, 66, 74) sleeve sts to stitch holder or waste yarn; using the cable CO (see Glossary), CO 12 (14, 16, 16, 18, 18) sts for underarm, k84 (92, 100, 109, 117, 127) front sts, transfer 51 (52, 56, 62, 66, 74) sleeve sts to stitch holder or waste yarn; using the cable CO, CO 12 (14, 16, 16, 18, 18) sts for underarm, k42 (46, 50, 55, 59, 64) back sts—192 (212, 232, 250, 270, 290) body sts.

Work even in St st for 48 (48, 52, 50, 56, 56) rnds.

FRONT POCKETS

Set-up rnd: K70 (80, 90, 94, 104, 114), place next 17 (17, 17, 21, 21, 21) pocket lining sts on a holder, pm; using the cable CO, CO 17 (17, 17, 21, 21, 21) pocket sts, pm, k18 (18, 18, 20, 20, 20) front sts, place next 17 (17, 17, 21, 21, 21) pocket lining sts on a holder, pm; using the cable CO, CO 17 (17, 17, 21, 21, 21) pocket sts, pm, knit to end.

Next rnd: *Knit to m, sl m, k1, [p1, k1] to m, sl m; rep from * once more, knit to end.

Rep last rnd 4 more times.

Work even in St st for 19 (19, 19, 21, 21, 21) rnds.

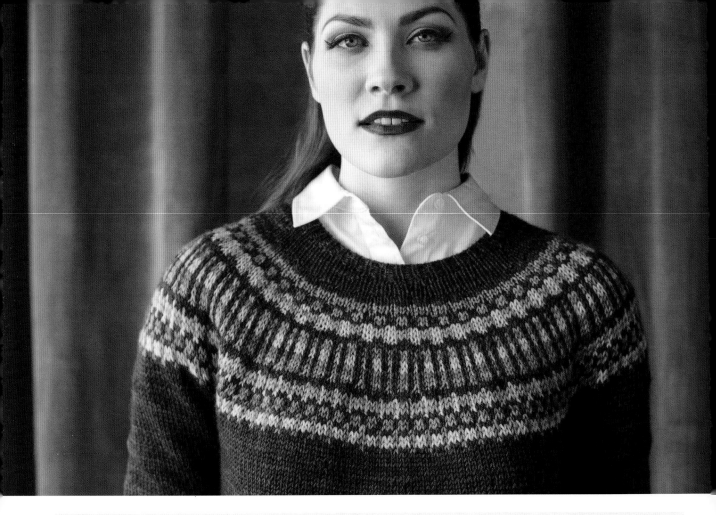

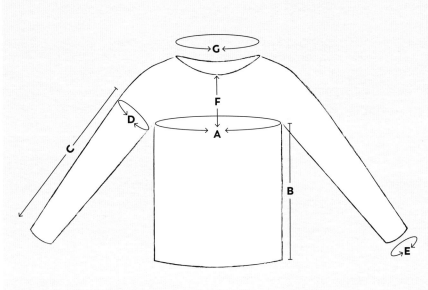

A: 38½ (42½, 46½, 50, 54, 58)"
(98 [108, 118, 127, 137, 147.5] cm)

B: 12½ (12½, 13, 13, 13¾, 13¾)"
(31.5 [31.5, 33, 33, 35, 35] cm)

C: 17 (17, 17¾, 17¾, 18, 18¼)"
(43 [43, 45, 45, 45.5, 46.5] cm)

D: 12½ (13¼, 14½, 15½, 16¾, 18½)"
(31.5 [33.5, 37, 39.5, 42.5, 47] cm)

E: 8½ (8½, 9½, 9½, 10¾, 12)"
(21.5 [21.5, 24, 24, 27.5, 30.5] cm)

F: 7¼ (7¾, 8¼, 8¾, 9, 9¾)"
(18.5 [19.5, 21, 22, 23, 25] cm)

G: 18 (18, 19¼, 19½, 21½, 22)"
(45.5 [45.5, 49, 49.5, 54.5, 56] cm)

Pocket Lining

Transfer 17 (17, 17, 21, 21, 21) pocket lining sts to middle-sized dpn. With new strand of MC and RS facing, pick up and knit 1 st on the edge of the front pocket, k17 (17, 17, 21, 21, 21), pick up and knit 1 st on the other edge of the front pocket—19 (19, 19, 23, 23, 23) sts.

Work 23 (23, 23, 25, 25, 25) rows in St st, ending with a WS row. Set sts aside and rep for second pocket lining.

Join Front Pocket and Lining

Resume working with main body yarn (attached at center back). Make sure pocket linings are lying to the inside of the sweater. Remove markers (except BOR m) as you come to them.

Next rnd: *Knit to 1 st before m, hold lining sts on dpn behind left (body) needle, [k2tog (1 st from front needle and 1 st from dpn)] 19 (19, 19, 23, 23, 23) times; rep from * once more, knit to end.

Next rnd: Knit to end.

HEM

Change to smaller needle.

Next rnd: *K1, p1; rep from * to end.

Rep this rnd 11 more times.

Using the sewn tubular bind-off (see Glossary), BO all sts.

Sleeves (make 2)

Return 51 (52, 56, 62, 66, 74) sleeve sts to middle-sized dpn.

With MC, RS facing, and beg at center of underarm, pick up and knit 5 (7, 8, 8, 9, 9) sts along underarm, k51 (52, 56, 62, 66, 74) sleeve sts, pick up and knit 6 (7, 8, 8, 9, 9) sts—62 (66, 72, 78, 84, 92) sts total. Pm and join for working in the rnd.

Work 10 (16, 11, 18, 5, 16) rnds in St st.

Dec rnd: K1, k2tog, knit to 3 sts before m, ssk, k1—2 sts dec'd.

Rep Dec rnd every 8 (6, 7, 5, 6, 5)th rnd 9 (11, 11, 14, 14, 15) more times—42 (42, 48, 48, 54, 60) sts.

CUFF

Change to larger needle and work 18 rnds of Cuff Chart, joining CC as necessary. Chart is repeated 7 (7, 8, 8, 9, 10) times around.

Change to smaller needle.

Next rnd: *K1, p1; rep from * to end.

Rep this rnd 11 more times.

Using the sewn tubular bind-off, BO all sts.

Finishing

Seam sides of pockets closed. Weave in ends. Wet- or steam-block to given measurements.

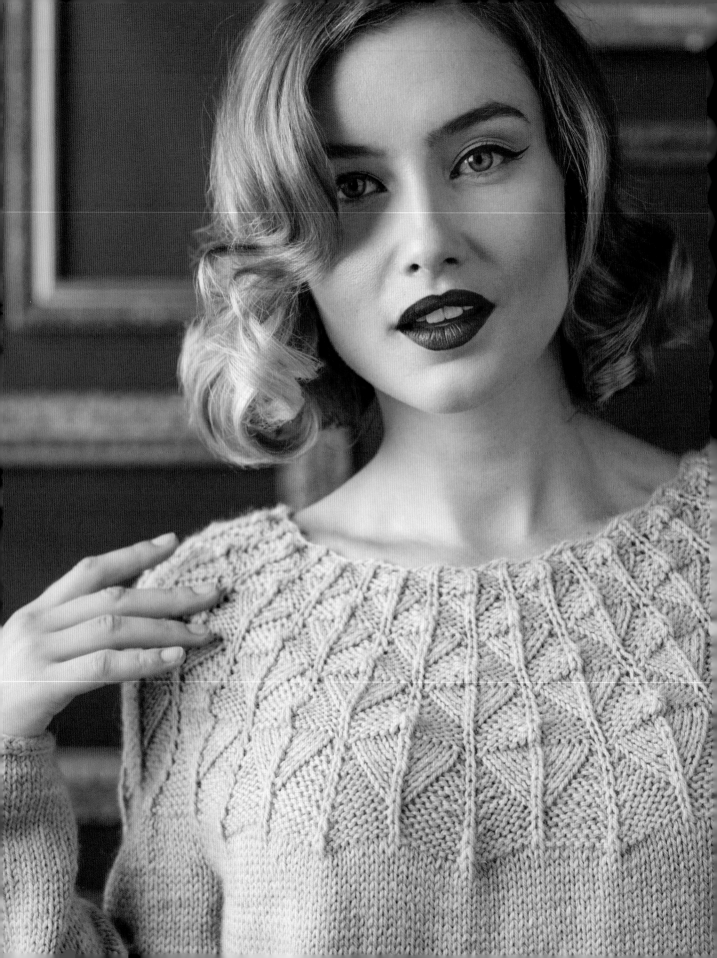

Modern Art

The contrast between the strongly tridimensional geometric pattern and the plain stockinette of the body, together with the fully reversible design, makes this striking pullover interesting to knit and unique to wear. The simple combination of increases and decreases produces a progressively growing diamond-shaped design that graces the yoke, while short-rows and gentle waist shaping allow a feminine but comfortable fit. | **BY STELLA EGIDI**

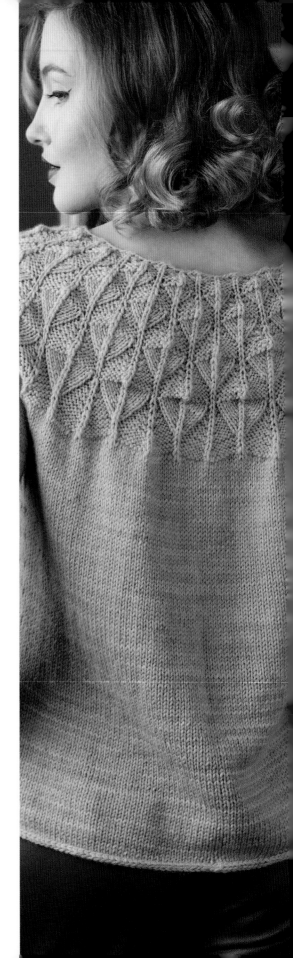

FINISHED SIZE
Bust circumference: about 31 (35, 39, 43¼, 47¼)" (79 [89, 99, 110, 120] cm).

Sweater shown measures 39" (99 cm), modeled with 7" (18 cm) of positive ease.

YARN
DK weight (#3 Light).

About 1100 (1150, 1250, 1425, 1600) yd (1000 [1050, 1150, 1300, 1450] m).

Shown here: SnailYarn Baby Alpaca + Merino DK (50% baby alpaca, 50% Merino wool; 246 yd [225 m]/3½ oz [100 g]): parchment, 5 (5, 6, 6, 7) skeins.

NEEDLES
Size U.S. 6 (4 mm): 16" (40 cm) circular (cir); 32" (80 cm) cir; preferred needle for working small circumferences (set of double-pointed, cir for Magic Loop, etc.).

Size U.S. 5 (3.75 mm): 16" (40 cm) cir.

Adjust needle size if necessary to obtain the correct gauge.

NOTIONS
Stitch markers (m); stitch holders or waste yarn; tapestry needle.

GAUGE
21½ sts and 29½ rnds = 4" (10 cm) in St st with larger needle.

NOTES
— The Modern Art sweater is worked from the top down in the round. After casting on, a tridimensional diamond design is worked all over the yoke through a simple combination of knit and purl stitches together with increases and decreases.

— Before dividing body and sleeves, short-rows are worked to make the back fit better. Body and sleeves are worked in St st down to the bottom edge, then finished with an I-cord bind-off. Gentle waist shaping is obtained thanks to side increases and decreases.

— The sweater can also be worn inside out. The yoke will then have a leaf-shaped motif, as shown in the photo on page 147.

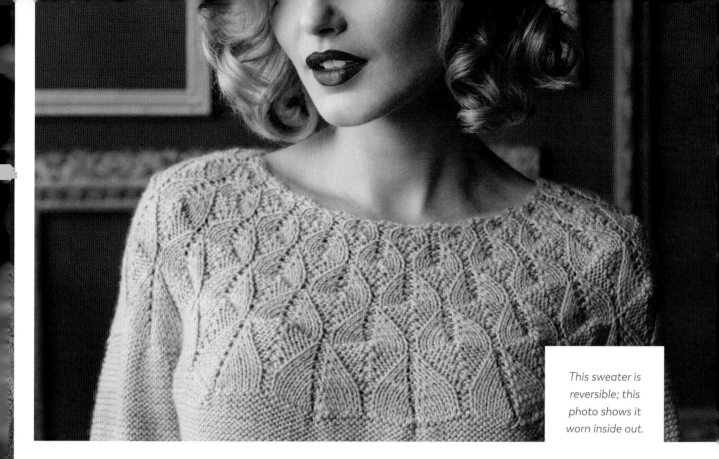

This sweater is reversible; this photo shows it worn inside out.

Yoke

With smaller 16" (40 cm) needle, using long-tail cast-on method (see page 40), CO 102 (108, 114, 120, 132) sts. Pm and join for working in the round, being careful not to twist.

Knit 1 rnd.

Change to larger needle.

Work all rnds of Yoke Chart (page 148); chart will be repeated 17 (18, 19, 20, 22) times around—272 (288, 304, 320, 352) sts after chart is completed.

Knit 1 rnd.

BACK SHAPING

Shape back with short-rows as folls:

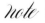 *note* | *See Glossary for details on working a DS (double stitch).*

Short-row 1: (RS) K22 (24, 25, 26, 29), turn.

Short-row 2: (WS) DS, purl to m, p22 (24, 25, 26, 29), turn.

Short-row 3: (RS) DS, knit to prev DS, knit both legs of DS together as one, k22 (24, 25, 26, 29), turn.

Short-row 4: (WS) DS, purl to prev DS, purl both legs of DS together as one, p22 (24, 25, 26, 29), turn.

Rep Short-rows 3 and 4 three more times.

Next Row: (RS) DS, knit to m.

Knit 2 (2, 2, 4, 6) rnds, working any rem DS together as one st.

Divide for Sleeves and Body

Rnd 1: K39 (43, 47, 51, 57), transfer next 59 (58, 59, 58, 63) sts to stitch holder or waste yarn; with backward-loop method (see page 32), CO 3 (4, 6, 7, 7) sts, pm, CO 3 (4, 6, 7, 7) sts, k77 (86, 93, 102, 113), transfer next 59 (58, 59, 58, 63) sts to waste yarn; with backward-loop method, CO 3 (4, 6, 7, 7) sts, pm, CO 3 (4, 6, 7, 7) sts, knit to m (BOR)—166 (188, 210, 232, 254) body sts.

Knit 9 rnds.

WAIST SHAPING

Dec rnd: *Knit to 3 sts before side m, ssk, k1, sl m, k1, k2tog; rep from * once more, knit to end—162 (184, 206, 228, 250) sts; 4 sts dec'd.

Rep Dec rnd every 6 rnds 5 more times—142 (164, 186, 208, 230) sts.

Knit 11 rnds.

HIP SHAPING

Inc rnd: *Knit to 1 st before side m, M1R, k1, sl m, k1, M1L; rep from * once more, knit to end—146 (168, 190, 212, 234) sts; 4 sts inc'd.

Rep Inc rnd every 6 rnds 5 more times— 166 (188, 210, 232, 254) sts.

Knit even until body measures 13½" (34.5 cm) from underarm, or until desired length.

BO all sts using I-cord bind-off (see Glossary).

Sleeves (make 2)

With larger small-circumference needle and RS facing, pick up and knit 6 (8, 12, 14, 14) sts along underarm cast-on span, k59 (58, 59, 58, 63) held sleeve sts, k3 (4, 6, 7, 7), pm for BOR—65 (66, 71, 72, 77) sts.

Knit 10 rnds.

Dec rnd: K1, k2tog, knit to 3 sts before m, ssk, k1— 63 (64, 69, 70, 75) sts; 2 sts dec'd.

Rep Dec rnd every 8 rnds 10 (10, 10, 9, 8) more times—43 (44, 49, 52, 59) sts.

Knit even until sleeve measures 13½" (34.5 cm) from underarm.

BO all sts using I-cord bind-off.

Finishing

Block to finished measurements.

Weave in ends.

YOKE CHART

Legend:
- □ knit
- ▪ purl
- (gray) no stitch
- ⋀ cdd
- M1P right leaning
- M1P left leaning

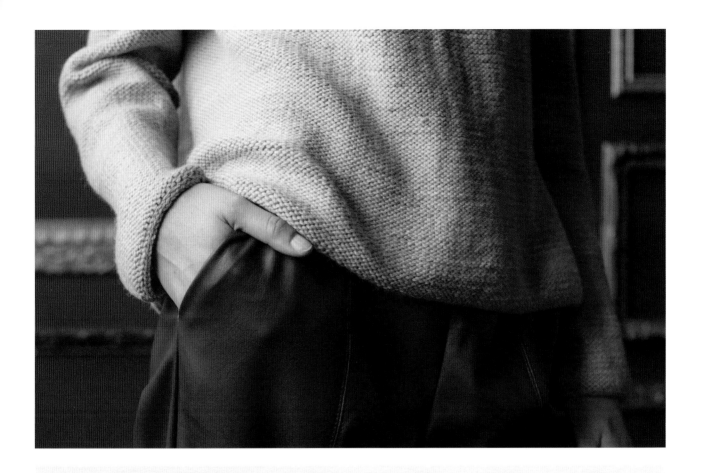

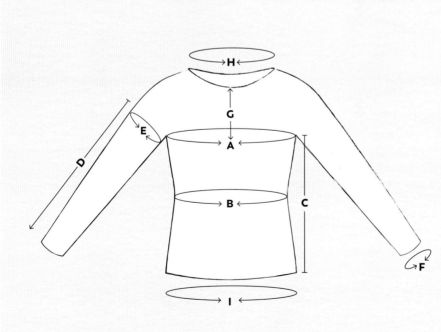

A: 31 (35, 39, 43¼, 47¼)"
(79 [89, 99, 110, 120] cm)

B: 26½ (30½, 34½, 38¾, 42¾)"
(67.5 [77.5, 87.5, 98.5, 108.5] cm)

C: 13½" (34.5 cm)

D: 13½" (34.5 cm)

E: 12 (12¼, 13¼, 13½, 14¼)"
(30.5 [31, 33.5, 34.5, 36] cm)

F: 8 (8¼, 9, 9¾, 11)"
(20.5 [21, 23, 25, 28] cm)

G: 7 (7, 7, 7¼, 7½)"
(18 [18, 18, 18.5, 19] cm)

H: 19 (20, 21¼, 22¼, 24½)"
(48.5 [51, 54, 56.5, 62] cm)

I: Same as A

ABBREVIATIONS

beg(s) begin(s); beginning

BO bind off

BOR beginning of round/row

CC contrast color

cdd centered double decrease (slip 2 stitches together knitwise, knit 1, pass slipped stitches over [decrease])

cir circular

cm centimeter(s)

cn cable needle

CO cast on

cont continue(s); continuing

dec(s)('d) decrease(s); decreasing; decreased

dpn double-pointed needles

est'd established

foll(s) follow(s); following

g gram(s)

inc(s)('d) increase(s); increasing; increased

k knit

kf&b knit into the front and back of the same stitch (increase)

k2tog knit 2 stitches together (decrease)

k3tog knit 3 stitches together (decrease)

kwise knitwise; as if to knit

LLI left-leaning lifted increase

m marker(s)

MC main color

mm millimeter(s)

M1 make one (increase)

M1L make one with left slant (increase)

M1P make one purlwise (increase)

M1R make one with right slant (increase)

oz ounce

p purl

p1f&b purl into the front and back of the same stitch (increase)

p2tog purl 2 stitches together (decrease)

patt(s) pattern(s)

pm place marker

prev previous

psso pass slipped stitch over

pwise purlwise; as if to purl

rem remain(s); remaining

rep(s) repeat(s)

RLI right-leaning lifted increase

rm remove marker

rnd(s) round(s)

RS right side

skp slip 1 stitch knitwise, knit 1, pass slipped stitch over (decrease)

sk2p slip 1 stitch knitwise, knit 2 stitches together, pass slipped stitch over (decrease)

sl slip (purlwise with yarn in back, unless instructed otherwise)

ssk slip 2 stitches knitwise, then knit slipped stitches together through back loops (decrease)

ssp slip 2 stitches knitwise, then return slipped stitches to left needle and purl 2 together through back loops (decrease)

sssk slip 3 stitches knitwise, then knit slipped stitches together through back loops (decrease)

st(s) stitch(es)

St st stockinette stitch

tbl through back loop

tog together

w&t wrap and turn

WS wrong side

wyb with yarn in back

wyf with yarn in front

yd yard(s)

yo yarnover

***** repeat starting point

() alternate measurements and/or instructions

[] work instructions as a group a specified number of times

Glossary

For any terms or techniques not referenced here that you aren't familiar with, please see the online glossary at **Interweave.com.**

Cast-ons

CABLE CAST-ON

If there are no established stitches, begin with a slipknot; knit 1 stitch in slipknot and slip this new stitch to left needle. Otherwise, simply start working using the existing stitches.

*Insert right needle between first 2 stitches on left needle. Wrap yarn as if to knit. Draw yarn through to complete stitch and slip this new stitch to left needle. Rep from *.

LONG-TAIL TUBULAR CAST-ON

Leaving a tail as for long-tail cast-on, drape the yarn over the right needle (counts as the first knit stitch). Insert your left thumb and index finger between two strands, with tail end on thumb side. To create the next purl stitch **(FIG. 1)**, take needle away from you, under both strands, up to grab front strand, and pull it under back strand to make loop on needle. To create the next knit stitch **(FIGS. 2 AND 3)**, bring needle toward you, under front strand, up between strands, over back strand to grab it, and pull it under front strand to make loop on needle. Continue alternating knit and purl stitches, ending with a purl stitch. Keep strands crossed to preserve the last cast-on stitch.

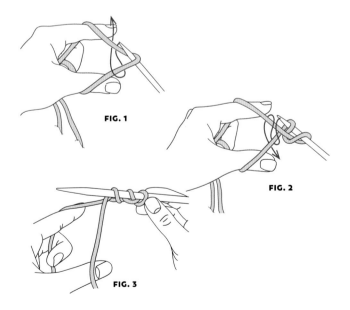

FIG. 1

FIG. 2

FIG. 3

Bind-offs

THREE-NEEDLE BIND-OFF

Place the stitches to be joined onto two separate needles and hold the needles parallel so that the right sides (or wrong sides, if specified in pattern) of knitting face together. Insert a third needle into the first stitch on each of two needles **(FIG. 1)** and knit them together as one stitch **(FIG. 2)**, *knit the next stitch on each needle the same way, then use the left needle tip to lift the first stitch over the second and off the needle **(FIG. 3)**. Repeat from * until no stitches remain on the first two needles. Cut yarn and pull tail through last stitch to secure.

FIG. 1

FIG. 2

FIG. 3

I-CORD BIND-OFF

CO 3 sts with knitted CO method, then *k2, k2tog through back loops, sl 3 sts back pwise to left-hand needle; repeat from * until last 3 sts. If bind-off forms a circle (if you end in the same place you began), graft the last 3 sts to I-cord CO edge.

FIG. 1

FIG. 2

FIG. 3

FIG. 4

K2TOG TBL BIND-OFF

Set-up: K2, slip both sts back to left needle and k2tog tbl.

*K1, slip sts back to left needle, k2tog tbl; rep from * until all sts have been bound off. Cut yarn and pull tail through last stitch to secure.

SUSPENDED BIND-OFF

K2, *insert the left needle tip into the first stitch **(FIG. 1)** and lift the first stitch over the second, leaving the first stitch on the left needle **(FIG. 2)**. Knit the next stitch on the left needle **(FIG. 3)**, then slip both stitches off the left needle—2 stitches remain on the right needle. Repeat from * until no stitches remain on the left needle, then pass the first stitch on the right needle over the second stitch. Fasten off the last stitch. Each bound-off stitch is slightly more elongated than with a standard bind-off **(FIG. 4)**.

TUBULAR BIND-OFF

Work so only one row remains until you achieve the desired finished length.

Set-up row/rnd 1: Work across the row or round, knitting the knit stitches and slipping the purled stitches purlwise with the yarn in front.

For the next row, if you're working flat, repeat set-up row 1. But if you're working in the round, instead work across the round, purling the purl stitches and slipping the knit stitches purlwise with the yarn in back.

Row/round 3: Slip each stitch purlwise, slipping the knit stitches onto the working needle (held to the front) and the purl stitches onto a spare needle (held to the back).

Now half (or about half, if you have an odd number of stitches) of the stitches are on each of two parallel needles. Cut the yarn, leaving a tail about three times the length of the edge. Thread this tail onto a yarn needle and use Kitchener stitch to graft together the stitches on both needles.

SEWN TUBULAR BIND-OFF

Break yarn, leaving a tail about 3–4 times the width of the area to be bound off, and thread it onto a yarn needle. *Insert yarn needle into first (knit) st kwise **(FIG. 1)**, pull through, and sl st off needle **(FIG. 2)**. Insert yarn needle into second (knit) st pwise **(FIG. 3)** and pull through, leaving st on needle. Insert yarn needle into first (purl) st on needle pwise **(FIG. 4)**, pull through and off needle **(FIG. 5)**. With yarn needle in back, insert it into the second (purl) st kwise and pull through, leaving st on needle **(FIG. 6)**.

(You may find it easier to break this last step into two steps: first pass yarn needle between the first and second sts from back to front, pull through, then insert yarn needle into the second [purl] st kwise.) Rep from * to end.

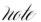 *Use consistent tension. You can also go back and manually adjust your tension every few stitches while working this bind-off.*

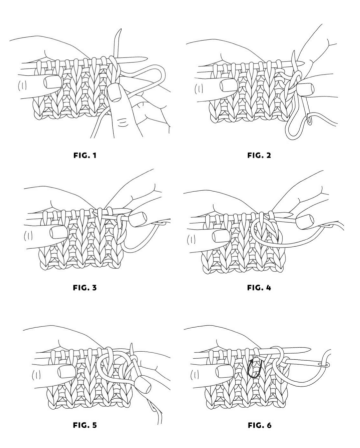

FIG. 1

FIG. 2

FIG. 3

FIG. 4

FIG. 5

FIG. 6

Short-rows

WRAP AND TURN (W&T)

Short-rows (Knit Side): Work to turning point, slip next stitch purlwise **(FIG. 1)**, bring the yarn to the front, then slip the same stitch back to the left needle **(FIG. 2)**, turn the work around and bring the yarn in position for the next stitch—one stitch has been wrapped, and the yarn is correctly positioned to work the next stitch. When you come to a wrapped stitch on a subsequent knit row, hide the wrap by working it together with the wrapped stitch as follows: Insert right needle tip under the wrap from the front **(FIG. 3)**, then into the stitch on the needle, and work the stitch and its wrap together as a single stitch.

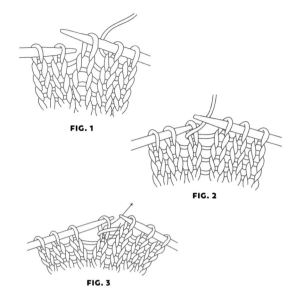

FIG. 1

FIG. 2

FIG. 3

Short-rows (Purl Side): Work to the turning point, slip the next stitch purlwise to the right needle, bring the yarn to the back of the work **(FIG. 4)**, return the slipped stitch to the left needle, bring the yarn to the front between the needles **(FIG. 5)**, and turn the work so that the knit side is facing—one stitch has been wrapped, and the yarn is correctly positioned to knit the next stitch. To hide the wrap on a subsequent purl row, work to the wrapped stitch, use the tip of the right needle to pick up the wrap from the back, place it on the left needle **(FIG. 6)**, then purl it together with the wrapped stitch.

Variation on hiding a wrap: When you come to a wrapped purl stitch on a subsequent knit row, hide the wrap by slipping the stitch and wrap together kwise to the right needle. Insert the left needle into stitch and knit them together through back loops.

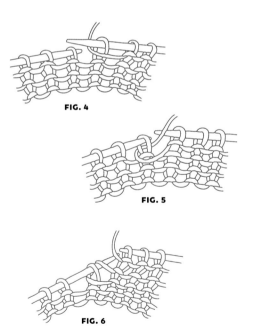

FIG. 4

FIG. 5

FIG. 6

DOUBLE STITCH (DS)

On a RS/knit row: Yarn forward between needles, slip 1 stitch purlwise, yarn back over needle.

On a WS/purl row: Slip 1 stitch purlwise, yarn back over needle, yarn forward between needles.

Pull the working yarn so that two legs of the DS are viewable on the needle.

On the following row, work the two legs of DS together as one.

Lifted Increases

LEFT-LEANING LIFTED INCREASE (LLI)

Insert the tip of the left needle from back to front into the stitch two rows below the stitch on the right needle **(FIG. 1)**. Knit this stitch through the back loop **(FIG. 2)**.

FIG. 1

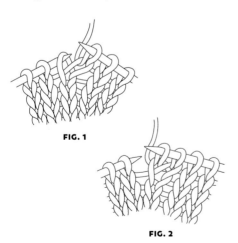

FIG. 1

FIG. 2

RIGHT-LEANING LIFTED INCREASE (RLI)

Insert the tip of the right needle from back to front into the stitch in the row below the next stitch on the left needle and lift this stitch onto the left needle, then knit into it **(FIG. 1)**.

Seaming

KITCHENER STITCH

1. Bring threaded needle through front stitch as if to purl and leave stitch on needle **(FIG. 1)**.

2. Bring threaded needle through back stitch as if to knit and leave stitch on needle **(FIG. 2)**.

3. Bring threaded needle through first front stitch as if to knit and slip this stitch off needle. Bring threaded needle through next front stitch as if to purl and leave stitch on needle **(FIG. 3)**.

4. Bring threaded needle through first back stitch as if to purl and slip this stitch off needle. Bring needle through next back stitch as if to knit and leave stitch on needle **(FIG. 4)**.

5. Repeat Steps 3 and 4 until one stitch remains on each needle, adjusting the tension to match the rest of the knitting as you go. To finish, bring tapestry needle through the front stitch as if to knit and slip this stitch off the needle. Then bring tapestry needle through the back stitch as if to purl and slip this stitch off the needle.

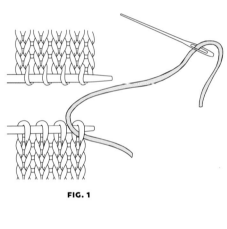

FIG. 1

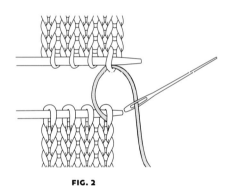

FIG. 2

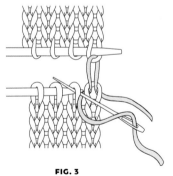

FIG. 3

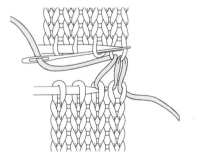

FIG. 4

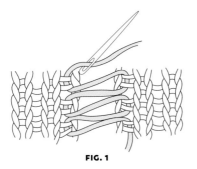

FIG. 1

MATTRESS STITCH

With RS of knitting facing, use threaded needle to pick up one bar between first 2 stitches on one piece, then corresponding bar plus the bar above it on other piece. *Pick up next two bars on first piece, then next two bars on other **(FIG. 1)**. Repeat from * to end of seam, finishing by picking up last bar (or pair of bars) at the top of first piece. Pull gently on seaming yarn to "zip" the seam closed so that seaming yarn is hidden.

Finishing

3-STITCH 1-ROW BUTTONHOLE

Work to where you want the buttonhole to begin, bring yarn to front, slip one purlwise, bring yarn to back **(FIG. 1)**. *Slip one purlwise, pass first slipped stitch over second; repeat from * 2 more times. Place last stitch back on left needle **(FIG. 2)**, turn. Cast on 4 stitches as follows: *Insert right needle between the first and second stitches on left needle, draw up a loop, and place it on the left needle **(FIG. 3)**; repeat from * 3 more times, turn. Bring yarn to back, slip first stitch on left needle onto right needle and pass last cast-on stitch over it **(FIG. 4)**, work to end of row.

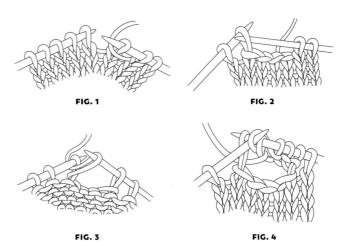

FIG. 1

FIG. 2

FIG. 3

FIG. 4

ABOUT THE Designers

K.M. Bedigan (aka Aphaia) is an Edinburgh-based knitting designer. She specializes in colorwork and textured knits, with an emphasis on unusual construction techniques to create interesting and intricate patterns.

Andrea Cull used to spend hours searching for the perfect thing to wear, yet it always eluded her. She solved the problem by designing the things that lived in her imagination. Find her at andreacull.com or on Ravelry as woolslayer.

Jennifer Dassau is an independent knitwear pattern designer and the author of the book *Knitting Short Rows*. Find her online everywhere as knittingvortex.

Mone Dräger lives in a village in Germany and loves to craft and be creative. She can't imagine a day without knitting and enjoys playing around with colors and stitch patterns. Find her on Ravelry and social media as monemade.

Formerly a humanitarian doctor, **Stella Egidi** lives in Italy with her husband and two sons. She loves designing simple, easy, and fun-to-knit garments and accessories and exploring styles and techniques, and has a preference for classic designs revisited with a touch of modernity. Find her on Ravelry, or on Instagram as @moody_knitter.

Amy Gunderson lives in North Carolina with her husband and their two adopted dogs. If she's not knitting, it's only because she's busy cuddling pooches.

Following an engineering career at Bell Labs and Jet Propulsion Laboratory, **Margaret Holzmann** has returned full-time to her first love, knitting. She has

created her own knitting designs since she was a teenager, but only within the last few years has she begun to consider herself a knitwear designer for others. She lives in Los Angeles with her husband and daughter and also has three grown daughters.

Jenise Hope is a designer from the west coast of Canada. Her knits reflect her love of playful colors as well as her affection for complex (and complex-looking) stitch patterns. She has worked as a designer since 2011. When she's not knitting, she can usually be found exploring the city with her husband and daughter, sewing herself clothing, or cooking and baking for dinner parties with friends.

Kate Gagnon Osborn is co-owner of Kelbourne Woolens, a yarn company and wholesale distributor based in Philadelphia. An avid knitter and crocheter, she has published designs in *Pom Pom, Interweave Knits, Knitscene, Wool Studio, Vogue Knitting,* and various knitting books. When not at work, she's most likely hanging out with her two daughters, husband, dogs, and cats in Flourtown, Pennsylvania, and can be found online at kelbournewoolens.com or @kelbournewoolens on Instagram.

Paula Pereira is a knitwear designer who believes that inspiration comes from people and nature. She loves to work with yarn and needles as tools to transform the daily inspirations of life into garments and accessories. She lives in São Paulo, Brazil, with her husband, two dogs, and tons of beautiful fibers. Find her on Ravelry as Paula Pereira and on Instagram as @paulapkl.

Sarah Redmond is a knitter, reader, drinker of tea, and lover of science. She learned to knit from her grandmother when she was five years old and continued to knit on and off until she picked it up again for good in high school.

Jenn Steingass is a Maine-based knitwear designer in love with all things knitting, color, wool, and circular yoke sweaters. She started knitting for her son when he was a baby and hasn't been able to put the needles down since. She strives for her designs to be simple yet beautiful while being easy to make and flattering to wear. Jenn believes that knitting is empowering and that knitting is a must-have life skill.

Jennifer Wood began Wood House Knits in 2009. Her designs unite classic and modern styling with beautifully detailed patterns for a contemporary romantic feel. For Jennifer, designing knitwear is a wonderful adventure, allowing her to express her creative impulses and drawing her closer to the creator of all. She is the author of *Refined Knits*.

Holli Yeoh is a Vancouver knitwear designer, known for her deliciously modern knitting patterns with a casually elegant vibe. Her designs appear regularly in books published by Interweave and Sixth & Spring, in collections by yarn companies, and in magazines including *Amirisu*, *Vogue Knitting*, and *Twist Collective*. Holli self-publishes her own line of knitting patterns at holliyeoh.com.

Inspired by the diversity of Los Angeles and the cities she has lived in and traveled to, **Mona Zillah** strives to make relevant designs that are clever additions to any wardrobe. With a background in science and art, Mona has been exploring and creating in a variety of mediums for most of her life. She has found a home in the fiber arts, enjoying every increase, decrease, and yarnover shaping her life.

Yarn Sources

Anzula
anzula.com

Berroco
berroco.com

Hazel Knits
hazelknits.com

Jamieson's of Shetland
jamiesonsofshetland.co.uk

Julie Asselin
julie-asselin.com/en

Ístex
istex.is/english

Kelbourne Woolens
kelbournewoolens.com

O-Wool
o-wool.com

Purl Soho
purlsoho.com

SnailYarn
snailyarn.com

Swans Island Company
swansislandcompany.com

The Uncommon Thread
theuncommonthread.co.uk

Tukuwool
tukuwool.com/en

Universal Yarn
universalyarn.com

YOTH
yothyarns.com

CRACK OPEN MORE MUST-HAVE KNITTING RESOURCES

100 KNITS

Interweave's Ultimate Pattern Collection

Interweave Editors

9781632506481 | $45.00

THE KNITTER'S DICTIONARY

Knitting Know-How from A to Z

Kate Atherley

9781632506382 | $19.99

KNITTING GANSEYS, REVISED AND UPDATED

Techniques and Patterns for Traditional Sweaters

Beth Brown-Reinsel

9781632506160 | $29.99